BROAD STROKES

BROAD STROKES

15 WOMEN WHO MADE ART *and* MADE HISTORY (IN THAT ORDER)

BY BRIDGET QUINN

WITH ILLUSTRATIONS BY LISA CONGDON

CHRONICLE BOOKS
SAN FRANCISCO

Library of Congress Cataloging-in-Publication Data:

Names: Quinn, Bridget, author.
Title: Broad strokes : 15 women who made art and made history (in that order)
 / Bridget Quinn ; with illustrations by Lisa Congdon.
Description: San Francisco : Chronicle Books, [2017] | Includes
 bibliographical references.
Identifiers: LCCN 2016023856 | ISBN 9781452152363 (hardback)
Subjects: LCSH: Women artists—Biography. | Women artists—History. |
 Art—History. | BISAC: BIOGRAPHY & AUTOBIOGRAPHY / Women. | ART / History
 / General.
Classification: LCC N8354 .Q47 2017 | DDC 709.2/52 [B]—dc23 LC record available at https://lccn.loc.gov/2016023856

Manufactured in China

Design by Kristen Hewitt

10 9 8 7 6 5 4 3 2

Chronicle Books LLC
680 Second Street
San Francisco, California 94107
www.chroniclebooks.com

FOR LUKAS & ZUZU,

ARTISTS & ATHLETES

& FOR

RO,

ALWAYS

& FOR

POLLY ANN QUINN,

WITH LOVE & ADMIRATION

(& APOLOGIES FOR THE BAD WORDS)

*I think it would be well, and proper, and obedient, and pure,
to grasp your one necessity and not let it go, to dangle from it
limp wherever it takes you. Then even death, where you're
going no matter how you live, cannot you part.*

—ANNIE DILLARD, "LIVING LIKE WEASELS"

TABLE OF CONTENTS

INTRODUCTION

IT WAS 1987, the spring of my first college year in California. I was still a teenager, though just barely, and what I would make of myself in the world preoccupied my waking hours. In a move that made no rational sense to anyone, including myself, I was majoring in art history, a topic I knew nothing about. But, somehow, art was the thing I wanted most to understand. So in I jumped, a girl raised on the high plains of Montana, where our town's one museum was dedicated to the work of local cowboy artist Charlie Russell.

That spring I was thrilled that my courses had entered the twentieth century at last, including a class dedicated to modern American art. After three thousand years of gods and nudes and kings and saints and boating parties on the Seine, I was finally comfortable. The class began with Regionalist painters like Thomas Hart Benton and Grant Wood, whose homey depictions edged along the paintings I'd grown up with.

The course was taught by my only female professor, a visiting scholar from Texas, who had long, untamed red hair and wore men's white shirts and jeans with cowboy boots. She walked with a cane and spoke in the flat, barely discernable drawl of the Texas Panhandle. I adored her.

So when she said, *Hey now, this is why abstraction is great and beautiful and true*, I wrote it down in my notebook and I believed it. For the first time, I experienced the artworks lit up on the big screens in that vast auditorium not as signifiers of *this time period or that artist*, but as objects of value in themselves, as sometimes beautiful— and sometimes failed—expressions of singular human beings in communication with . . . well, with all of humanity. With me, even, a pale and clueless woman-child with dyed black hair and a newly pierced nose. I fairly swooned with the romance of it.

And yet, there was something. Some niggle I couldn't quite put my finger on. Some itch or need I could not locate clearly enough to ameliorate.

By the second week of Modern American Art, we were in New York and left only to peek in on Europe and see what was happening there. Or to follow Duchamp or Dalí or Mondrian or any other dozens of artists fleeing toward Manhattan. Occasionally, a wife or female model was mentioned, but rarely. I took notes and mostly liked what I saw and tried not to worry about anything else.

But then one afternoon our redheaded professor did not dim the lights. She started out just talking, leaning at a jaunty angle on her cane while glancing at her notes and relaying with some pleasure the story of one Jackson Pollock, who was born in Wyoming and went to high school in California. I leaned forward in my institutional seat. I hadn't known any great artists came out of the American West.

She put on her glasses, smiled, and read something young Jackson had written in a questionnaire, right about the time he was my age: "As to what I would like to be. It is difficult to say. An artist of some kind."

The whole world narrowed to the pinprick of my professor on stage. The niggle squirmed, but as I tried to locate its source and meaning, the lights went down and up came two ravishing paintings. One by Pollock and one by someone named Lee Krasner. *Who was his wife*, my professor said, removing her glasses. This Lee was a woman, and she was a painter, and she was good.

The niggle became sound, a roar in the brain so violent I missed most of the remaining lecture. When class was over, I marched my combat boots to the arts library and checked out three books on Jackson Pollock.

There were no books dedicated to Lee Krasner, so I had to find out about her through her husband. About how she had attended the Art Students League before him, where she was so accomplished that her instructor, Hans Hofmann, paid her the ultimate compliment: "This is so good you would not know it was painted by a woman."

I closed the book, thinking of the volumes on art I'd grown up with.

My family owned a set of Time Life books dedicated to important artists, dozens of them on a shelf in my father's study, each with the same gray cover, but each one dedicated to a different painter or sculptor. I loved these books for years, until about age ten, when I suddenly realized that not a single one was about a woman. Then I believed I'd uncovered yet another terrible adult truth: girls could not be great artists. After that, those books just made me sad.

I went to my locker in the art library and took out our main text, a massive volume called *History of Art* by H. W. Janson, hoisted it onto a table, and started flipping through. At last, on page 500, the early seventeenth-century section on the Italian Baroque, it read: *Artemisia Gentileschi*, followed by, "We have not encountered a woman artist thus far." I wrote down her name, then worked slowly, page by page, to the end. By the time I hit the back cover, I had a list of sixteen women, one of them Lee Krasner.[1] In more than 800 pages, this was all "official" art history could offer.

I mentioned the women artists in Janson's book to my professor at her office hours. Except for Mary Cassatt and Georgia O'Keeffe, and now Krasner, I'd never heard of any of them.

She gave a throaty, smoker's chuckle. "You've got the new edition! Our version didn't have a single woman in it with her clothes on." She waved a broad hand in the air, as if flicking away smoke. "Not really, but you know what I mean. No women *artists*." She let me do my research paper on Krasner, with the understanding that it would be difficult to find sources.

It was.

But whenever I had the chance, I ferreted out what I could about the women on my Janson list. Some didn't interest me much, but others, like Gentileschi and Krasner and Rosa Bonheur, a swaggering animal painter from the nineteenth century, I couldn't get enough of. I also uncovered other incredible women not in Janson, like Edmonia Lewis, who was part Chippewa, part African American, came of age during the Civil War, and spent much of her adult life as a successful sculptor in Rome. Or Frida Kahlo, who, believe it or not, was just then starting to appear alongside Che Guevara on the T-shirts of Latina activists on campus. Kahlo wasn't in Janson either, but the first English biography had come out a few years earlier and I found a copy in the main library (not the arts library).

Then, as now, I called myself a feminist, but my fixation with these artists went beyond feminism, if it had anything to do with it at all. I identified with these painters and sculptors the way my friends identified with Joy Division or The Clash or Hüsker Dü. In some strange way, I felt they understood me. They belonged to me.

Janson wrote his art history bible when he was a professor at the Institute of Fine Arts at New York University, which is where I ended up for graduate school. There, I encountered the painter Paula Modersohn-Becker in Gert Schiff's course on German Expressionism. She died young, but her work was among the first of what would become the bold vanguard of German Modernism. Her paintings and those of her journals translated into English blew the top of my head off. It wasn't the last time I'd regret my poor, though passing, German score.

My French was better. In Robert Rosenblum's seminar on Jacques Louis David during my second year of grad school, I was assigned a portraitist named Adélaïde Labille-Guiard, about whom almost nothing was written in English. At the Metropolitan Museum of Art across the street, in a gallery at the top of the grand staircase, there was a monumental self-portrait of Labille-Guiard with two of her female

students. I visited the painting almost daily, locking eyes with an artist who gazed out from the canvas with sure confidence, modeling that and more for the students behind her, and for me.

I worked hard. I wanted to do well, yes, but more than that I wanted to know Labille-Guiard's story. Who was the formidable woman, this masterful painter, forgotten by history? And maybe most important to me—a shameful, even prurient need—I just wanted to know what happened.

One night, home late from a day spent wrestling with eighteenth-century French at the Institute library, where I discovered that Labille-Guiard had been forced to burn her most ambitious composition, I turned off the lights in my room and lit votive candles from the corner bodega. Candles flickering and the Velvet Underground crackling from my boom box, I ate chocolate chip cookies washed down with beer, stared out my window at the people and cars and lights, and wondered why I ever wanted to study art history.

Half a six-pack—tall boys—and a second VU album later, I suddenly knew at long last: *I want to be an artist, not study them. I came to New York to become a writer.*

* * * * *

Great lives are inspiring.

Great art is life changing.

The careers of the fifteen artists that follow run the gamut from conquering fame to utter obscurity, but each of these women has a story, and work, that can scramble and even redefine how we understand art and success.

* * * * *

At a cocktail party not long ago, a friend asked what I was working on. *I'm writing about artists I love*, I said happily.

"Which artists?" She asked, grinning and sipping her cocktail. I imagine she pictured a fierce Mission muralist or half-naked performance artist.

I got no further than a single word—*Baroque*—when she lowered her drink. "The worst class I took in college was art history," she said. "So. Boring."

"Maybe you had the wrong teacher," I said, about to add a titillating art historical tidbit when she caught sight of something more interesting over my shoulder, and moved on.

It strikes me that we might need a little caveat here before getting started. Can we agree at the outset to lay down our qualms about *Ye Olde Arte Hystore* at the door of this book? Put them down. Walk away. Let us agree that together we shall fear no corsets, nor nursing saviors, nor men in top hats and cravats, nor vast expanses of peachy dimpled thighs.

Let us withhold judgment until we know more.

* * * * *

When I was still an undergraduate, my first TA paid for grad school with his pool shark winnings. As a hustler, he went by the nom de pool of *Santa Barbara Jim*. However lamentably prosaic his moniker, SBJ lived better than your average grad student. He wore natty linen blazers and cognac-colored wingtips. He'd mastered pool and understood people. By the marriage of those two assets he made a fine living.

In addition, SBJ knew a thing or two about art. Good art, he once said, gave him a hard-on. He aimed to shock, but I was charmed, writing it down in my notebook, along-side definitions for *oeuvre* and *sfumato*. I liked hearing him talk dirty about art. Though a better sort of undergraduate might have objected to his gender-exclusive language, I did not. I took *hard-on* metaphorically. That great art should move you bodily, not just intellectually. That a good erotic jolt is appropriate to good connoisseurship.

And also, that you can't know what will turn your crank, until it does.

* * * * *

Let's get started.

1. Janson's artists, in order: Artemisia Gentileschi, Élisabeth Vigée-Lebrun, Rosa Bonheur, Berthe Morisot, Mary Cassatt, Gertrude Käsebier, Georgia O'Keeffe, Lee Krasner, Helen Frankenthaler, Judy Pfaff, Audrey Flack, Barbara Hepworth, Margaret Bourke-White, Dorothea Lange, Berenice Abbott, Joanne Leonard.

ARTEMISIA GENTILESCHI

There were many Caravaggisti, but only one Caravaggista.

—MARY GARRARD

HERE IS THE FIRST THING I think you should know: Art can be dangerous, even when decorous.

And sometimes, decorous art looks dangerous, too. Case in point, Artemisia Gentileschi's *Judith Severing the Head of Holofernes* (see page 20). Painted right around 1620, it has lost none of its power to shock.

You may well be asking: *What the hell?* Though, in one sense, the painting here is self-explanatory. Two women hold down a struggling man, while one of them draws a sword across his neck.

No question, this is a brutal, bloody painting. So are many paintings—violence, like romantic love and spiritual passion, being one of the great themes of art. But there is so much in this particular painting that is disturbing.

The two women work in dispassionate exertion. They could be Julia Child and Alice Waters deboning a turkey. Sure it's bloody and sure it's some work, but it must be done.

Really, it must be done. The women are a Jewish widow named Judith and her maidservant, Abra. They are executing an Assyrian general named Holofernes who will otherwise destroy their people.

However heroic the task, their images are not flattering ones. The women's faces are brightly lit from the lower left, casting unflattering shadows as they gaze down at their victim. Somewhat difficult to distinguish from each other in age and rank, the women are likewise both steadfast in their work, though Judith leans away slightly from the spurting blood. Maybe because it's staining her dress. Blood spatters

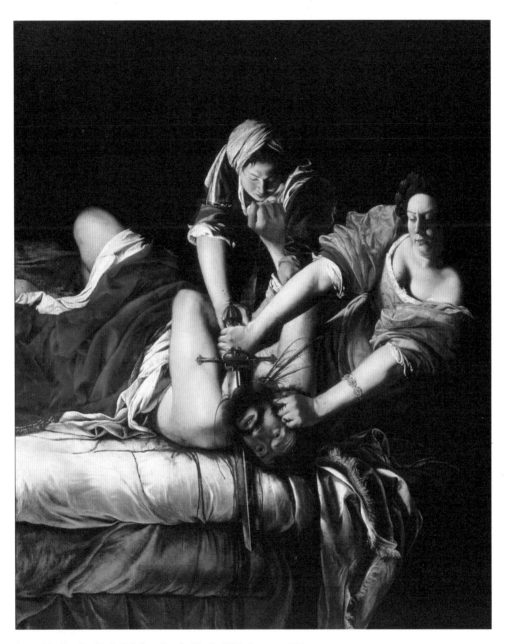

Artemisia Gentileschi. *Judith Severing the Head of Holofernes.* c. 1620.

Judith's bodice and breast, and it runs in thick red rivulets down the white mattress Holofernes struggles upon.

Judith's victim, writhing in death throes and shock, is naked. Judith and Abra are dressed. They stand while he is prone. Judith wields a deadly weapon; he has nothing. In short, the women have all the power here.

Not only are the women dressed, in stark juxtaposition to their victim's nudity, but one of them is well dressed. Judith wears an elegant gold gown with capacious sleeves hiked above the elbows (she's a woman at work, after all) limned with red that rhymes with the blood she's spilling. Her strong left fist is entangled in Holofernes's black hair, while higher up on that same arm she wears a pair of gold bracelets. As Artemisia scholar Mary Garrard points out, one bracelet is slight, simple, while the other is thick and ornate, with scenes inscribed in separate ovals that, on close inspection, look to be images of the goddess Diana. Also known by her Greek name, Artemis, this is the namesake of the very painter who has created this turbulent world.

Judith in her plainness and her elegance, in her blood-letting calm and life-taking power, all of it, seems to beg the question: Is this a task appropriate to women?

Is beheading?

Is painting?

<center>* * * * *</center>

Like the vast majority of women who became artists before the twentieth century, Artemisia Gentileschi (1593–1656) was the daughter of an artist. Her father, Orazio Gentileschi, was a reputable Baroque painter in Rome. He was blessed, or cursed, with enough talent to recognize those who were brilliant.

Orazio was an early follower of Caravaggio and his revolutionary art. Caravaggio had established a new visual language, one that married the immediacy of naturalism with a heightened dramatic flair. He utilized *chiaroscuro* (bold contrasts of light and dark) to great effect, pushing it to the point of *tenebrism* (extremes of dominating darkness pierced by bright, insistent spotlights) for high drama in a world all viewers could relate to. Contrast Caravaggio's earthy vision with Leonardo's mysterious otherworldly scenes of all-over haze (the aforementioned *sfumato*) or Michelangelo's crisply outlined superheroes. It was a radical, and masterful, departure.

Orazio was chummy enough with Caravaggio to go to prison with him for a short time, in 1603, when Artemisia was just six, after the two artists were found guilty of libel for writing nasty verses about another painter's altarpiece.

Note that I'll refer to Artemisia by her first name, both to distinguish her from her painter-father and because first names are often standard for the Italian greats: Dante, Leonardo, Michelangelo, Raphael, Madonna, and so on. It's true that Caravaggio is known by the name of his birthplace,

but that's because Michelangelo was already taken.

To his credit, Orazio recognized early that his own child, though a girl, was very good. Artemisia was the oldest of four and his only daughter, but Orazio trained her from an early age in the art of painting. When Artemisia was just twelve, her mother died, and so she spent the rest of her childhood in a world of men. Not just her father and brothers, but also her father's students and assistants and colleagues and models. In coming centuries, one of the strenuous feelings against allowing women to study the creation of art was the coming and going of so many men in the "dark hallways" of academies, studios, and ateliers.

At the death of his wife, another man might expect his only daughter to put away childish things—drawing, paints—and take up some duty as woman of the house. But Orazio recognized Artemisia's talent and she became a valued member of his work-shop. Her education must have included artistic necessities like prepping canvases, mixing paints, life drawing, and the like, but as with most non-aristocratic girls, niceties like reading and writing did not figure in. At the age of nineteen, Artemisia would tell a Roman court, "I cannot write and I can read very little."

Still, her father took her artistic education seriously. As part of her training, Orazio hired his colleague Agostino Tassi, who specialized in illusionistic architectural paintings, to instruct Artemisia in the subtle details of perspective.

Artemisia was rarely out in public. She was mostly secured at home or in her father's studio, as was culturally expected. Think of all those high-walled gardens and nearly impregnable homes of Romeo and Juliet, or the fact that Dante only met his beloved Beatrice, a neighbor girl since childhood, just twice in his entire life.

But even staying home could not protect Artemisia. When she was just seventeen, her neighbor—an older woman named Tuzia, a friend to the motherless girl—slipped the instructor Agostino Tassi into the Gentileschi apartment through an adjoining door. There, the older painter raped his student, while Artemisia called out for help that did not come.

Artemisia's account of the rape is heart-breaking: *Lifting my clothes, which he had a great deal of trouble doing, he placed a hand with a handkerchief at my throat and on my mouth to keep me from screaming. . . . I tried to scream as best I could, calling Tuzia. I scratched his face and pulled his hair . . . After he had done his business he got off of me. When I saw myself free, I went to the table drawer and took a knife and moved toward Agostino, saying, "I'd like to kill you with this knife because you have dishonoured me."*

* * * * *

It's crucial to point out here that what Tassi had done was not "rape" as we know it, but "defloration" or the "theft" of Artemisia's

father's property. That is: his only daughter's virginity.

Tassi knew he was in trouble. He'd broken the law in depriving Orazio of his daughter's hymen, so he told Artemisia he'd marry her. If they married, then all was well. Artemisia, who, under Italian law and church doctrine and social propriety and every other measurable yardstick of female ease in the world, was ruined otherwise, agreed to the arrangement.

Alas, after months of promises, it turned out that Tassi was already married. Orazio sued, offering up his "despoiled" daughter for legal, and very public, scrutiny.

The seven-month trial that followed was gruesome. To verify the truth of her rape account, Artemisia was subjected to torture in the form of the *sibille*, a kind of thumbscrew where chords are fastened to rings around the fingers of one hand and then tightened to excruciating degrees. It was the seventeenth-century version of a lie detector test, the legal gold standard for truthfulness of its time. In agreeing to the sibille, Artemisia not only accepted terrible pain but also risked damage to her hand, an unthinkable fate for an artist. But to be believed, she had to endure it.

Court transcripts record that midtorture, when to every question asked by the court, Artemisia insisted, "It is true, it is true, it is true, it is true," she suddenly broke off and cried out, "This is the ring that you give me, and these are your promises"! Tassi was sitting in the courtroom.

Possibly as torturous as the sibille itself was the requirement that the teenaged Artemisia endure two obstetrical exams to confirm her "defloration." The court notary was present, in order to record the findings. The record shows that both midwives "touched and examined the vagina of Donna Artemisia Gentileschi" and found "that she is not a virgin" on account of her "broken hymen." One added, "And this happened a while ago, not recently, because if it were recent one would recognize it."

Orazio won his case. This was due in no small part to his daughter's fierce endurance, but also because in the course of the trial it came out that Tassi had contracted to have his wife murdered and had impregnated his sister-in-law. He was an exceptionally bad guy. It was a blessing that Artemisia could not marry him.

Tassi was "banished" from Rome, which was never enforced, and he even worked with Orazio again on a commission. Economics sometimes trump honor.

For her part, Artemisia was bundled off in marriage to a minor Florentine painter named Pierantonio Stiattesi within a month of the trial's end in 1612. By 1614, they were living in Florence.

In essence, Artemisia fled her Roman home where, no matter what the trial's outcome,

her name was forever tainted. For centuries her reputation as a "loose woman" was remarked upon whenever her name was resurrected by historians.

What she fled to was an arranged marriage to a man her inferior as an artist and to a city that was the seat of Medici power. If you are unfamiliar with the dangerous reputation of the Medicis, there's a slim volume I can recommend called *The Prince*, written by a Florentine official named Niccolo Machiavelli from his jail cell.

Artemisia was essentially alone in a volatile new world. True, she had a husband, but she was no longer her father's daughter, working under him in his studio. She had to stand on her own merit as a professional, and secure her own commissions. She had no choice but to proffer her talent and the new style of Caravaggio, with its heightened emotion and theatricality, at the feet of the Medicis. Fortunately, they liked it.

Florence was, on the whole, good to her. Her mentor was none other than Michelangelo Buonarroti the Younger, grandnephew of the High Renaissance master. Artemisia was one of the first artists he commissioned for the frescoes of Casa Buonarroti, then being decorated in lavish tribute to Michelangelo. Her contribution was, fittingly, a female nude. She was good at them. Because, unlike male painters, she had access to her own body and to those of female models (forbidden to men).

Even an anatomical master like Michelangelo had some trouble with the female form. Consider his tomb sculptures for the New Sacristy of San Lorenzo. There, the female personifications of Night and Dawn have distinctly male-looking chiseled torsos beneath wide-set breasts that are as bulbous and affixed looking as any inept plastic surgery. The lack of access to female models explains the odd female anatomy of many Renaissance and Baroque nudes. (No one can explain the plethora of strange babies.)

Artemisia was friendly with members of the Medici court, most notably Galileo Galilei, and the Medicis provided her with crucial patronage. By 1616, just two years after arriving in Florence, she was elected to membership in the Accademia del Disegno, the first woman member since its founding in 1563.

But life was not, nor would it ever be, one of unbroken success. By 1624, the census of her household makes no mention of her husband, who disappears from history entirely. By the time Artemisia painted the *Judith* here, she had given birth to at least four children, one of whom, a girl, was also a painter. She'd also taken a lover. She was her household's only breadwinner, busy beyond belief with children and getting commissions and making paintings and, not always successfully, getting paid.

Artemisia painted her first version of *Judith* not long after the trial, a veritable prototype of the painting here, which she did in

Florence after the birth of her children. She may have felt it suited Medici taste, with its high drama, opulence, and violence. Or maybe given her reputation, there was interest in a scene of implied revenge. *I'd like to kill you with this knife because you have dishonoured me.* Tassi had dark hair, and also a beard.

* * * * *

If it is difficult to look at Caravaggio's full-lipped young men and not feel a sexual undercurrent (he may have been gay), then the case for reading a biographical urge into Artemisia's work is even more tempting. A young woman experiences rape followed by public torture and humiliation. Shortly afterward, she paints her first version of a scene depicting a woman decapitating a bearded man.

But Artemisia was hardly the first artist to depict the story of Judith. It was long a popular theme. Caravaggio has a famous version, with a more typical Judith as a lovely young thing (complete with erect nipples pushing through her blouse) and Abra as a Disneylike old crone. Less typical is that Caravaggio, like Artemisia, chose to illustrate the moment of decapitation.

The vast majority of artists skirt the gruesome act: Botticelli has a beautiful Judith swaying through a field with Abra carrying Holofernes's head in a basket perched atop her own. They might have been out picking apples for the ruddy wholesomeness of the scene.

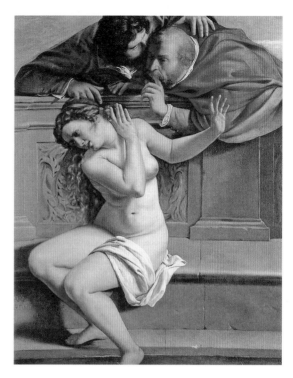

Artemisia Gentileschi. *Susanna and the Elders.* 1610.

John Ruskin thought Botticelli's version by far the best of a terrible tradition. If you don't know Ruskin, he was a voluminous Victorian critic whose influence was vast. (I can't resist this take on him from a *New York Times* review of the Mike Leigh film, *Mr. Turner*: "Ruskin [Joshua McGuire] appears as a pretentious carrot-topped nitwit with a voice like a posh Elmer Fudd." But I digress.) Ruskin complained of the "millions of vile pictures" of Judith, specifically in Florence.

But Ruskin was just one of many critics of Artemisia's *Judith*. The last Medici, the Grand Duchess Anna Maria Luisa, loathed it. And according to feminist historian Germaine Greer, when British writer Anna

Jameson beheld Artemisia's masterpiece in 1882, she called it a "dreadful picture" and of its maker, "a proof of her genius and its atrocious misdirection."

But why? Why despise Artemisia's version above the hundreds of *Judiths* (Ruskin said "millions") to come before hers?

* * * * *

This may be the moment to back up and ask, just who is Judith and why is she doing that very bad thing to the oddly named Holofernes?

The story goes that Judith was a beautiful Jewish widow living in the village of Bethulia. Like all of Israel, her village was threatened by King Nebuchadnezzar, who sent his Assyrian general Holofernes to destroy it. The Assyrians were unspeakably bad. The kind of conquerors who would flay an entire army, then paste the human skins outside their palaces like wallpaper advertising how badass they were. No one messed with Assyrians if they could help it.

The Jews of Bethulia are rightly terrified, but their fear annoys Judith, so she sneaks into the enemy camp with her maidservant Abra and becomes friendly with the general, if you know what I mean. Her beauty inflames Holofernes, who goes about seducing her. Pretending to be willing, she gets him drunk. When he reclines on his bed, a come-hither or a nodding-off moment, Judith leaps upon him with a sword.

Judith and Abra escape the enemy camp, bringing the head of Holofernes with them as evidence of their triumph. Head in hand, they inspire their people to victory.

For artists of the Middle Ages and Renaissance, the Judith story was akin to David and Goliath, a tale of the victory of weakness over might. David was only a shepherd boy, and Judith was just a woman. But favored by God, they do the impossible, destroying otherwise invincible enemies.

* * * * *

When Artemisia was "rediscovered" in the twentieth century (not long after Caravaggio himself) it seemed obvious in both a Freudian and a feminist sense to interpret her powerful *Judith Severing the Head of Holofernes* as a *cri de coeur*, a symbolic wish fulfillment to hurt the man who made her suffer. In short: a painterly act of revenge.

This may be true. And it was likely viewed that way even in her own time. But it doesn't explain Artemisia's interest in other great heroines, both before and after she painted her first *Judith*. And it doesn't explain why her *Judith* was so despised.

* * * * *

Artemisia's earliest dated painting is from 1610, the year of Caravaggio's death. She was just seventeen. *Susanna and the Elders* also depicts a scene from the Catholic Old Testament. It's the story of two older men who spy on a young woman bathing,

trump up a charge of promiscuity (punishable by death), then blackmail her to secure sexual favors. The painting is dated from before we know Artemisia experienced her own violation by an older man. But again, the Susanna motif had long been popular with artists, not least because there weren't many opportunities for depicting the female nude outside of Eve, some unfortunate saints (Agatha, Barbara), and Venus.

Though young, Artemisia shows a handling of anatomy that is already sure. And in this, her first professional picture, she already stakes out her vision of the ideal heroine. Susanna is solid, not soft. For the rest of Artemisia's life, her heroines tend to this type of full-bodied but not overtly erotic women. Rather, they are heroic-size. Powerful, but in the sense of real power—physical, artistic—not sexually manipulative.

She also establishes a new perspective for viewers. Susanna turns midwaist, cringing away from the men leering down at her. As spectators, our point of view is allied with the nude woman. We cringe with her, disgusted, rather than voyeuristically eyeing her nudity like another leering elder on the other side of the picture plane.

All viewers of Artemisia's time would have known the full story of Susanna. That she refused sexual demands and risked death as a result. Here the men are clothed and she is naked, but ultimately Susanna is the powerful one. Willing to face death before dishonor, she is pardoned at the last minute when it's discovered the elders have lied. Then they are the ones who pay with their lives.

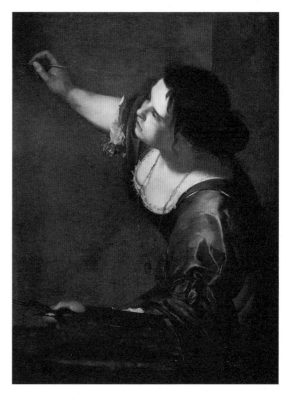

Artemisia Gentileschi. *Self-Portrait as La Pittura*. 1638–1639.

Portraits of many formidable women followed: Esther, Mary Magdalene, Cleopatra, Lucretia, etc. A virtual pantheon of feminine power, one that included Artemisia herself.

* * * * *

While briefly reunited with her father in England at the court of Charles I, Artemisia painted a deceptively simple composition that contains multitudes: *Self-Portrait as La Pittura.*

La Pittura is the Allegory of Painting, female embodiment of the art itself.

Crucially, La Pittura is not a muse. She is no female goad to the (almost universally) male artist. No, La Pittura is the art of Painting itself, with all the procreative power and mystery that evokes.

It's a radically simple canvas: the artist at work. And at the same time, Artemisia here is manifold and audacious. She is subject and object, creator and created. A deceptively uncomplicated and persuasive portrait of Painting herself, in the person of a painter and woman. By declaring that

I AM SHE, Artemisia claims a position that no male artist ever can.

The ideal of La Pittura had been around about a hundred years when Artemisia painted herself as such. La Pittura's attributes were outlined in Italian Cesare Ripa's influential emblem book (a text filled with allegorical figures embodying the arts and sciences, virtues, vices, and more), called the *Iconologia*. First published in the 1590s, Ripa's book was widely consulted by painters, sculptors, and architects. In her own painting, Artemisia cleanly ticks off La Pittura's attributes as codified in the *Iconologia*:

Hair. La Pittura's hair appears undone, indicative of creative passion. Embodied by Artemisia, this, we can imagine, is just how a woman at work looks: hair pulled out of the way, but not fussed over. She's not there to be looked at, but to make something happen. She is the subject of this painting, not its vapid object.

Chain. Around her neck, Artemisia wears La Pittura's attribute of a gold chain with a mask charm. The mask symbolizes imitation, which, as a follower of Caravaggesque naturalism, is Artemisia's forte. Naturalism continues in the casual hanging to one side of the necklace. It's not there to make her more beautiful or more affluent looking, not even to call attention to the bosom across which it hangs. It hangs askew, unnoticed, as she works.

Gown. Artemisia as La Pittura wears a green gown of some iridescent material that shimmers violet in places like a

Cesare Ripa. Cropped image of La Pittura from *Iconologia*. 1644.

sharkskin suit. This is the *drappo cangiante*, a garment of changing color, indicating a painter's skill with color, amply on display by Artemisia here.

The dress has three-quarter sleeves, giving the effect that she has "rolled up her sleeves" before the canvas. It's both fitted through the torso and puffy in the arms, but somehow doesn't look odd on a woman at work. Artists in self-portraits of this time, and later, often depicted themselves in fancy dress, to the point where your first reaction is, "You're really gonna paint in that?" But such finery was a necessary conceit, a way to separate one sort of manual labor—painting or sculpting, say—from horseshoeing or bricklaying.

Hands. Artemisia's left hand, holding her palette, rests on a solid table or stool, indicating her grounding in the material necessities of the craft, while her right hand is held high, grasping the brush. Here, where brush meets canvas, is where inspiration and intellect meet.

Face. The artist has done nothing to flatter herself in terms of appearance, and does nothing to seduce the viewer into admiring her. She looks away from us, lips closed, eyes intent on her work. A dark shadow falls along a third of her face.

But it is her face that tells everything. Here, Artemisia does omit one key aspect of La Pittura's depiction that is called for by the *Iconologia*: the Allegory of Painting should be depicted with a gag around her mouth, because painting is mute.

Virtually all depictions of La Pittura include this device.

Artemisia refuses the gag.

* * * * *

When I was a teenager, there was a bar my father liked called The Quiet Woman. Hanging in front was a wooden pub sign, of the kind found outside Ye Olde England–type alehouses. The sign consisted of the carved and painted outline of a woman's body outfitted in seventeenth-century dress, with no head. There was the stump of a neck, but then nothing after.

The Quiet Woman. Get it?

* * * * *

Artemisia Gentileschi was never quiet. She was instead the heroic center of her own art, fashioning a new language of womanhood, in action and in form.

Her heroic women are not man-eaters, but man-beaters. That's one reason why her *Judith Severing the Head of Holofernes* appalled so many for so long. Not only is a woman depicted performing a heinous act on a man, but also it's a woman daring to depict it.

Artemisia refused the gag. And from four hundred years away she speaks to us still, saying: *Dare to be great.*

JUDITH LEYSTER

*I can't decide whether Leyster feels contemporary
or makes me feel Old Dutch.*

—PETER SCHJELDAHL

EVER READ *THE DA VINCI CODE*, or see the movie? They both begin with the gruesome murder of a Louvre curator. It's fiction, of course, but calls to mind real Louvre crimes, like the famous theft of Leonardo's own *Mona Lisa* in 1911 (recovered two years later). Or less famously, the 1893 discovery that the magnificent new Frans Hals the Louvre had recently acquired was . . . not by Hals at all.

The "Hals" affair may be more boondoggle than crime, but still a novel- (or movie-) worthy event. I picture the painting uncrated in a dim gallery. Slats of wood eagerly pried apart, nails and boards left scattering the ornate parquet floor. Someone pulls on white gloves and eases the painting from its protective bed. Those assembled—all men—chuckle with undisguised pleasure as the titular *Carousing Couple* is held up to the light.

It's a coup, no question. Dutch seventeenth-century painter Frans Hals was hugely popular in late nineteenth-century France. His loose brushstrokes and lively subjects (drunken duo, anyone?) appealed to Modernist sensibilities. French Impressionists and Post-Impressionists loudly admired, and even copied, Hals's work. And now not only does the Louvre have a wonderful new painting by the Dutch Golden Age master, but "one of the finest he ever painted." Awesome.

The painting is bundled off to conservation (the smoke, sweat, and spit of centuries mar its lively surface), where after painstaking cleaning what's revealed is decidedly not the signature of Frans Hals. I like to imagine the men of the Louvre gathering around the painting to take a look as the conservator grimly points.

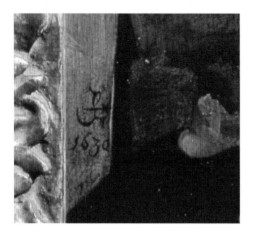

Judith Leyster. Monogram (detail of *Carousing Couple*). 1630.

Right there, above the foot of the male half of the *Carousing Couple*. No signature at all, but a monogram of a strange sort of *J* with a star shooting out to the right. Unfortunately for the Louvre, this same *J* monogram has been noted before, by one Wilhelm von Bode writing on the history of Dutch painting a decade earlier. He decided the *J* referenced Frans Hals's less esteemed brother, Jans. Bad news.

But von Bode was wrong. It was "worse" than that. In the flurry of accusations and the following trial—you'd need an Excel spreadsheet to keep track of who was suing whom and where—the fabulously named art historian Cornelis Hofstede de Groot unraveled the monogram's true source: a previously unknown *woman* painter named Judith Leyster.

The Louvre was pissed. Token reparations were paid. And then silence. In the words of feminist writer Germaine Greer in her pioneering study of women painters, *The Obstacle Race*, "At no time did anyone throw his cap in the air and rejoice that another painter, capable of equaling Hals at his best, had been discovered."

* * * * *

Judith Leyster. Born 1609 to a non-artistic Dutch family. Obtained her artist training from no one knows who. But by age twenty she'd painted her *Self-Portrait*, a precocious display of obvious mastery.

Dressed in high style in a corseted wine-colored dress, accented with a most unsuitable projecting collar and matching white lace cuffs, Leyster is glorious in attire, and in attitude. She turns casually toward us, painting arm balanced atop a pokey-looking chair finial. Her mouth is slightly open as if to speak, and the start of a sly smile says she's up to something.

There is at least one joke in the painting. As *New Yorker* critic Peter Schjeldahl has pointed out, Leyster's paintbrush, held with assurance in her beautifully rendered right hand, aims directly at the crotch of the merry fiddler on her canvas. Deep meaning? Or a near-adolescent's bawdy humor? Maybe a little of both. In the phrase of my friend art historian Mark Trowbridge, "This pipe is not just a pipe" (that's a Magritte pun, for those keeping art history score at home). Whatever it means, the whole painting feels lively and a little naughty. It makes me hope that if I'd been twenty in 1620s Haarlem, Judy Leyster and I would've hung out.

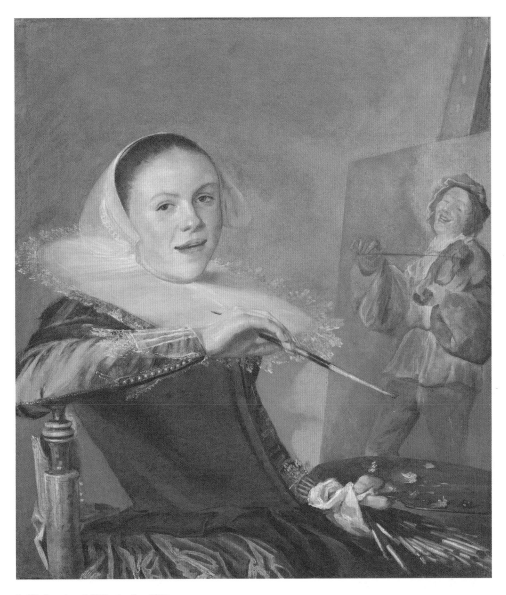

Judith Leyster. *Self-Portrait.* c. 1630.

Her pointing paintbrush isn't the only veiled meaning in the painting. Infrared photography shows that the fiddler now depicted was not Leyster's first impulse. The musician covers what was originally the face of a young woman. Schjeldahl speculates that it may have been a self-portrait—a fascinating meta-portrait within a portrait—and that covering her own face with that of a male figure was a premonitory act of self-effacement. In other words, Leyster predicted her own erasure from the history of art.

There's no question that Leyster understood the challenges for a woman artist, in history and in the marketplace. By 1633, the year of her *Self-Portrait*, Leyster had joined the Haarlem Guild of St. Luke as just its second female painter ever. It's possible that utilizing a monogram—a conjoined JL, plus shooting star—rather than her signature may have been aimed at a marketplace not quite ready for a talented woman painter.

Leyster came of age in a peaceful era of rocketing prosperity for newly independent Holland. For the first time in Western history, artists didn't depend on the wealth of the church or aristocratic patrons. Instead, they competed in an open market increasingly interested in status luxury goods, from tulips to oil paintings. It was an era of upheaval and unheard-of social mobility. Both essential if you are, say, the eighth of nine children in a cloth-manufacturing family, a girl, and it turns out you want to be an artist.

Her family embraced the prosperous moment, changing its name (from Willemsz to Leyster) and its business (from weaver to brewer), and Judith emulated their example by futzing her own identity on canvas. The new family name, and also the name of their brewery, meant "Lodestar" or "Leading Star." It's a statement, and so is Leyster's use of a monogram that is both distinctive but somewhat opaque. She is a leading star. She is also mysterious. Maybe, like women writers such as George Sand and George Eliot, she assumed a non-feminine nom de plume so her work would not be ignored out of hand. Or possibly, as a painter with no connections in the art world, associating herself with the family brewery might offer familiarity and notoriety. Hey, beer sells.

Whatever the reason, Leyster used her monogram from the outset. Her earliest known paintings, *Serenade* and *Jolly Topper*, both from 1629, are signed with it. And thank goodness. Without her unique symbol, Leyster might be entirely lost. As Virginia Woolf famously laments in *A Room of One's Own*, "For most of history, Anonymous was a woman."

Within a decade of her rediscovery in 1893, Leyster was embraced by a women's movement looking to find inspiring forebearers. She was included in early twentieth-century retrospectives on women in art, and the first doctoral dissertation on Leyster was written in the 1920s by a female student.

It took longer for mainstream art history to acknowledge her. Whitney Chadwick, in her survey *Women, Art, and Society*, quotes James Laver from 1964: "Some women artists tend to emulate Frans Hals, but the vigorous brushstrokes of the master were beyond their capability. One has only to look at the work of a painter like Judith Leyster to detect the weakness of the feminine hand." Typical but without merit. Leyster was tough enough for ten Lavers. Even her earliest work reveals a bold, independent, and preternaturally self-assured artist.

The Leyster/Hals comparison is common. She did her share of jolly genre scenes—drinkers, lute players, fiddlers—reminiscent of Hals (her *Self-Portrait* is a type pioneered by Hals: a sitter captured mid-turn as if greeting the viewer), but her work could also be radically unlike his, anticipating the quiet, tense interiors of Vermeer.

Leyster's tiny masterpiece, *The Proposition*, just 1 ft/30 cm high and less than 1 ft/30 cm wide, is one example. Here, a woman in a white smock sews intently by candlelight while a bearded older man in a fur hat leans over her, touching her shoulder with one hand and offering her money with the other. She ignores him. He insists, casting a dark, looming shadow. Candlelight highlights the coins thrust beneath the woman's face. At her feet, a brazier glows beneath her skirt. The room must be cold. She could probably use the money.

It's a creepy, unsettling scene, ripe with Mephistophelean overtones. The man is temptation, no doubt. The fur hat, strange indoors, implies wealth, but also something else. It looks foreign, at least very un-Dutch. From where does this dark stranger hail? At any rate, the older man does not seem to belong next to the much younger woman, who rebuffs his offer by focusing on her work.

Sewing—the old in and out—can easily be construed as a sexual metaphor. In fact (thanks again, Dr. Trowbridge), the medieval Dutch word for sewing was slang for "making carnal union." In modern Dutch, *sewing* is still used the same way, though

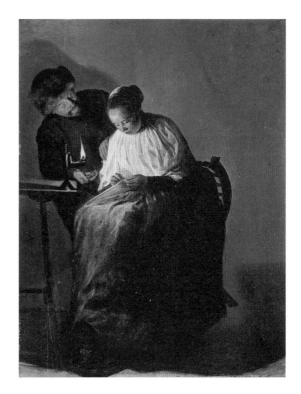

Judith Leyster. *The Proposition*. c. 1631.

probably now better translated as a single word starting with *f*.

Regardless, in seventeenth-century Holland, needlework was something all proper women, highborn or low, should do well. Something a well-brought-up woman took pride in. It's Leyster's innovation to insert this virtuous activity into a scene of seduction that would usually take place in a brothel or bar. There, the come-on is depicted as welcome, a lark, some fun. But in Leyster's scene it is unwanted, unacknowledged, and, as the dark shadow implies, sinister.

In other words: this scene is from the woman's point of view.

Judith Leyster. *Early Brabantian Tulip*. 1643.

It's tempting to read *The Proposition* as a parable of the artist, resisting easy money and sticking with her creative work. Maybe saying, too, that a woman painter is as virtuous as any seamstress.

It's also tempting to see it as a preemptive rebuff to the assaults on Leyster's reputation far in the future.

* * * * *

Not long after her resurrection from a historical black hole, people began concocting all kinds of liaisons for Leyster. She was

Rembrandt's lover. Or no, she was Hals's lover. There is in fact no more evidence that she was romantically involved with either man than there is of a love affair between Hals and Rembrandt themselves. It is a wholesale fantasy based on the fact that she was a woman, they were men, alive in the same nation in the same century. They must have had sex.

Though there was no romance between Leyster and Rembrandt (or Leyster and Hals or between Rembrandt and Hals or, oh, never mind), there was romance between Leyster and another Haarlem painter (sex, too). It's impossible to know whether this was good or bad for Leyster personally. But for the history of art, the line is pretty clear: all but two of Leyster's known works were painted between 1629 and 1635. On June 1, 1636, Leyster married fellow painter Jan Miense Molenaer. He was more successful than she was in terms of sales, though her inferior as an artist. We don't know why there are no Leysters from the six months before her marriage, though things for Haarlem painters were difficult just then due to an outbreak of plague. The Guild of St. Luke suspended its annual dues that year and the following, as its members found it difficult to generate income in a city more concerned with survival than pretty pictures.

Possibly to escape the plague and in pursuit of a better art market, the newlyweds moved from Haarlem to Amsterdam within months of their marriage. There, Leyster gave birth to five children between 1637 and 1650: Johannes, Jacobus, Helena, Eva, and

Constantijn. Only Helena and Constantijn survived to adulthood.

Historians tut over Leyster's loss of self on becoming a wife, as if she willfully threw away the artist part of her when she got together with Molenaer. But first it was the plague, and then wooing and a wedding, and then moving to a new city, and then her first pregnancy. And my God, five children! When my two children (two!) were young, I mostly stopped writing for six years. I simply couldn't manage the time and attention to art, and the time and attention young children required. How much more impossible for Leyster with five? And not just the pregnancies and births and babies and toddlers and the household and her husband's studio and perhaps her own studio, but the impossible loss, the terrible grief. Yes, what of the deaths of her children, something not once mentioned in any of the many thousands of words I've read on Leyster?

Should we be shocked if her oeuvre stopped abruptly with marriage and family? Saddened at such artistic loss, yes, but surprised? How could Leyster have gone on?

But somehow, she did.

For a long time, the only known work signed by Leyster after her marriage was a watercolor from 1643 of a lone tulip. According to Leyster scholar Frima Fox Hofrichter, if painted from life, then *Tulip* was done in April that year, the flower's blooming season, shortly after the birth of Helena, her daughter who would live.

Leyster already had other children, along with her newborn, but in some hours of peace, or some way amid the chaos of family life, Leyster painted this flower: simple, well observed, lovely.

Tulip is in all essential ways the opposite of her renowned genre paintings, imparting no parable or moral, symbol of nothing but itself. Beautiful, if slight.

For a century, Leyster's *Tulip* was believed to be her final work, a lovely though insufficient coda for a career that began in brilliance and abundance. Then in 2009, a still life by Leyster done in 1654 was discovered in a private collection, painted eleven years later than *Tulip*.

* * * * *

So Leyster did not stop painting. There must be more Leysters in the world than we know.

I picture a painting uncrated in a sky-lit gallery. Slats of wood eagerly pried apart, nails and boards left scattering the floor. Someone pulls on white gloves and eases the painting from its protective bed. The assembled curators—all women—lean in. A collective gasp. That monogram—"J+L" with a star shooting to the right like an arrow bursting from its bow—they recognize it instantly. Judith Leyster. Stunned silence. Then hugs all around. Then carousing worthy of a Dutch Golden Age master.

ADÉLAÏDE LABILLE-GUIARD

*She had rendered even more faithfully than the glimmer of silk and velvet
and the froth of lace the impression of an earnest, recollected personality,
whose will and courage are overlaid by patience and steadfastness.*

—GERMAINE GREER

AT AGE TWENTY-THREE I began near-daily visits to eighteenth-century painter Adélaïde Labille-Guiard's *Self-Portrait with Two Pupils* (see page 40) in the Metropolitan Museum of Art. This went on for a good five years. A conservative estimate would put me at, say, twelve hundred viewings.

In the fall of 1990 I'd been assigned Labille-Guiard in Robert Rosenblum's graduate seminar on Jacques Louis David. I'd never heard of her, did not recognize her work. Rosenblum I knew about before even getting to the Institute of Fine Arts. He was one of two professors there (Kirk Varnedoe the other) who was both hallowed-be-thy-name art historian and pop-culture cool. When Andy Warhol's diaries were published in early 1991, Rosenblum had his own entry in the index.

Rosenblum seemed to embody the ultimate in worldliness: European in his erudition, American in his earthiness. Short, spiky hair, an amused pose, he was impossibly kind to me and I have no idea why.

Still, I almost didn't get into the seminar where I discovered Labille-Guiard. "I'm sorry," Rosenblum had said when I'd handed him the form requiring his signature to enroll, "but you haven't even had a class with me yet."

I imagined I was easy to turn away: long hair dyed jet black, a nose ring (when this was unusual), red lipstick, granny boots, and a leather jacket with Edvard Munch's *The Scream* charmingly superimposed upon a mushroom cloud. I'd sat in Rosenblum's Neoclassicism lecture the entire previous semester and he hadn't noticed. In essence,

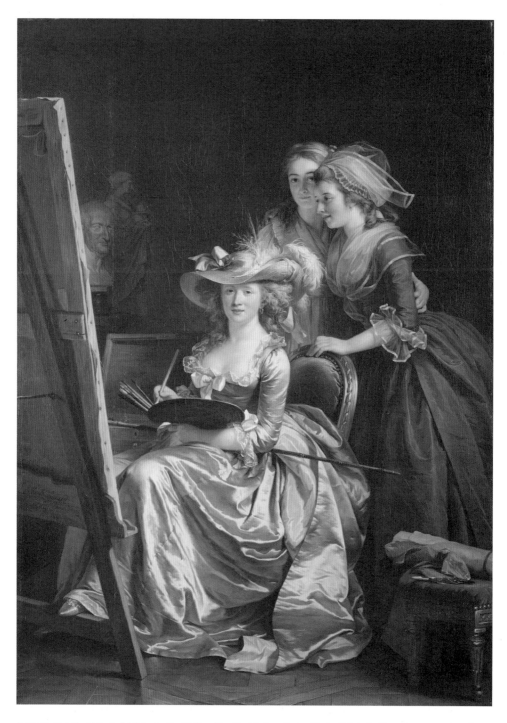

Adélaïde Labille-Guiard. *Self-Portrait with Two Pupils, Mademoiselle Marie Gabrielle Capet (1761-1818) and Mademoiselle Carreaux de Rosemond (died 1788)*. 1785.

my greatest fear. I was invisible. While my fellow students had attended Ivies or power-house liberal arts colleges like Vassar, Ober-lin, and Carleton or overseas eminences like the Courtauld and the Sorbonne, I'd gone to UC Santa Barbara. I came from nowhere, had zero connections, did not matter.

"I took Neoclassicism!" I yelped, thrusting the paper at poor Rosenblum. "I got an A." I really said that. Rosenblum, startled, looked back with amusement and pity. Then reached for the pen.

The first day, Rosenblum's PhD students div-vied up aspects of David's oeuvre, followed by his immediate predecessors, famous peers, and acolytes getting snatched up around the table until there seemed nothing left. My fellow students were, I believed, smarter and savvier. They were certainly more self-confident. But then Rosenblum reached into his breast pocket, dug out a slide, and slipped it into the projector. Up came *Self-Portrait with Two Pupils*.

He looked at me across the big round table. "Adélaïde Labille-Guiard," he said. "She wasn't strictly a follower of David, but she survived the Revolution and this terrific painting is across the street." He gestured toward Fifth Avenue. "How's your French?" he said.

French was a requirement of the seminar. I'd passed my reading exam, though just barely. "It's good," I said.

Rosenblum popped out the slide and handed it over. It was a gift.

* * * * *

Raised mostly in Montana, with some years in California beach towns, I'd had contact with fine art, but 99 percent of it was slides or printed reproductions. I told myself this was fine: reproductions were tidy, and slides tiny reliquaries, uncorrupted and jewel-like. In many ways, ideal.

I was wrong. What I discovered as a grad student in New York was the necessary and exhausting emotion of confronting art itself. The messy, sexy, physically unnerving shock of the real. That paintings can seduce you, sicken you, haunt you.

Nearly seven feet high and five feet wide, Labille-Guiard's multi-figure composition is meant to grab you. Its full title is *Self-Portrait with Two Pupils, Mademoiselle Marie Gabrielle Capet (1761-1818) and Mademoiselle Carreaux de Rosemond (died 1788)*, which matters because the younger women are central to the point. They stand behind their teacher where, in a self-portrait by a male artist, we might find a female muse (see Courbet's *The Artist's Studio*, for a standard, if witty, example). Her students are lovelier than the woman who has painted them, though their dresses are many shades more demure. Labille-Guiard protects their modesty.

Mlle. Capet looks over her teacher's shoul-der, openly admiring the canvas we can't see, while Mlle. de Rosemond stares out at us, frank and confident. The young women have their arms around each other, and lean

in toward their teacher in a circle of mutual support. They'll need it.

Self-Portrait with Two Pupils was first exhibited in Paris at the Salon of 1785.

Salons were official exhibitions for members of the exclusive Royal Academy of Painting and Sculpture. They were every-other-year affairs, a cross between the Oscars and the Olympics. A place to bring your best game, win glory, be admired and lauded. And like any red carpet today, also a place to be mocked, derided, and taken down a notch.

Exhibiting at the Salon was not for the faint of heart.

It was never intended for a woman.

* * * * *

I visited Labille-Guiard's portrait the way you replay a favorite song, craving its emotional hit. I visited before or after classes, or on study breaks. After grad school I worked at the Met, so lunchtimes I climbed the Great Hall's big marble staircase to peek in on her, though the cafeteria was in another direction entirely.

I sensed she recognized me, the way you might feel if you paid regular visits to an animal in the zoo. There was a flicker of living intelligence behind those painted eyes. In all of New York, standing before her portrait was where I felt most seen.

When other museumgoers inevitably wandered over, they distracted and annoyed me. They giggled and cooed over Labille-Guiard's flamboyant finery. Sometimes said how amazingly like real silk her dress was, shimmering unevenly with reflected light. It took everything not to offer an impromptu tutorial utilizing the word *reflet.*

The bald man with a fanny pack, the tall one squinting like a critic with a pince-nez, they loved to sigh dismissively before her. "Isn't that just like a woman? So vain." Other typical barbs: "Why is she wearing a hat indoors?" and "For all that effort, she's not much of a looker."

I took it all very personally. Labille-Guiard's painting embodied everything I longed for: Talent. Passion. Courage. Also I thought we looked alike, with our heavy-lidded eyes in soft, pale faces.

* * * * *

I could not get enough of her, stalking every sketch, pastel, painting, and possible attribution, every street, teacher, friend, and correspondent. A sense of duty (and mad pleasure) urges me to write Labille-G's 500-page biography, but in fairness to this book's other artists, the CliffsNotes:

Labille-Guiard was born in 1749 and raised in a neighborhood near the Louvre—itself used at the time as a residence for artists. Her father was a cloth merchant to the French aristocracy. They counted on Claude-Edme Labille for pretty wares and pretty girls (Jeanne Bécu, a.k.a. Madame du Barry, worked in his shop before taking up her infamous stint as King Louis XV's mistress).

The youngest of eight children, Labille-Guiard was the only child to live well into adulthood. And when she was just nineteen, her mother died.

Longing to become an artist, Labille-Guiard had contrived to study with neighbors since the age of fourteen. Shortly after her mother's death, in 1769, she married another neighbor, a bureaucrat with the Treasury of the Clergy. He must have looked good at the time. In Catholic France, divorce was impossible, but by 1777 they'd legally separated. That same year, coincidentally (or not at all) Labille-Guiard began studying oil painting with François-André Vincent, a childhood friend and the son of her first teacher, miniaturist François-Elie Vincent.

* * * * *

They'd both studied with his father, but François-André left his father and his friend behind when he was accepted to the Royal Academy's prestigious art school. The school was barred to women, and without Academic training Labille-Guiard's own career stalled. She knew as well as anyone the immutable hierarchy of styles that moved upward from lowly *still life* to *animal painting* to *landscape* to *genre painting* to *portraiture*, and, finally, to the ultimate achievement of *history painting* (big-ass canvases with a story to tell). To be a history painter meant mastering all styles, and required, among other things (such as education in mythology, history, theology, literature, philosophy), access to the nude, impossible for women.

But the younger Vincent did not allow his old friend to fall far behind. By 1777, he was back from some years in Italy studying Renaissance and Classical art, ready to teach her everything he'd learned. And according to gossip, sharing more than that.

There was an eighteenth-century version of trolling that supported an entire economy of the most vicious satire. As a woman artist, Labille-Guiard was an easy target.

TO MADAME GUIARD

What do I see, oh heaven! our friend Vincent
Is no better than an ass?
His love creates your talent
Love dies and talent is less
Resign yourself proud Chloris
Say your prayers, your De Profundis

The anonymous writer of the above went on to accuse Labille-Guiard of having Vincent as a lover or maybe also two thousand lovers. Said out loud, Vincent's name sounds kind of like "two thousand" in French. In other words, that Adélaide Labille-Guiard is nothing but a slut. An untalented slut at that. For women artists the leap from intimacy with a man to being an untalented slut has, in the public eye, never been a big one.

Slut or not, she was shrewd. With no husband to defend her, or support her financially, Labille-Guiard defended herself. By going on offense. Between 1782 and 1783 she showed six portraits of important male

Academicians. It was a brilliant stroke, securing valuable eyewitnesses to her talent. If any man admired his portrait, he must admire Labille-Guiard's ability as well.

* * * * *

The history of accusing women artists of sleeping with their sitters is a long one, as is the charge that some man has done a woman's art for her. But what I found early in researching Labille-Guiard and her female peers was the illogical claim of both. At the same time. In other words: She's not the author of a given painting, but she is having sex with its subject. Her story was endlessly interesting, and often complicated—though not in the ways people chose to imagine.

On May 31, 1783, Labille-Guiard was voted into the Royal Academy. Just the twelfth woman member since its inception, she was admitted on the same day as her "rival," Élisabeth Vigée-Lebrun.

For as long as both women had exhibited they'd been compared. One was mostly given good criticism only at the expense of the other, a practice not restricted to art. Personal appearance was fair game, to Labille-Guiard's disadvantage.

Vigée-Lebrun was pretty (verified by her self-portraits), wealthy, successful, and court painter to the queen. And she was the wife of an art dealer. She was originally denied Academy membership on the grounds that being in the "art business" was forbidden (a woman was identified

with her husband's profession). But this was the *Royal* Academy and what Queen Marie-Antoinette wanted, she generally got. And what she wanted was her painter in the Academy.

One can imagine how little the Academy liked being forced to admit a woman, by a woman. They let Vigée-Lebrun (and her patron) know this by admitting Labille-Guiard on the very same day. Academy minutes specify that Vigée-Lebrun was admitted *par ordre* ("by order"), while after Labille-Guiard's name it says, *les voix prises a l'ordinaire* ("vote taken in the usual manner"). Labille-Guiard gleefully signed the register that day as Adélaïde des Vertus. Adélaïde of the Virtues. Take that, gossips.

Unfortunately, the Academy's pleasure in their spiteful gesture was short-lived, and they quickly established a quota on women members. Four. By astounding coincidence, the very number of its current female membership.

* * * * *

At the next possible Salon, Labille-Guiard unveiled *Self-Portrait with Two Pupils*. It was an act of insurrection aimed straight at the Academy.

Labille-Guiard depicts herself in high style (Germaine Greer fabulously calls it "full sail") before her easel, wielding a painter's tools with casual competence. She holds brushes and a palette. Resting across her lap is a long mahlstick, used to steady an

artist's hand at work. It's a typical prop, one signifying "painter" (see Vermeer's *The Art of Painting* or Sofonisba Anguissola's *Self-Portrait*).

In the background is a classically inspired bust of her father. Nearly hidden in dark shadows behind him is a statue of a Vestal Virgin, those antique exemplars of virtuous unmarried women. On a low stool near Labille-Guiard's feet lie scissors and a bolt of fabric, likely canvas. Sewing is often linked with women in art. Take David's famous *Brutus*, for example, where a centrally placed sewing basket divides the upright masculine world of war from the fainting female world of domestic grief. Labille-Guiard's canvas and scissors, attributes of an artist rather than a seamstress, assert a new task as one appropriate to women.

Her elegant dress speaks to the elevated social position due an artist of her rank. And it affirms her femininity. According to exacting art historian Laura Auricchio, "The sweep of her luxurious silk dress catches the eye, and her breasts are prominently featured at the very center of the composition—an *X* drawn from corner to corner would cross directly at her cleavage." So Labille-Guiard here embodies all kinds of womanly virtue. She's talented and fashionable, with a pretty great rack, as well as a devoted daughter and teacher.

She never lets us overlook her heroic-size students, Mademoiselles Capet and de Rosemond, who share her stage. Young women who are neither muses nor mere pretty objects. They are painters, active producers of art in their own right.

By including Capet and de Rosemond in her composition, Labille-Guiard has brazenly defied the Academy's quota on female artists. Two more women painters now hang on the walls of the Academy's official Salon.

It's a painting that says, in effect: *Screw you*. Followed by the emoticon of the painter's own visage: *Smiley face*.

No wonder I couldn't get enough of it.

* * * * *

I traveled up and down Manhattan that winter, intent on locating every potential source. There was no Internet, no laptops. Most stacks were closed and rarely could books be borrowed. Xeroxing was almost never an option; pens were banned. I tromped, pencil in hand, to the New York Public Library, the Frick, the Morgan, Bobst at NYU, and the Met, always hauling along a big French dictionary. It was slow going, though my French improved by the hour.

One afternoon in the Met's Watson Library I wanted to hurl that dictionary at a cool glass partition, dig pencil lead into the pristine wood surface of the big table where I worked, and leave an ugly mark. I'd discovered how it was the Met came to own Labille-Guiard's masterpiece. In 1878, her heirs had offered *Self-Portrait with Two*

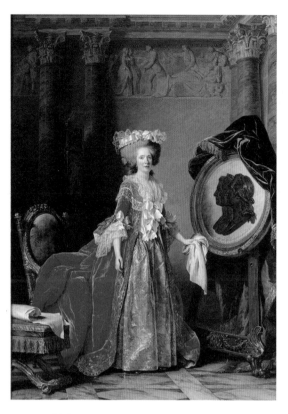

Adélaïde Labille-Guiard. *Portrait of Madame Adélaïde*. 1787.

Pupils to the Louvre. It was refused. Not good enough.

* * * * *

Labille-Guiard's artistic chutzpah wasn't limited to personal causes. She was also, quite happily, a brush for hire. Two years after *Self-Portrait with Two Pupils*, she fired off another political shot: *Portrait of Madame Adélaïde* at the Salon of 1787. Painter Adélaïde Labille-Guiard, meet Princess Adélaïde, daughter of King Louis XV.

One the daughter of a Paris shopkeeper,

one the daughter of the former king of France, but their portraits share so much. Both are full-length images of luxuriously attired women posed before easels. Both are unmarried and childless. Both have scissors and rolled-up cloth beside them. Behind both Adélaïdes, a Vestal Virgin. Above Madame Adélaïde is a carved frieze of her father, much as the bust of painter Adélaïde's father hovers near her. The remarkable thing here isn't so much that Labille-Guiard has presumed royal grandeur, but that Princess Adélaïde assumes the role of artist.

The French nobility was bitterly divided between the current King Louis XVI, with his wife Marie-Antoinette, and the "old guard" of the Mesdames (the king's aunts, of whom Mme. Adélaïde was one). The program for the 1787 Salon identifies Labille-Guiard as the *premier Peintre de Mesdames*. Her ostensible rival, Vigée-Lebrun, was already painter to the queen.

Vigée-Lebrun's *Marie-Antoinette Surrounded by Her Children* also debuted at the 1787 Salon. They were hung essentially as matching pendants, and viewers were encouraged to compare and contrast the female artists and their royal subjects.

Vigée-Lebrun tried to boost Marie-Antoinette's reputation by depicting her as the motherly type, gifting the future of France with her offspring. But Labille-Guiard's childless Madame Adélaïde stakes out her own honorable position. She stands before three profiles (apparently created

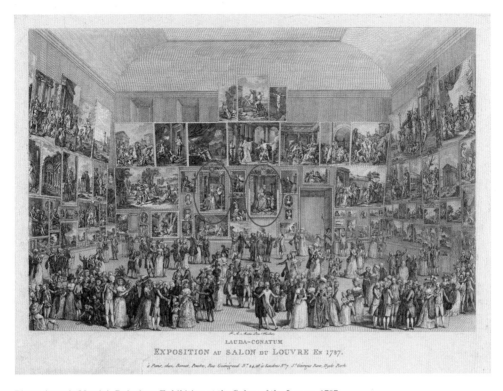

Pietro Antonio Martini. *Paintings Exhibition at the Salon of the Louvre.* 1787.

by her own hand) in silhouette: her father, mother, and brother. In other words, the glory of France's better past. Meanwhile, the frieze running above Madame Adélaïde depicts a bedridden King Louis XV dying of virulent smallpox. But what is this? Just as the king has sent away his sons to save them from his cruel fate, his daughters rush to his bedside.

The frieze might be interpreted two ways: *One*, princesses are more expendable than princes. Or *two*, princesses are more badass than princes.

On the whole, the painting asks us to lean

toward the latter. Unmarried women can be brave and virtuous. Maybe even more virtuous than fertile queens.

* * * * *

Success at the Salon of 1787 led directly to Labille-Guiard's big break. *Reception of a Chevalier de Saint-Lazare, by Monsieur, Grand Master of the Order* would at last elevate her to the rank of history painter. Commissioned by the Comte de Provence (the king's brother), the painting was to be a massive 17-x-14-ft/518-x-427-cm group portrait celebrating his role as head of the

Knights of Saint-Lazare (a very old, by then mostly ceremonial order).

But just a year into her grandest project, everything changed. The Storming of the Bastille led to the Reign of Terror: sixteen thousand enemies of the revolution guillotined and twenty-five thousand executed by other means. The king and queen were beheaded, of course, and so were friends of the aristocrats, like Madame du Barry. Artists died, too, and many, like Vigée-Lebrun, fled. The Mesdames also made it out, taking money they owed Labille-Guiard with them.

But Labille-Guiard stayed, together with

Adélaïde Labille-Guiard. *Portrait of François-André Vincent.* 1795.

Vincent, in a home they rented (wisely) outside Paris. Both were in perilous positions as former painters to the court.

Amid such danger, Labille-Guiard did a shrewd, familiar thing. Just as with members of the Royal Academy, she painted the portraits of key deputies of the revolution's National Assembly. Including one Maximilien Robespierre, author of the Terror.

As with her earlier portraits, painting these men made Labille-Guiard subtly allied with them. She needed such alliances. That she survived the Terror is nothing short of incredible.

Amid other unwise acts, she continued to work on the monumental canvas celebrating the king's brother. Even as the Mesdames and the Comte de Provence himself fled for their lives, she clung to her ambition. Her portraits of Robespierre and men like him may have saved Labille-Guiard's life, but no one could save her history painting.

On August 11, 1793, the Directory of the Department of Paris demanded she deliver "the large and small portraits of the former prince and all studies related to these works, to be devoured by flames." She had no choice but to comply. Anything else would have been sure suicide.

* * * * *

I discovered the fate of Labille-Guiard's painting after a long day of classes, followed by hours puzzling out details (*Grand Master of the Order?*). By the time I left

the Institute, a bright moon was rising over Central Park.

Marching along the cold avenues, then rattling on the subway back downtown, I couldn't shake my depression. This was why Labille-Guiard was nearly lost to history. Her most ambitious work had been destroyed. And though she fought the Academy quota on women, that long fight came to nothing. Her students did not go on to glorious careers. She had no successors.

* * * * *

My seminar presentation was exhilarating and, at nearly two hours, exhausting. In the darkened room no one could see my sweaty hairline and flushed face, lipstick gone, mascara smearing, but I felt exposed. Such passion I knew was gravely unacademic, maybe even unseemly.

Lit up behind me was Labille-Guiard's final painting of Vincent, from 1795. It's a tender portrait of an aging fellow artist holding what power he still wields in a volatile world: paintbrushes and a palette. Unidealized and clear-eyed, it is nonetheless a portrait forged, like her career itself, in fierce loyalty and love.

Maybe the only good thing to come out of the revolution for Labille-Guiard was the legalization of divorce. In 1800, after decades of devoted artistic and romantic partnership, she and Vincent were married. Labille-Guiard lived just three more years.

From out of the dark, Rosenblum's voice.

"Where is it now?" His tone said he liked the painting.

"The Louvre," I sighed, thinking but not adding: *They don't deserve it.*

* * * * *

Weeks later, Rosenblum stopped me in the hall, handing me the slide of a painting possibly by Labille-Guiard to authenticate for a midtown gallery. The sort of task promising grad students were given. To be singled out for my work on Labille-Guiard felt like an art historical benediction, and I was grateful. Rosenblum was a kind and excellent teacher.

Just not, it turns out, my teacher. But he pointed the way to her.

I put the slide in the back pocket of my binder, and did not look at it again. I had already decided to follow Labille-Guiard, not study her. I wanted to be like her, to explore what talent might lie inside me with passion and courage. The way she'd taught me to. At the end of the school year I was leaving, to write.

MARIE DENISE VILLERS

*Perhaps the greatest picture ever painted by a woman is
the portrait of Charlotte du Val d'Ognes.*

—THOMAS B. HESS, *ARTNEWS*

*Its cleverly concealed weaknesses, its ensemble made up from a thousand subtle
artifices, all seem to reveal the feminine spirit.*

—CHARLES STERLING, THE METROPOLITAN MUSEUM OF ART

AS A BABY ART HISTORIAN, I was taught that the very essence of my training was in cultivating an unerring sense of connoisseurship.

Um, what?

Basically: knowing who made what, just by looking at it. To be able to perceive, by attitude, gesture, mood, and style, what belongs to whom. A lofty goal. Daunting. But when I got into grad school in New York at an old-world bastion of connoisseurship training, I believed such power would someday be mine.

At lunch one day when still an undergraduate—newly cocky about my acceptance to grad school—I was eating at an outdoor table with a new boyfriend (fellow art history student, now husband) when Professor Alfred Moir came out, tray in hand, and asked to join us. I licked my teeth, feeling for lettuce bits. My boyfriend, a grad student used to proximity with the great man, was capable of inviting him to sit down.

Moir was a formidable presence, big-headed, bearded, and curly haired, as classical and timeless looking as Laocoön (look it up). But he was also charming, earnest, and

funny. I couldn't wait to drop my good news about going to New York.

I finally did it, in some ham-handed *look at me* gesture. Instead of heaping on praise, as every other person in the know had done, Moir pushed back his chair and crossed his big arms. "The Institute, huh?"

I nodded, awaiting congratulations.

Moir nodded back. "You know the problem with connoisseurship?"

I did not. I had no idea there was a problem with connoisseurship.

"It doesn't take into account the artist waking up on the wrong side of the bed." He leaned forward and lifted a finger, as if to shake it in my face. "It doesn't consider the really shitty day."

Years later, when I'd discover that Moir had been one of the first Caravaggio scholars to champion Artemisia Gentileschi, I'd think, "Yeah! That's my guy!" I was team Moir from that afternoon on.

I never forgot it: *The Really Shitty Day.*

Later it would occur to me, what about the opposite? *The Day When Everything Goes Right. The Fucking Excellent Day.*

* * * * *

In 1917, The Metropolitan Museum of Art in New York received what was, even by their august standards, a fabulous gift. One Isaac Dudley Fletcher bequeathed a monumental painting, *Portrait of Charlotte du Val d'Ognes*, by father and undisputed master of eighteenth-century French Neoclassicism, Jacques Louis David.

The Met could hardly overstate the importance of the gift. The original press release (they had them already in 1917) announced, "As one of the masterpieces of this artist, the Fletcher picture will henceforth be known in the art world as 'the New York David,' just as we speak of the *Man with a Fur Cap* of the Hermitage, or the Sistine Madonna of Dresden." In other words, a landmark work in the Met's already world-class collection.

The press release also crowed over the impressive original price: "Mr. Fletcher is said to have paid $200,000 for this great David." In 1971, Thomas B. Hess wrote, "The Fletchers paid the contemporary equivalent of about $2 million." So how much would that be today? Who knows how to even figure out such things? But let's say it would be millions and millions in today's dollars.

Why was Hess writing about the cost of the Met's painting—a gift, after all—more than fifty years later?

Because, as it turns out, "the New York David" is not by David. It's by a woman. And that changes everything.

* * * * *

Right away the *Portrait of Charlotte du Val d'Ognes* was one of the Met's most popular

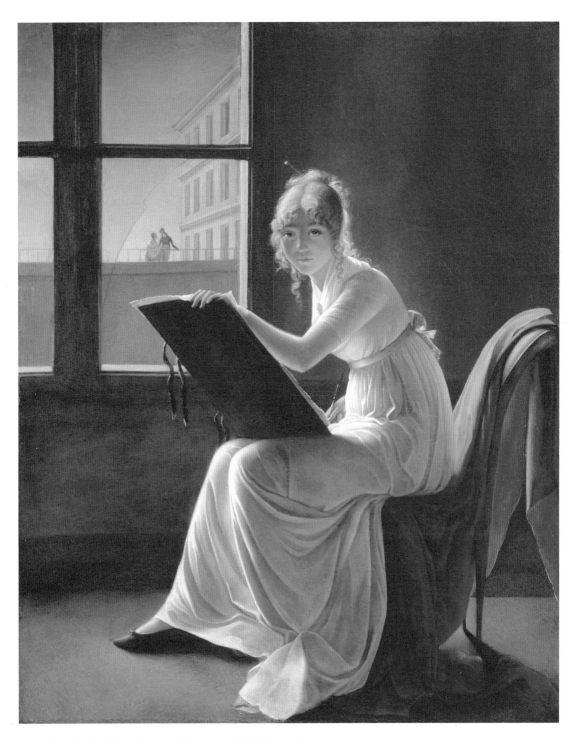

Marie Denise Villers. *Portrait of Charlotte du Val d'Ognes*. 1801.

works. If they'd had merchandising back in 1917, it would have been slapped on umbrellas and coasters and sold like beer at a ballpark. Which is to say, widely and well. Generations of visitors penned letters telling the Met how they adored it, how it moved them, and what it meant to them.

It is a haunting painting. Standing before it, it's difficult to look away. For years I paused in front of the young and compelling Charlotte du Val d'Ognes on my near-daily visits to Labille-Guiard's *Self-Portrait with Two Pupils*. They hung on adjacent walls. Sometimes I lingered with Charlotte for as long as I spent with Labille-Guiard, the reason I'd come. The feeling never left me that if the gallery would just clear out and leave me alone with her, she might speak. There was something she wanted me to know.

Charlotte wears a simple white dress and hunches in a slightly adolescent, but not un-winning, way. Her only adornments are a rose-colored sash tied just below her small breasts, a simple brooch holding together a scarf at her neck, and a single pin in her upturned hair. Thrown over the back of her chair—she's sitting on part of it—is a plain, solid-colored shawl that matches her ribbon. This is not the fabulously attired artist we've come to expect (compare to Judith Leyster, or Labille-Guiard nearby), though this young woman is an artist.

In her right hand she holds a pencil or pen, and with her left she balances a large cardboard folder across her thighs, of a type traditionally used to hold drawings. She stares out so intently that we—or whatever we stand in place of—must be the subject of her sketch. Her expression is impossible to read. Is she smiling or serious? Thoughtful or sad? She is mysterious. She might be called the Mona Lisa of the Met.

The simple chair where she sits is the only piece of furniture in an otherwise empty room. The wall behind her is dark, nothing to see, but there is a window and, looking closely, the pane nearest to Charlotte is cracked. Through the broken pane we can just make out a man and woman on some kind of raised balcony, their indistinct faces turned toward each other. The woman in the background looks to be dressed like Charlotte in the foreground, in a white dress, with a rosy shawl around her shoulders.

It's a great painting.

But what does it mean? What's happening? How are we supposed to understand it?

No one knows for sure. But had I encountered it back when it was supposed to have been by David, I know how I'd interpret it. I'd say it was about a love affair. That the woman in the background and the woman in the foreground are the same person, that two separate moments in time occur within the same picture, as in early Renaissance paintings. See Masaccio's *Tribute Money* for a good example.

And then I'd think that the broken window symbolizes a loss of innocence, a sexual

awakening. Maybe the sitter's mysterious secret is that she's pregnant. The picture it reminds me of most is on the other end of the century, Edvard Munch's *Puberty* from the mid-1890s, a painting unquestionably about sexual anxiety.

But, that's me.

And anyway, our painting is not by a man.

* * * * *

The first frisson of dissent came from within the Met itself. Charles Sterling, a French art historian who was at the Louvre until fleeing the Nazis (along with most of Europe's Jewish artists and art historians, probably the greatest boon American art has ever known and certainly the greatest for New York) and was after the war attached to both museums, made a startling discovery. In 1947 he was preparing catalogs for the Met's French paintings collection, when he found an engraving from the official Salon of 1801. There, he saw something chilling: the David portrait of Charlotte du Val d'Ognes, depicted hanging on the Salon wall. Why was this a problem? Because David had loudly refused to show at the 1801 Salon. If the Met David was in the engraving, then it had been in the Salon, which meant it was not by David.

In 1951, Sterling published a piece in the *Metropolitan Museum of Art Bulletin* revealing publicly that it was not by David and tentatively assigning it to Constance Charpentier. She'd shown work at the 1801 Salon and her one known signed painting, *Melancholy*, also depicts a woman in white, a bit hunchy, and looking to the right.

Sterling was surprised when his *possible* attribution was instantly taken as gospel. But it mostly was, and it was big news for academic and mainstream publications alike. It was reported as fact in *TIME* magazine, and in the *Saturday Review*, where James Thrall Soby found "a certain poetic justice in the fact that an outstanding icon of a masculine epoch is probably the work of a woman."

Still, no one much celebrated having found a previously unknown painter who was equal to the great David. Though the public continued to love the painting—they may not have known David from Delacroix, at any rate—some academics had a change of heart about the painting itself.

Sterling (see start of chapter) said some not-very-nice things, beginning with, "The notion that our portrait may have been painted by a woman is, let us confess, an attractive idea." Why attractive? Because it explains everything wrong with the work: "cleverly concealed weaknesses" and "a thousand subtle artifices" that all add up to "the feminine spirit."

In other words: Isn't that just like a woman?

After the reattribution, scholars also would claim they were never fooled. British critic

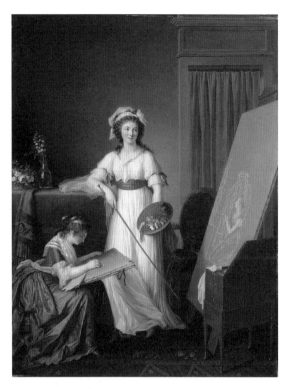

Marie Victoire Lemoine. *The Interior of an Atelier of a Woman Painter*. 1789.

James Laver wrote, "Although the painting is extremely attractive as a period piece, there are certain weaknesses of which a painter of David's caliber would not have been guilty."

But none other than Bernard Berenson, one of the most renowned art historians of his day and famous for his work in attributions, still considered it one of the greatest masterpieces of all time. And so also continued to insist that it must be by David.

It may be worth saying here that though the Met itself had published in its January 1951 *Bulletin* that the famous painting was not by the famous painter, it wasn't until 1977 that David's name was removed from the bottom of the picture frame.

* * * * *

After he retired from museum work, Sterling crossed Fifth Ave and became a professor at the Institute of Fine Arts in 1969. I would attend grad school at the Institute twenty years later, when a woman named Margaret Oppenheimer was working on her PhD there. I didn't know her (though wish I had), but that's not the point.

The point is that while still a doctoral candidate, Oppenheimer realized that Sterling was wrong (he would not have been surprised). By astounding coincidence—considering that less than 15 percent of the artists showing at the 1801 Salon were women—she discovered that the *Portrait of Charlotte du Val d'Ognes* must be by another female painter, Marie Denise Villers.

About whom, little is known. Her maiden name was Lemoine and she went by "Nisa." She was married to an architect. She came from a family of artists, and her two older sisters, Marie Elisabeth Gabiou and Marie Victoire Lemoine, were also painters. Perhaps her mother, like my mother, believed girls are best named Mary.

One sister, Marie Victoire Lemoine, has her own work, *The Interior of an Atelier of a Woman Painter*, in the Met's collection. It's not found in the same grand gallery as Villers's painting, which hangs alongside

masterful portraits by David, Labille-Guiard, and Vigée-Lebrun. It is, in fact, rarely on view. But Lemoine's painting also depicts a young artist, bent over a folder of drawing paper balanced on her thighs. And there the similarities end. It's just not very good.

Lemoine's painting is thought to be a tribute to Élisabeth Vigée-Lebrun, who, dressed all in white (not ideal for painting surely) with a long mahlstick in hand, stands before a canvas depicting the goddess Athena, while her apprentice sketches at her feet. The student is believed to be Lemoine herself, and the painting a not entirely successful homage to her teacher.

* * * * *

But then, even Villers's own paintings aren't nearly as good as the one in the Met. Oppenheimer based her reattribution on an oil *modello*, a reduced-scale preliminary version, of a lost painting by Villers, *A Young Woman Seated by a Window*. It depicts a woman in white who looks similar to the sitter in the Met's painting, down to a lovely oval-shaped face, updone hairdo, and the very same pin in her hair. What's more, she wears white, her body hooks to the right, and she sits on a window seat.

But even with all that, it's hard to believe it's by the same person. It's bland and a little illustrate-y, more like a Maxfield Parrish print in my grandparents' bedroom than the towering genius of Jacques Louis David.

The only signed work by Villers in a major collection is *Study of a Woman from Nature*, at the Louvre, where Sterling himself must have seen it. It's also a bit like the *Portrait of Charlotte du Val d'Ognes*. A young woman, this time mostly in black, facing right, bent over tying her shoe. Her face is similarly shaped to the Met painting, her hair is also up. She looks out at us.

But there is no magic.

So how can the Met's portrait possibly be by Villers?

Marie Denise Villers. *A Young Woman Seated by a Window*. 1801.

Marie Denise Villers. *Study of a Woman from Nature* (also sometimes called *Madame Soustra*). 1802.

* * * * *

We need a closer look at the painting's ostensible subject, Charlotte du Val d'Ognes. In a Metropolitan Museum of Art lecture from 2014 (online, and well worth seeing), art historian and consummate gumshoe Ann Higonnet describes traveling to Paris in search of the very room where the young woman sits for her portrait.

And finding it.

It is a gallery of the Louvre itself. An atelier dedicated to female art students, where they could receive instruction (separate and unequal) apart from male colleagues.

Further sleuthing by Higonnet concludes that while the painting's authorship should be transferred to Villers, the identity of the sitter remains Charlotte du Val d'Ognes. Both studied there at the time the portrait was done.

Higonnet's discovery helps us close an important gap in our psychic understanding of the painting: It's the portrait of one young female artist by another.

So it's not about sexual anxiety after all, but about artistic anxiety. Though in the case of early nineteenth-century women artists, the two can hardly be untwined. For the vast majority of female art students then, giving in to romantic love meant giving up painting. And in Marie Denise Villers's portrait, what separates the interior of the Louvre (where art is made and fame secured) from the outside world (of romance and domestic life) is a broken pane of glass.

Charlotte du Val d'Ognes is an object lesson. Like so many women, she gave up the dream of success as a professional artist when she became a wife. Her giving up is not surprising. Not just because social pressure bore down on women to put their husbands and children before all else. But it was also a terrible time to be a woman artist in France. "Although politically advanced," notes feminist art historian Linda Nochlin, "the revolution was in many ways socially conservative."

The gains that women painters like Labille-Guiard hoped to achieve never materialized.

In fact, things only got worse. By 1804, Napoleon had shut down every avenue of official education and exhibition for women artists in France. Not until the end of the century would women be admitted to the prestigious École des Beaux-Art. And only then because the rise of Modernism was making its sort of classical training obsolete.

Villers had already been married five years when she painted the portrait of her fellow art student, Charlotte du Val d'Ognes. Her husband, it seems, supported her ambition. Villers carried on as a professional even as things in France became more difficult. Her last painting is dated 1814. She died seven years later. What happened in between is unknown, though of course, as we've seen, paintings are easily lost or misattributed.

* * * * *

So a singular moment in time is the secret of Villers's marvelous, moving painting: two young women longing to make art found themselves in a brief period of opportunity, when instruction, exhibition, and even fame were possible.

And in that moment, perfection happened. *A Fucking Excellent Day.* Longing and kinship and ability became great art. A masterpiece.

ROSA BONHEUR

Mlle. Rosa paints almost like a man.

—THÉOPHILE THORÉ-BÜRGER

The fact is, in the way of males, I only like the bulls I paint.

—ROSA BONHEUR

IN THE SUMMER OF 1889, Rosa Bonheur—mourning the recent death of her spouse—sought distraction in the Paris World's Fair. Like le Tout-Paris, she took in the architectural debut of the Fair's *succès de scandale*—the Eiffel Tower—and then, if later depictions can be believed, she dragged her shrouded black visage to the encampment of that great nineteenth-century American entertainer, Buffalo Bill Cody. A riveting spectacle of shooting, roping, and cowboy versus Indian "battles," Buffalo Bill's *Wild West* show was just the thing to perk a person up. And Bonheur, who'd long had a thing for America, and an even longer thing for horses, was more susceptible than most.

Many remarkable artists visited the *Wild West* show in the seven months it camped in Paris, including such vanguards of Modernism as Paul Gauguin, Vincent van Gogh, Edvard Munch, and James McNeill Whistler. But it was Bonheur, animal painter of a passing era, who got Buffalo Bill's attention.

They shared a spirit. Cody: frontiersman, tracker, Pony Express rider, Army scout during the Indian Wars, buffalo hunter. Bonheur: painter, horsewoman, avid hunter, lover of women, wearer of pants.

A telling American lithograph—featuring a long-dead Napoleon (bucktoothed and slouching like a sack of potatoes atop his horse), Buffalo Bill (strapping and handsome astride his), and Bonheur (staring at Bill while painting)—captures the feel of their first meeting; a banner beneath the artist reads: *Art Perpetuating Fame—Rosa Bonheur painting Buffalo Bill—Paris 1889.*

Rosa Bonheur. *Portrait of "Buffalo Bill" Cody.* 1889.

Shortly after their meeting, Cody granted Bonheur total access to his Paris encampment. Bonheur made good use of her time there, completing some seventeen paintings, including a portrait of Buffalo Bill on his favorite horse.

It's a straightforward picture of a man on horseback, but Bonheur tips her hand as an artist primarily interested in animals. While Cody glances to one side, maybe enacting the tracker he once was, his white horse meets our gaze.

Bonheur's equestrian portrait of Buffalo Bill became an American icon. Cody had the painting shipped straight away to his wife. Years later, when he learned that his Nebraska home was in flames, he wired her:

"Save the Rosa Bonheur and let the flames take the rest!"

Buffalo Bill was a metaphor for all that America stood for; it's no surprise Bonheur was drawn to the man. Bonheur thought of herself as a forward-thinking woman in the American vein. "If America marches at the forefront of modern civilization," she said, "it is because of their admirably intelligent manner of bringing up their daughters and the respect they have for their women." For its part, America always liked Bonheur back. America's little girls played with Rosa Bonheur dolls then the way, a hundred years later, they would covet those that looked like Shirley Temple.

* * * * *

Stepping through the front doors of the Metropolitan Museum of Art into the grandeur of the Great Hall, the first thing I looked for was Bonheur's *The Horse Fair* (see next spread). I was a twenty-something small-town girl in Manhattan, and that painting, hanging high above, reminded me of where I'd started, Montana, where we kept horses in the small corral behind our house. The art I'd grown up with—Russell, Remington, Curtis—was filled with horses, shorthand for a disappearing way of life.

Bonheur's roiling horseflesh was very different from the rangy mustangs and Appaloosas I'd grown up with, on canvas or in fact. Her muscular Percherons, native to France, were as fleshy and erotic as any Rubens or

Renoir in the galleries upstairs. But still, they felt familiar. Passing beneath them was a kind of blessing. They helped me believe I might belong there.

I was hardly the first to fall under *The Horse Fair's* dramatic spell. Bonheur's enormous canvas—more than 8 x 16 ft/ 244 x 488 cm—was one of the most beloved paintings of the entire nineteenth century. First exhibited at the Salon of 1853, *The Horse Fair* won instant popular and critical acclaim, and made thirty-one-year-old Rosa Bonheur an international celebrity.

The finished painting was a cannonball lobbed at the highest echelon of art. Roiling curves of strength and splendor, the buttocks, bellies, and necks of Bonheur's muscular Percherons provide a rhythm of curves across the massive canvas. This French breed—beloved of the emperor—is here lord of horses, lunging across ground churned to dust under heavy hooves. Punctuating the rhythm of the enormous mounts are the white and blue smocks of their more diminutive handlers. Bonheur's horses rear this way and that, displaying her anatomical skill. The fact that they are oversize in relation to the humans among them can be no accident.

It's something of a convention in Western art to depict a heroic-size (i.e., bigger than life) rider on a life-size mount. This emphasizes the mastery of man, since it's too easy for a spindly, near-hairless human to be upstaged by a big ol' muscled horse. See the *Equestrian Statue of Marcus Aurelius* for

an obvious example of extra-human proportion. (Note that Aurelius is so supremely badass, he doesn't even need shoes.)

Bonheur's grooms, on the other hand, are smaller than they should be in relation to the horses, and their mustachioed faces are turned away or tucked in shadow. All but one. Right there near the center of the canvas, smooth-faced, head tilted in the same sidelong gesture as the rearing white horse nearby. Art historian James M. Saslow contends that this "man" isn't one. Because this is the only groom without facial hair and the only figure to lock eyes with us as viewers—always a knowing gesture on the part of a subject—Saslow convincingly argues that it is the artist herself who meets our gaze. It seems Bonheur has created a secret self-portrait, saying, in effect, *This is who I am.* A bit masculine, in total control, and in the white-hot center of things.

The Horse Fair was the rare Salon painting admired by artists, critics, and the public alike. Delacroix—undisputed king of Romantic painting—wrote approvingly of it in his journal, and even the emperor and empress cooed over it. The emperor did not, however, approve the ample size (and audacious display of flesh) of Realist artist Gustave Courbet's *Nude Bather* at the same Salon. He gave Courbet's canvas an irritated slap with his riding crop, while the empress slyly inquired, "Is that a Percheron, too?"

She was poking fun at the monumental curves of Courbet's nude, but it's true that

Rosa Bonheur. *The Horse Fair*. 1852–1855.

Bonheur's horses are pretty sexy. And just as girls of a certain age love horses, so do royal women. When *The Horse Fair* traveled to England, Queen Victoria commanded a private viewing. And when Empress Eugenie briefly served as regent in the emperor's absence, she bestowed the Cross of the Legion of Honor on Bonheur, who became the first woman ever to receive the illustrious medal. The award, said Empress Eugenie, proved that "genius has no sex."

In America, reproductions could be found throughout the country, from post offices to schoolhouses to Elks lodges. The original ended up in the United States after it was purchased by one of the richest men in American history, Cornelius Vanderbilt, and gifted to the Met. Its landing in a foreign museum troubled its French author not at all. She'd offered it to her birthplace of Bordeaux at a reduced price, but the town fathers had passed. *Tant pis.*

Bonheur was once among the most celebrated artists in the world, but her art—big and muscular and naturalistic—was not where French art was headed: to Impressionism and Post-Impressionism, Pointillism, Fauvism, and the like. She, like many other once-great Academic painters of the nineteenth century, became something of an art historical footnote. They'd bet on the wrong horse, so to speak.

* * * * *

Her fame could not have been more unlikely. Bonheur came of age in the dark years for women artists after Napoleon, and was born in the hinterlands of Bordeaux. Her father, a not-very-successful painter named Raimond Bonheur, married one of his pupils, Sophie, and they produced four children. The marriage certificate lists Raimond's occupation as "history painter," that high-flown style well on the wane in Paris.

When Rosa, the eldest, was just six, Raimond left his young family for the capital of art. He meant to send for them when he found work. After a year they came anyway.

Raimond hadn't done much art in his year away. Instead, he'd fallen feverishly in love with Saint-Simonianism, a utopian quasi-religion with a radical social agenda preaching, among other things, total equality between the sexes. Which should have been great for Sophie, who was raising four young children without a hint of help. Reality was, of course, otherwise. "My father was a born apostle," Bonheur wryly told her biographer. "He loved us impulsively, but his first priority was social reform. He never sacrificed noble ideals to personal matters." Though Saint-Simonianism never aided Sophie, her eldest child embraced its spiritual impulse and its creed of gender equality.

When at age eleven Bonheur lay near death with scarlet fever, her mother nursed her tirelessly. Unlike many children in the neighborhood, Bonheur survived. But soon after Sophie herself fell ill and died, likely from exhaustion. Bonheur never forgot her mother's punishing existence, claiming that's why she never married (by which

she meant become the wife of a man). But she believed Sophie was always with her, a guardian angel guiding and gifting her life.

* * * * *

Belief in her mother's divine intervention was likely one source of Bonheur's unwavering self-confidence. *Art* and *animals* and *women* were the entwined passions of her life; no social conventions impeded their pursuit.

Art. Raimond's four children with Sophie all became artists. The Bonheurs became so renowned that Francis Galton (a cousin of Darwin) wrote an 1869 essay called "Hereditary Genius" that touted the Bonheurs as living examples.

Rosa had started them off. After she was kicked out of even progressive co-ed schools, and bullishly resisted being apprenticed to a seamstress, Raimond resigned himself to becoming her teacher. He sent her to the Louvre for long days of sketching alone from the Masters, and corrected her drawings at night.

Animals. Always resistant to traditional education, Bonheur learned to read as a child only after her mother created an alphabet of animals to spark her interest. When she was a teenager, her father allowed a menagerie in their Paris apartment that included "rabbits, chickens, ducks, quails, canaries, finches, and a goat" that needed to be carried down six flights of stairs to the street for an occasional airing.

"Couldn't I become famous," Bonheur once asked, "by just painting animals?"

She could, Raimond assured her. And with Saint-Simonian fervor, he declared, "Maybe, daughter, I'll fulfill my ambitions through you!" Icky or awesome, it was a vote of confidence in a young female artist just starting out.

Women. When Bonheur was fourteen, she caught sight of her father painting the portrait of a younger girl in his studio. I imagine Bonheur, stocky and normally self-assured, peeking from behind a curtain at a sickly Nathalie Micas, prostrate on a chaise longue. Nathalie's parents feared their daughter might not live much longer, so had asked Raimond for a painted memento.

Behind the curtain, Bonheur held her breath. She recognized Nathalie from a dream. At once she believed her mother had sent the younger girl to her. It was love at first sight. Bonheur became her protector, while Nathalie looked after her motherless friend. When Bonheur was old enough to rent her own studio, Nathalie visited every day. Their bond was so obvious that on his deathbed Nathalie's father had the girls kneel before him, then consecrated them to each other for life. It was a marriage in everything but legal papers.

Nathalie did not die young. She remained steadfast at Bonheur's side for more than fifty years.

* * * * *

Rosa Bonheur. *Ploughing in the Nivernais*. 1849.

Their unconventional marriage came just a year before Bonheur's first great public success, *Ploughing in the Nivernais*, unveiled at the Salon of 1849. On a clear fall day, a dozen Charolais oxen (native to Nivernais) yoked in pairs plow the soil in preparation for winter. Rich, turned-over earth fills the foreground while muscled animals march the middle. They are the heroes of the scene. The farmers and drivers with them are mostly tucked beneath wide-brimmed hats or behind the oxen's majestic bulk.

Bonheur more than ennobles the beautiful creatures doing God's work under a clear autumn sky. She loves them. Adores their fleshy ox bodies and big bovine heads. She makes us love them, too.

Though raised on a dairy farm, I never saw the worthiness of cows until standing before Bonheur's painting at the Musée

d'Orsay one rainy November in Paris. I sensed the steam rising from those sweaty flanks, smelled their earthy, pungent scent. These were noble creatures of admirable will and intelligence. PETA could only hope for a propagandist today as convincing as Bonheur.

It's often noted that humans mostly take second place to animals in Bonheur's work. Ruskin (remember him?), who dined with Bonheur once, later disparaged this tendency in her: "No painter of animals ever yet was entirely great who shrank from painting the human face, and Mlle. Bonheur clearly *does* shrink from it."

For her part, Bonheur was unimpressed with the eminent critic. "He is a gentleman," she conceded after their dinner, "an educated gentleman, but he is a theorist. He sees nature with a small eye, just like a

bird." Bonheur knew animals. And she knew art from the position of the painter, not the theorist. She was no birdbrain.

Bonheur was fond of characterizing people as animals, including herself. In letters and other writing she variously refers to herself as a dog, a calf, an owl, a donkey, a boar, a tortoise, a bear, and no doubt more. But the animal she felt most kinship with was the ox or bull.

So is it any surprise that the heroic center of *Ploughing in the Nivernais* is no farm boy, but a great white ox who seems to have caught sight of us from the other side of the picture plane? There's beautiful intelligence, and personality, in those bovine eyes.

What is a painter, or any artist, if not one who *sees*?

It seems to me that *Ploughing in the Nivernais* is, again at least in part, a self-portrait.

When Édouard Louis Dubufe painted Bonheur in 1857, she didn't like his depicting her leaning on a "boring table." With Dubufe's permission, Bonheur herself painted in a lovely brown bull cuddled at her side instead, her painting hand draped over its broad, hairy neck. And while Dubufe's Bonheur stares a little vacuously into the distance (shades of fashion models to come), Bonheur's bull engages us with frank intelligence.

An odd couple at first glance, Bonheur with her bull would be familiar to anyone raised in Catholic France from depictions of the four Evangelists. Matthew, Mark, Luke,

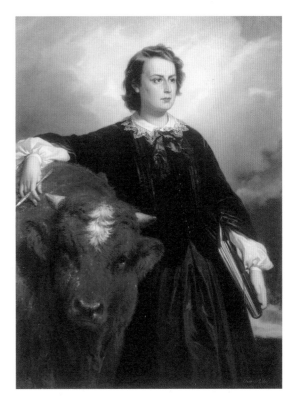

Édouard Louis Dubufe. *Portrait of Rosa Bonheur.* 1857.

and John each have a corresponding symbol: man, lion, ox, and eagle, respectively. As authors of the Gospels, the Evangelists are usually depicted with a book, a writing instrument, and their symbol nearby. Note that Saint Luke is represented by the ox. Saint Luke is also the patron saint of artists.

* * * * *

Perhaps such saintly connotations offered a counter-narrative to Bonheur's many public "unorthodox" habits. The smoking, the cropped hair, the wearing of pants—all taboos for women, some illegal.

Bonheur's excuses always sounded valid enough: She wore her hair short because, after her mother died, "who was going to take care of my curls . . . ?" Perhaps true at age eleven, but she was still wearing short hair when she died six decades later.

As for her preferred attire, according to Bonheur, only by dressing as a man could she move among the rough throngs at slaughter-houses and the horse fair "unmolested." In other words, office casual was essential to her art.

By 1850, Bonheur had received a *Permission de Travestissement*—cross-dressing permit—from the police. Cross-dressing (a.k.a. wearing pants) was illegal, so to evade arrest, Bonheur needed the official document. It allowed her to wear men's clothing in public, with certain restrictions against male attire at "spectacles, balls or other public meeting places." The permit was renewable every six months and required the signature of her doctor.

* * * * *

With money from *The Horse Fair* and other sales (Nathalie was an excellent business-woman), Bonheur, Nathalie, and Nathalie's mother, Madame Micas, left Paris for the village of By, near the forest of Fontaine-bleau, in 1860. There, they purchased a château Bonheur christened the "Domain of Perfect Affection." They lived surrounded by a vast menagerie that included monkeys, lions, horses, hounds, farm animals by the dozens, and three wild mustangs sent by an American admirer.

When Nathalie's mother died in 1875, things went on much as they always had. Rosa and Nathalie were the original Gertrude Stein and Alice B. Toklas, a woman artist and her helpmeet living life (and loving each other) on their own terms in the French countryside. Nathalie managed the house and menagerie, while Bonheur painted and hunted in Fontainebleau's famous woods, thanks to special dispensation from the emperor.

When Nathalie died in the spring of 1889, Bonheur was bereft. "You can very well understand how hard it is to be separated from a friend like my Nathalie, whom I loved more and more as we advanced in life," she wrote to a friend. "She alone knew me."

According to art historian and biographer Dore Ashton, with Nathalie gone, Bonheur "found life almost unendurable."

* * * * *

Then Buffalo Bill's *Wild West*. Then renewal. That fall of 1889 an American artist studying in Paris came to the house at By to act as translator for John Arbuckle, the New York coffee magnate who'd gifted the mustangs. Arbuckle wanted an excuse to meet the famous artist. Bonheur said a hasty thanks (before giving the horses to Cody), then set about seducing the young translator, Anna Klumpke.

Born in San Francisco but trained as an artist in France, Klumpke had been lame in one leg since childhood. Her parents figured she'd never marry. She also had a big enough nose that Bonheur gallantly compared her to the great French lover of the grand schnoz, Cyrano de Bergerac.

Like Frank Lloyd Wright's mother who hung cutouts of English cathedrals above his cradle, Klumpke's mother raised four daughters to excellent, varied careers by nurturing them since childhood. She'd given Anna a Rosa Bonheur doll to cherish as a girl, and later a print of *The Horse Fair* for inspiration. It worked. Anna studied painting at the renowned Académie Julian in Paris and won an honorable mention at the Salon of 1885 for a portrait of her sister.

When Klumpke met Bonheur she was ready to adore the older woman, who adored her at first sight. Yes, it's a little creepy, like Katie Holmes crushing on Tom Cruise in a Toledo movie theater as a girl and then growing up to marry him. But it's also a little bit wonderful. For a gruff bear of a woman, Bonheur had the tenderest of hearts. "The thing is decided, right?" Bonheur wrote, once Klumpke had promised never to leave her. "This will be a divine marriage of two."

Bonheur died at the age of seventy-seven and was buried alongside Nathalie in Paris's legendary Père Lachaise Cemetery. Forty-some years later, Anna Klumpke joined them there, forever.

Two years after her death, a monumental bronze in memory of Rosa Bonheur was dedicated on the Place Denecourt in the town of Fontainebleau. The Rosa Bonheur Monument did not depict the artist herself, but rather—in rare sympathy with an artist's heart—featured a life-sized bronze bull, muscular and striding forward. A beautiful beast.

EDMONIA LEWIS

I thought of returning to wild life again; but my love of sculpture forbade it.

—EDMONIA LEWIS

IN THE LATE 1980S, independent scholar and curator Marilyn Richardson was researching the life of nineteenth-century sculptor Edmonia Lewis. Biographical evidence was scarce, and Lewis's most celebrated work, *The Death of Cleopatra*, (see page 74) had been missing for a century. As one did in those pre-Internet days, Richardson put out a call in the *New York Times Book Review* asking for material of any kind.

A curator at the Metropolitan Museum of Art, perhaps lingering over bagels and orange juice some lazy Sunday, happened to see it and recalled a recentish letter from one Frank Orland, a dentist/history buff from a Chicago suburb, who'd written to the Met looking for information on the very same Edmonia; he thought he might have something of hers. The museum curator, feeling generous, set down the juice and contacted the number listed in the *Times*.

Richardson pounced on the lead. She called. And called. She left messages. They were not returned. So what would any academic on an independent scholar's salary do? Damned straight—she got on a plane, then in a car, and then marched up Frank Orland's front steps and rang his bell.

A now-pliant Orland led Richardson to a barren corridor in a nearby suburban shopping mall. Hardly the place one might expect to find, say, a monumental marble statue of an Egyptian queen. Here's where things in a detective caper might turn sinister—*Don't go in there, Marilyn!*—but no, Frank was okay. In a nondescript industrial hallway, he and Richardson stopped before a closed door. Orland pulled out his keys.

A moment as iconic as Howard Carter and George Herbert unsealing the ancient tomb of King Tut in the Valley of the Kings and striking a match. But this was way more

Edmonia Lewis. *The Death of Cleopatra.* 1876.

American: Orland leaned into the storage room and flicked on the light.

There sat Edmonia Lewis's *The Death of Cleopatra*, a regal monarch limp on her marble throne. Tragic, moving . . . and, noted Richardson, "surrounded by holiday decorations and papier-mâché turkeys and Christmas lights and Christmas elves."

Richardson was shaking.

A celebrated work by one of nineteenth-century America's most important sculptors, lost for a hundred years, was now quite suddenly found.

* * * * *

Why is an artist lost and then found? In the case of Lewis, the reasons are almost too numerous. The low-hanging ones: she had no descendants, her Neoclassical style—so beloved in America of the 1860s to 1880s—fell out of favor. There was nothing to keep her in the news, no one to complain about her lack of attention. For a century, no one knew what happened to her. Some said she died in Rome, some said Paris, some even believed she died in Marin County, California, and was buried in San Francisco. In fact, she died in 1907 of Bright's disease (painful), and was buried in London. Her will identifies her as "spinster and sculptor." That leaves out a lot.

In an 1866 interview with a British critic, Lewis described her origins this way: "My mother was a wild Indian, and was born in Albany, of copper color, and with straight black hair. There she made and sold moccasins. My father, who was a negro, and a gentleman's servant, saw her and married her. . . . Mother often left her home and wandered with her people, whose habits she could not forget, and thus we her children were brought up in the same wild manner."

It goes without saying that being black and Indian wouldn't make Lewis's future path any easier. And then she was orphaned.

Both parents had died by the time Lewis turned nine. She spent the rest of her childhood with her mother's people, who were Chippewa (Ojibwe), wearing moccasins and selling beads and other wares to tourists around Niagara Falls. Samuel, her brother, was called Sunshine then and she was Wildfire. Her Indian name suited the headstrong girl.

At some juncture Samuel left for the gold rush in California and Lewis began studying at New York Central College, though she was soon "declared to be wild" and was asked to leave. With Samuel's financial support and assistance from abolitionists, Lewis next enrolled at Oberlin College.

Oberlin was an abolitionist hotbed, the first college in the United States to educate men and women, whites and blacks. Together.

Lewis lived with the family of the Reverend John Keep, where things were pleasantly unremarkable, until the winter of 1862:

Cleveland Plain Dealer, February 11, 1862.

Mysterious Affair at Oberlin—Suspicion of Foul Play—Two Young Ladies Poisoned—The Suspect under Arrest.

The poisoned were white girlfriends of Lewis's. Wine was involved, as was a sleigh ride on a winter evening alone with male companions. The poison: Spanish fly. Lewis was accused of sneaking the dangerous aphrodisiac into the girls' drinks.

It's worth noting that the Civil War had begun the year before; even in idealistic Oberlin times were tense. Before she could be officially charged, Lewis was abducted by vigilantes one evening as she left the Keep home, taken to a deserted field, stripped, beaten, and left for dead. She was bedridden for days, and on crutches after.

Not long after the beating, she was arrested. Fortunately, her lawyer was John Mercer Langston, one of Oberlin's first black graduates and later the first dean of Howard University's School of Law. A brilliant orator, Langston ended the trial with a six-hour closing argument. Lewis was acquitted of all charges.

It's a testament to Lewis's phenomenal grit and ambition that she returned to Oberlin—only to be accused the following year of stealing art supplies. Again acquitted, she was not allowed to re-enroll.

Not to be too Pollyannaish, but being forced out of Oberlin was probably a blessing.

* * * * *

Lewis struck out for Boston in pursuit of art. There she met William Lloyd Garrison, a hell-raising newspaperman, abolitionist, and suffragist. He introduced Lewis to her future teacher, sculptor Edward A. Brackett.

Brackett specialized in busts of great men, and Lewis, a quick study, started out the same way. Her bust of Robert Gould Shaw, the fallen Boston Brahmin who led the first all-black regiment in the Civil War (i.e., Matthew Broderick in *Glory*), sold over a hundred copies at $15 each. With the first real money she'd made from art, Lewis set sail for Rome. "The land of liberty had no room for a colored sculptor," she told the *New York Times* a dozen years later.

I've always seen Lewis as an awesome inversion of Paul Gauguin, who late in the same century left staid old Europe for uninhibited Tahiti. Lewis abandoned the New World for the Old in 1866. The reversal worked.

* * * * *

Can it be a coincidence that the first important piece she completed as an expatriate was called *The Freedwoman on First Hearing of Her Liberty*?

That work is now lost, but Lewis followed it with the celebrated and similarly themed *Forever Free*, depicting a male and female couple, slaves, at the moment of hearing news of the Emancipation Proclamation. The woman, barefoot and in a simple belted

tunic, kneels with clasped hands, gazing upward. Her long hair, parted in the center, falls softly to either side of her classically idealized face. The man standing beside her is nearly nude, wearing only loose-fitting shorts. His large right hand rests protectively on the woman's shoulder. A chain hangs from his still manacled left wrist, but he raises that fist in triumph.

His left foot rests atop the ball of his broken chain, where in a classical statue the head of a vanquished enemy might be (see Donatello's *David* for a Renaissance take). Positioning one leg higher than the other causes Lewis's contemporary figure to naturally stand in that most classical pose: *contrapposto*, a trick of the Greeks whereby having one active leg enlivens a standing figure (check out the *Doryphoros* by Polykleitos).

Though Lewis celebrates a recent (for her) historical event in *Forever Free*, it is thoroughly grounded in tradition. This marriage of new and old is her genius. A clothed woman with an unclothed (or barely clothed) man can be seen as far back as ancient Egypt (*Prince Rahotep and His Wife Nofret*, for example). Or in the Kore and Kouros figures of Greece, where male Kouros are nude and female Kore wear belted *peplos*, tunics similar to the one worn by the kneeling woman in *Forever Free* (see the *Peplos Kore* from the Acropolis). *Forever Free* was as timely as America itself and as timeless as the classical world.

Lewis found her own freedom in Rome, the eternal city, alongside a small group of fellow women expats. They included the

Edmonia Lewis. *Forever Free (The Morning of Liberty)*. 1867.

sculptors Harriet Hosmer, Margaret Foley, and Emma Stebbins. (The internationally successful Hosmer helped Lewis secure the former studio of Italian Neoclassical master Antonio Canova.)

The equivalent boy clubs must have been threatened; they let it fly.

Nathaniel Hawthorne, whose wife Sophia was herself a painter, wrote a popular novel called *The Marble Faun* that treated women artists as mere copyists, doomed to tragedy. (Hawthorne had even less respect for women writers, telling his publisher, "All women as authors are feeble and tiresome. I wish they were forbidden to write on pain of having their faces deeply scarified with an oyster shell." To which, if I might interject, the only possible response is, *Screw you, Nate*.)

But it was Henry James whose blow stuck. In his biography of male expat sculptor William Wetmore Story, James describes the women artists of Rome as "that strange sisterhood of American 'lady sculptors' who at one time settled upon the seven hills in a white marmorean flock."

Marmorean being a fancy word for marble.

Flock being a condescending way of saying they were flighty, undifferentiated followers of one another, a huddled horde shitting on great art. Birdbrains, maybe.

And just as once pejorative labels like *Impressionist* and *Fauve* would stick to later movements, "White Marmorean Flock" became shorthand for the women sculptors of mid-nineteenth-century Rome.

But James didn't stop there. "One of the sisterhood . . . was a negress, whose colour, picturesquely contrasting with that of her plastic material, was the pleading agent of her fame."

In truth, James had much in common with Lewis (maybe his screed was self-abuse). Both were Americans alone abroad. Both were unmarried and childless, very likely gay. Both were dedicated to their arts. The difference was that while James might pass as straight, and Lewis might as well, she couldn't pass as white. For some reason James wanted to stab home that point, in print.

While we're on the subject of color, I can't go on without bringing up Lewis's medium: white marble. Lewis worked in marble because that's what fine artists did. There's no message in it and no "self-hating" aspect to it either (both have been proposed). Newsflash: Caucasians aren't white like marble either. That's why in the ancient world, sculpture was always painted (Google *classical Greek art polychrome* and prepare to freak out). Marble is an academic conceit that telegraphs *this is high art*. It's an imaginary state that has nothing to do with specific skin color, whether people, horses, leather breastplates, or anything else.

* * * * *

Italy appealed to sculptors because of its abundance of marble and the great tradition of its stonecutters. Sculptors generally created a smaller-scale model that they turned over to a stonecutter who used pointing machines to accurately copy and enlarge the model into a full-size version in

Edmonia Lewis. *The Wooing of Hiawatha* (*Old Arrow-Maker and His Daughter*). 1872.

stone. The nearly finished work was then returned to the sculptor, who added glossy final touches.

This simple fact of sculpture making is as true today (Jeff Koons, anyone?) as it was in the nineteenth century. But critics of the Marmorean Flock used it to raise the ageless trope against women artists: they are not the authors of their own works. Marmorean Flock member Harriet Hosmer railed against such spiteful ignorance: "We women-artists have no objection to its being known that we employ assistants; we merely object to its being supposed that it is a system peculiar to *ourselves*." Nearly all sculptors of the time used stonecutters and other artisans in executing their works.

Except, not Lewis. She famously wielded the chisel herself. Early on she probably couldn't afford assistants, but she no doubt continued because as a woman of color she could not afford any hint of fraud.

* * * * *

This makes *The Wooing of Hiawatha* (also called *Old Arrow-Maker and His Daughter*) all the more remarkable.

Henry Wadsworth Longfellow's "The Song of Hiawatha" was the most popular American poem of the nineteenth century. Many esteemed painters and sculptors created works inspired by it, but none of those artists was able to be inside and outside of a scene. That is, be artist and Indian, Western chronicler and Native knower.

But Lewis could.

The Wooing of Hiawatha is an exquisitely detailed scene of a moccasin-clad father crouched beside his daughter, both looking up mid-task. The man, again less clothed than the woman, is chipping an arrowhead, while his daughter weaves a mat balanced across her knees. At their feet lies a small, dead deer.

The artist's mastery of stone is on full display here. From soft leather moccasins to the heavy skins the figures wear, from the hard flint held by the father to the soft mat in his daughter's lap, there is a sensitive, tactile profusion of weights and surfaces.

In addition to her mastery of material, *The Wooing of Hiawatha* is further remarkable for what it makes of its viewers. English speakers of her time would all have known Longfellow's poem of a Chippewa brave who falls in love with a girl from the rival Dacotah tribe:

> At the doorway of his wigwam
> Sat the ancient Arrow-maker,
>
> · · ·
>
> At his side, in all her beauty,
> Sat the lovely Minnehaha,
> Sat his daughter, Laughing Water,
> Plaiting mats of flags and rushes
>
> · · ·
>
> At the feet of Laughing Water
> Hiawatha laid his burden

Hiawatha is nowhere in Lewis's piece, but there is the deer lying before Minnehaha, and it's us she looks up at. We are Hiawatha. Lewis has done away with the privileged white viewer, even while depicting the work of an august white poet. We are all Chippewa now.

* * * * *

I'm white, but two of my siblings are Native American. My sister Diane, an enrolled member of the Blackfeet Nation, is eleven years older than me. A great boon to my childhood, since she could drive and, crucially, still liked going to fun places, such as Taco John's and the YMCA. And every summer of my childhood she took me for long days at the Montana State Fair.

One summer when I was about eight, our brother Tom won a blue ribbon for one of his paintings. His canvas of a man in a hospital bed was one of very few in the Fine Art Hall not on a "Western" theme (what art I saw growing up mostly concerned horses, cowboys, Indians, bison, and the like). I held Diane's hand as we walked along looking for Tom's painting, silently bestowing titles on those we passed: *Indian Girl with Doll. Cowboys Shooting Up Saloon. Braves Painted for War. Singing Cowboy on Horseback.* They all looked a little bit the same, like illustrations in books of fairy tales. Nothing like Western life as I knew it.

Diane stopped walking. She was staring at a painting of a young Plains Indian woman, about her age. The woman was pretty, like

Henry Rocher. *Carte-de-Visite of Edmonia Lewis.* c. 1870.

my sister, with high cheekbones and dark braids falling over buckskin-covered breasts. Her brown eyes stared back at Diane's, but they were vacant, like an Indian doll. Nothing like my lively sister, whose favorite fair ride was the terrifying Zipper.

The first time I saw Edmonia Lewis's work, when I was an undergrad, I thought of that long-ago day with Diane. I happened to open a slim book on Neoclassical sculpture

directly to a reproduction of *The Wooing of Hiawatha*. I'd never heard of Lewis, but already liked what I saw. Her father and daughter pair was idealized—a Neoclassical tenet—but there was also something bright and vibrant in them. Not *other*, but *us*. Like people I knew. Like my own family.

Lewis has sometimes been accused of milking her heritage. But there's no evidence of that in her publicity material.

Her carte-de-visite photo, for example, is a straightforward portrait of a thoughtful young woman. Carte-de-visites were calling cards, like a Twitter icon or Facebook page image today, conveying your best self—or cleverest or happiest or whatever you wanted most to suggest—out in front of the "real" you.

As a successful artist, Lewis knew her carte-de-visite was also a promotional tool. As such, she might have exploited her heritage with costumes, backdrops, or props. Instead, she wears the plain, somewhat mannish clothes she was known for. Her face is thoughtful, her hands small but strong looking. Her famously "below average height," is evident in her missing feet dangling somewhere inside her skirt well above the floor.

She is diminutive, yes. But her work speaks volumes.

* * * * *

So *Cleopatra*.

The public admired Lewis's abolitionist works, and adored her Indian ones, but perhaps her finest piece had nothing to do with America, politically or historically. Lewis spent more than four years crafting her moving *The Death of Cleopatra*. Five feet high and weighing over two tons, it was her most ambitious undertaking.

Cleopatra was a fraught subject. She was queen of Egypt from 51 B.C.E. until her death by suicide twenty-one years later. No one knows her heritage. She was a Greek Ptolemy on her father's side, but her mother may have been Egyptian, Nubian, or Ethiopian. In other words, African. In the nineteenth century, this possibility was hotly contested.

Cleopatra's sexuality was also a hot topic. She was married to her younger brothers in turn, both of whom she murdered. She was the mistress of Julius Caesar, followed by Marc Antony (she later married him, though he had a wife). In the nineteenth century Cleopatra was variously seen as a great African queen and as a tramp who got what was coming to her.

Antony and Cleopatra joined forces against Rome and lost. Antony fell on his sword, while Cleopatra died by deliberate snakebite rather than be paraded through Rome in chains. Her own will be done.

First shown at the Centennial Exposition of 1876 in Philadelphia among some five hundred other sculptures, Lewis's *The Death of*

Cleopatra was one of the sensations of the day. In a startling innovation, her queen is not contemplating suicide, holding an asp seductively to her breast. No, Lewis's queen is already dead, lips slightly parted with her last breath, left arm hanging limp. Hers is a poignant portrait of the queen of Egypt not as seductress, but as a monarch as great and tragic as Lear.

By capturing the moment of death, Lewis's sculpture was sometimes considered horrible, even ugly, but her *Cleopatra* was written about and widely admired. An African American weekly of the time reported that *"The Death of Cleopatra* excites more admiration and gathers larger crowds around it than any other work of art in the vast collection of Memorial Hall." Mainstream histories have called it "the most remarkable piece of sculpture in the American section."

Cleopatra went next for exhibition to Chicago in 1878, where it again drew crowds. Lauded, argued over, widely seen, nevertheless, *Cleopatra* did not sell. Too expensive to ship back to Rome and no doubt hoping a buyer would come along, Lewis put *Cleopatra* into storage in the town where it was last shown.

Somehow, by 1892 it was on display in a Chicago saloon. Later it became the property of a notorious local gambler, "Blind John" Condon, who may have won it in a bet. He used Lewis's masterwork as the grave marker for his favorite horse, also named Cleopatra. The horse was buried in front of the grandstand of the Harlem Race Track in nearby Forest Park. Condon's will required that the statue mark his horse's grave forever.

So there *The Death of Cleopatra* remained, even after the racetrack became a golf course, then a torpedo plant. But in the early 1970s the Postal Service built a new facility there and—so much for covenants—*Cleopatra* was shuttled off to the contractor's outdoor storage yard in a nearby town, marble amid the backhoes. There it was discovered by sympathetic Boy Scouts who cleaned and painted it, well-intended but not strictly recommended conservation practices. Finally, the statue was brought to the attention of the Historical Society of Forest Park and they acquired it in 1985, tucking it away in the mall for safekeeping.

It was as head of the society that Frank Orland stood in the dim doorway of a holiday storage space in a suburban shopping mall as scholar Marilyn Richardson stepped inside.

PAULA MODERSOHN-BECKER

I love waking in my studio, seeing my pictures
come alive in the light. Sometimes I feel
it is myself that kicks inside me,
myself I must give suck to, love . . .

—ADRIENNE RICH, "PAULA BECKER TO CLARA WESTHOFF"

IT IS A TRUTH universally acknowledged that the *annus mirabilis* of twentieth-century Modernism occurred, quite specifically, in 1907 in the city of Paris, making way for everything that was to follow.

Every movement loves a start date. But, of course, Modernism was well underway before 1907. The Romantics had already depicted a world devoid of organized religion, but soulful and sublime; Realists had given us the heroism of everyday life ("How great and poetic we are in our cravats and our patent-leather boots," said Baudelaire); the Impressionists faithfully captured on canvas the play of light across skin, field, water, and air; and Post-Impressionists took such facts to the unseen world of spirit and emotion, what Symbolist (and proto-Expressionist)

Edvard Munch called, "the soul's inner pictures."

So what happened in 1907 that branded it ground zero of twentieth-century Modernism?

One of the oldest things in art: the female nude. As painted by two men.

In the spring of 1907, former Fauve bad boy Henri Matisse showed his *Blue Nude (Souvenir de Biskra)*, an unclothed woman in the odalisque tradition (reclining, Orientalizing, sexualized) reduced to disjointed color, line, and form.

As if summoned to a duel, Picasso answered by painting *Les Demoiselles d'Avignon*, a shocking and disorienting brothel scene credited with ushering in Cubism. "The

contest for the supremacy of the avant-garde was being fought in the arena of the female nude, painted large in scale," writes Cubism scholar Natasha Staller. *Contest* is certainly *le mot juste* in this case.

Yet that contest was underway before 1907. The previous year, a nude as groundbreaking as those by Matisse and Picasso had already been painted, by a woman. In Paula Modersohn-Becker's *Self-Portrait, Age 30, 6th Wedding Day*, the unclothed subject is the artist herself. Standing life-size, she

Paula Modersohn-Becker. *Self-Portrait, Age 30, 6th Wedding Day*. 1906.

stares out at us, comfortable and impassive. From the waist up she wears only an amber necklace that rests between her small breasts. Her left hand holds a kind of skirt or drapery around her waist, while her right rests—protectively? meaningfully?—above her protruding belly.

It's painting as manifesto, not one brushstroke less so than Picasso's *Les Demoiselles d'Avignon*. In a *New Yorker* interview, art historian Diane Radycki describes Modersohn-Becker as "the missing piece in the history of twentieth-century Modernism."

"Cézanne is the father of us all," is a line attributed both to Picasso and to Matisse. Certainly it's true he fathered them both.

It's equally true that Modersohn-Becker is mother to an alternative strand of Modernism: psychologically probing, personally brave, flagrantly and unrepentantly female. Think Frida Kahlo and Alice Neel, Ana Mendieta, Kiki Smith, Nancy Spero, Cindy Sherman, Catherine Opie, and countless more. The list is eminent and long.

* * * * *

I like to picture Modersohn-Becker in a cold Parisian flat, in the spring of 1906. She's waited until the light is good, but sun in May is weak at best. She's stripped to the waist, chilled, and alone but for her camera. She's left her husband, her parents, and her

sisters behind in Germany. She is there, in a foreign city, because she has no choice. This is where she first saw Cézanne, Gauguin. Where the ancient art of the Louvre— Egyptian, Etruscan, Roman—waits for her every day. The Old Masters are there, too, of course. And in the galleries, so much that's new. Something entirely fresh is happening in art; she must be part of it.

She's painted nudes for years, German peasants, even old women and young girls, from the village of Worpswede. Here in Paris, it's not so easy. Models are a professional lot. They must be paid—in francs, not in trade or promises—and, just now, she has no money.

But what luck, she has herself with her. She smiles and adjusts the light, the lens, and steps back. She varies the tilt of her head, takes one photo with hands to necklace, another with them resting across the flat plane of her stomach. She plucks small flowers from a jar on her bedside table, the first buds of spring, and holds them before her as she stares into the camera.

She develops the film, likes what she sees.

As soon as she wakes each morning, she paints. Paints all day while the light lasts. She forgets to eat. The work is enough; it sustains her. Though she grows thinner, in paint she grows fuller. She gives herself a wholesome round belly, big with promise. She is as full of potential as a bud in spring.

When she's done, she steps back. She knows she's becoming something at last. Never again will she apologize when saying she is a painter.

She signs this self-portrait *P. B.* Though she notes the day as her fifth anniversary (or sixth wedding day) of marriage to Otto Modersohn, that's done now. She uses only the initials of her maiden name: Paula Becker. *I made this.*

A friend from home, the poet Rainer Maria Rilke, stops by soon after, catching sight of the new work. He eyes his friend's swollen belly on canvas with concern. Rilke believes art must trump life. A child would be a disaster.

He should relax. Paula Becker is not pregnant.

* * * * *

Modersohn-Becker painted the first female nude self-portrait in Western history. It is true that Artemisia Gentileschi likely used her own body as the model for her Old Testament heroine in *Susanna and the Elders*, but that's not the same thing. In *Self-Portrait, Age 30*, Modersohn-Becker is her own heroine. She is artist, subject, object, metaphor, nature, and actor.

Compare the not-pregnant, but pregnant-looking artist, here, to her flourishing forebearers in paint: Botticelli's famous curving Venus in *La Primavera*, for

example. The goddess is not with child, but is part of a (nearly) baffling allegory pertaining to the fertility of all creation. Or consider the female half of *The Arnolfini Wedding Portrait* by Jan van Eyck. On seeing it (if you have not, trust me), the inevitable first question is, "Why is the bride pregnant?" She's not. Round-bellied women, believe it or not, were considered the most beautiful.

Though revolutionary, Modersohn-Becker is more than aware of the past. She is Botticelli *and* his Venus, Jan *and* his full-bellied bride, in a cold Parisian garret in spring, procreative as all hell.

By the time Modersohn-Becker painted her first nude self-portrait at the age of thirty (she went on to do six more), she'd been grappling seriously with art for a good decade, ambitious from the start.

When I was twenty-two, I read this, written by the artist in 1897 when she was my same age: "I walk along the boulevards and crowds of people pass by and something inside me cries out, 'The beauty I have before me, none, none, none of you have.'" By the time I read those words, I was in love with New York and in love with the idea of writing, though I'd done little outside the academic.

In a course on German Expressionism, our professor, Gert Schiff, had shown one of Modersohn-Becker's nude self-portraits and mentioned he'd put a volume of her translated letters and journals on the "class hold" shelf in the library. At the break, I raced upstairs, found the book, and moved it to "my" chair in a study room. Books on class hold could not be checked out.

I spent the next week at my boyfriend's place on the Upper East Side so I could get to school early and get dibs on the book. Mornings I waited on the cold sidewalk for the building to open, vainly warming my palms on cardboard to-go cups of too-milky tea. Once in my chair upstairs, I devoured Modersohn-Becker's words, wanting to know, in order to re-create, her recipe for making oneself an artist.

* * * * *

It was her diaries and letters, not her paintings, that first made Modersohn-Becker famous. Rilke, her close friend, refused to act as editor and begged his own publisher not to release them: "For where do they let us learn that this accommodating creature, who met the demands of family communication so compliantly and cooperatively, would, later, seized by the passion of her task, renouncing all else, shoulder loneliness and poverty?"

Where else but in the paintings themselves?

Though the writings don't always pertain directly to her art, I'm so glad they were revealed. They give us the backstory, and all the conflicted emotion behind that story.

Paula Modersohn-Becker. *Portrait of Clara Rilke-Westhoff*. 1905.

Modersohn-Becker's father (named—unfortunate in our Harry Potter age—Woldemar) had insisted she train as a governess. There'd be no hinging hopes on marriage, much less the utter fantasy of art. But his driven daughter snuck in art training when and where she could. She never had her father's blessing ("I don't believe you will be a divinely inspired artist of the first rank—it would have shown in you well before this"), but then neither did Cézanne.

On her own, Modersohn-Becker discovered the artists' colony of Worpswede near her hometown. It had been founded in 1889 by two art students, Fritz Mackensen and Otto Modersohn, as part of an embrace of a naturalist movement romantically fixated on nature and the ennobling qualities of shoveling ox dung and burning peat.

It was in Mackensen's drawing class for his female students that Paula Becker met the sculptor Clara Westhoff in 1899. The young artists became intimate friends, working together, dreaming, talking, planning. They were soon joined by the poet Rilke, who seemed a little in love with them both ("I am with you. Am gratefully with you both, / Who are as sisters to my soul."). But it was Clara he married.

In Modersohn-Becker's *Portrait of Clara Rilke-Westhoff*, painted in 1905, just a year before her flight to Paris and breakthrough self-portrait, she depicts her friend all in white, a dramatic contrast to her dark hair and the red rose she holds to her chest. The rose was Rilke's flower, used often in his poems. His wife looks out of the picture to her left, her face a mask of forbearance and longing.

The painting illustrates how crucial ancient art was to Modersohn-Becker's burgeoning late style. Her figures are simplified, monumental, and timeless. But they also demonstrate her grasp of Modernism's penetrating psychology, its flatness and powerful form married to mysterious symbol.

Becker often used flowers in her portraits of women, archetypes of nature, of beauty, of femininity, but also mysterious in the way they are often held up for the viewer, a secret sign we sort of understand, the way we comprehend things in dreams.

* * * * *

Modersohn-Becker's visits to Paris began on January 1, 1900. In the first six months, she wrote effusive letters back to Worpswede, entreating others to come experience the transformative new art there. Several Worpswede artists came, including Otto Modersohn, eleven years her senior and one of the colony's founders. His sick wife, left abed at home, died three days after he arrived. Three months later, he and Paula Becker were engaged.

Otto Modersohn is sometimes painted as the bad guy in the story of his artist wife, but he loved and admired her. She had a

Paula Modersohn-Becker. *Reclining Mother and Child II.* 1906.

studio outside their home in Worpswede (as did he), painting from nine in the morning until seven at night, with a two-hour break midday for family lunch, prepared by a cook. She had more support than most women artists, of any era. But even with that and with yearly visits to Paris, she struggled. A rural art colony, Worpswede looked backward while Modersohn-Becker saw the future. "She is understood by no one," wrote her husband, who tried to understand.

While working on her *Portrait of Clara Rilke-Westhoff*, Modersohn-Becker wrote her mother, "That one is so terribly stuck when one is married is rather hard."

Rilke-Westhoff herself later wrote, "Paula threw one piece of peat on the other through a little squeaking door in the kiln, as one tear after another rolled down her cheek while she explained to me how very important it was for her to be out 'in the world' again, to go back to Paris again.

"'When I think of it, the world'—she said."

In early 1906, just days after Otto's birthday, Modersohn-Becker fled Worpswede, intending never to return.

* * * * *

In letters from Paris she begged Otto not to try to win her back. At the same time, she asked for money. As a married woman, she had none of her own.

Practical necessities were a constant problem—food, heat, model's fees—but still, her art flourished. After only a few months in Paris, she broke through to a powerful new style. Shortly after painting the life-size *Reclining Mother and Child II* she wrote her sister Milly, ecstatically, "I am becoming something—I am living the most intensely happy period of my life." Then she asked Milly to send money.

Traditionally, a reclining nude is a come-hither sign of sexual availability, whether cloaked in mythology (Titian's *Venus of Urbino*, say) or Orientalizing romanticism (Ingres's *Grande Odalisque*) or straight-up prostitution (Manet's *Olympia*). In these and hundreds (thousands?) of similar works, a nude woman stares undefended at the viewer, welcoming his gaze. It is impossible to presume the viewer is anything but a man; it is presumed for us.

But in her *Reclining Mother and Child*, Modersohn-Becker broke with three thousand years of convention. Her mother and child face each other, oblivious to any viewer. They do offer sensuality, but it's one of food and touch and warmth and animal love. For each other.

Equally groundbreaking, Modersohn-Becker does not fear a woman's body or what it's made for. Her monumental mother reclines with breasts, navel, and pubic hair exposed. Her hairstyle and features are undifferentiated, masklike, in imitation of ancient or non-Western sources. She is as timeless as the *Venus of Willendorf*, which is about how far you have to go back—the Paleolithic—to find a frank and frankly unsexy pubic view.

In addition, the artist has entirely reimagined the nursing mother and child. Not as Virgin suckling a holy (male) child, or as earthy peasant wearily opening her blouse, but as Woman, Mother, Nude offering sustenance and love, and getting those in return from a child whose sex we do not know.

Modersohn-Becker's nude mothers are powerful and protean, also natural. As artists are. As this artist and woman is.

Critics have sometimes sensed a conservative streak in Modersohn-Becker's mother and child paintings, an obsession with womanhood's being bound up in motherhood. But Modersohn-Becker's vision has a feminist core. She wants it all: art and child.

We don't know whether the artist was pregnant when she made *Reclining Mother and Child II*, but she likely was. If not quite yet, then soon.

* * * * *

I remember the very moment I saw Modersohn-Becker's work for the first time, sitting near the front of the Institute's lecture space, in the mansion's former ballroom. Professor Schiff was a few feet away, peering into his notes at the lectern. He'd fought on the German side in World War II, was captured by the French, and then came to New York, where he lived among the bohemians at the Hotel Chelsea. A few years ago I read this by Patti Smith in her memoir *Just Kids*, from when she lived there: "Occasionally I would bump into Gert Schiff, the German scholar, armed with volumes on Picasso." I smiled, picturing Schiff just as he was at the lectern twenty years later, hunched over a text on art, rumpled, wry, impassioned.

A slide of Modersohn-Becker's *Self-Portrait with Amber Necklace* popped up, many feet high beside him, the crystal chandeliers and mirrored gilt walls of the room disappearing behind a woman's pale torso. Schiff glanced up, looked startled, then gave a sigh—of what? Recognition? Admiration? I followed his gaze. An ample nude seen from the waist up, body turned toward us, her eyes cast somewhere to our right. She stands before a sky-blue background filled with vines and flowers. She wears an amber necklace— warm gold against peach skin—and in her pulled-back hair are three small pink flowers. She holds two similar flowers against her chest, the one in her left hand turned upward between her breasts.

Paula Modersohn-Becker. *Self-Portrait with Amber Necklace II.* 1906.

"They are," Schiff said beside her, "nearly the same color and shape as her areolas." His German accent slipped softly on the *s*'s.

It looks so clinical written down, but sounded beautiful to me then. Unlike every other nude we'd seen in the course, she was sensual but not sexual, brimming with health and strength. So unlike her Nordic and Germanic peers, slashing, sultry nudes as she-wolves and sex objects, devourers and meat.

I was stunned by the painting, trying to take notes, but not wanting to look away. When Schiff said it was a self-portrait, I almost dropped my pen. When he said that

here, this artist was pregnant, I did. Somehow, I hadn't known such a thing was possible. I didn't know you could have a child and make great art, I really didn't. Maybe not entirely a surprise that I didn't know. *Self-Portrait with Amber Necklace* is the first pregnant nude self-portrait in history.

Years later, when I was teaching a yearlong Survey of Modern Art course at Portland State, I lingered on *Self-Portrait with Amber Necklace* with my students, in a lecture hall ten times the size of the old mansion ballroom where I'd first encountered it. Like Schiff, I pointed out the small flowers and the artist's nipples and how she was, like nature, lovely, generative, eternal. I mentioned the child inside her, and the work without. I glowed at the lectern with admiration for such a woman.

When grading finals, where the painting had been one of the slide IDs, more than one student parroted back what I'd said about it, then added comments about the nipples and flowers like, "Which is weird," or "I still don't get why anyone would do that," or "Maybe being pregnant made her act strange." I went back and made a small stack of the exams with such comments. They were all male.

* * * * *

Otto Modersohn showed up in Paris unannounced, just a week after his estranged wife had completed her *Self-Portrait, Age 30, 6th Wedding Day*, signed with just the initials of her maiden name. She was painting Rilke's portrait—another model she didn't have to pay for, like herself—when Otto burst in.

In the beginning she resisted his entreaties, but then, finally, she took him back. Who knows why? Money? Loneliness? Love for him?

They lived together in Paris through the summer before moving back to Worpswede. Modersohn-Becker had by then created a handful of revolutionary nudes, including her two self-portraits and the monumental *Reclining Mother and Child.* And she was well along in her first pregnancy.

Before leaving France that fall, she could have seen exhibitions by Rousseau, who was her neighbor, as well as Courbet, Cézanne, Gauguin, Rodin, Derain, and Matisse. She might have seen the latter's incendiary *Blue Nude* just as she was packing up her own revolutionary nudes for her return to a small German art colony still fixated on the previous century. But she was untroubled, certain of her breakthrough.

She did write a chilling letter to her sister Milly in November: "I look at it this way: if the good Lord allows me to create

something beautiful once more, I'll be
happy and content just as long as I have a
place where I can work in peace, and I will
be thankful for what part of love comes
my way. As long as one stays healthy, and
doesn't die young." Possibly no surprise
that a woman coming near to giving birth in
that era might think of death.

* * * * *

Later that same month, Modersohn-Becker
gave birth to a daughter, Mathilde. Photo-
graphs show a beaming mother and scream-
ing baby, both healthy and thriving.

The mother and artist kept telling visitors:
"You should see her in the nude!"

As was common practice, the new mother
was put on two weeks of complete bed rest.
After one week, she complained of leg pains.
After two, she was allowed up. She braided
her hair, weaving roses in it, and asked for
her daughter. Suddenly she was in pain.
She raised one leg, then collapsed. Her last
words: *What a pity.*

CHAPTER 8:

VANESSA BELL

Charles Tansley used to say that, she remembered,
women can't paint, can't write.

—VIRGINIA WOOLF, *TO THE LIGHTHOUSE*

Indeed, I am amazed, a little alarmed
(for as you have the children, the fame by rights belongs to me)
by your combination of pure artistic vision and brilliance of imagination.

—VIRGINIA WOOLF IN A LETTER TO HER SISTER

IN SOME EARLYISH MONTH OF 1912, two sisters—Vanessa Bell (née Stephen) and Virginia Stephen (soon to be Woolf)—worked together quietly indoors. It's convenient to imagine a fire roaring nearby. England in late winter or early spring calls to mind chill, dampness, probable rain. Yes, there must have been a fire.

The younger, Virginia (yes, *that* Virginia Woolf), knit or crocheted while listing left in an enveloping orange armchair. Vanessa, older by just two and a half years, propped her modest canvas nearby and captured something there of her sister's writerly focus, her weaving together of threads to create pattern, beauty, something useful and of value. Crochet as corollary to

writing. *Women*, the painting declares, *at work*.

Painting, writing, crocheting. Women's work, all of it.

Seen another way: one of the twentieth century's greatest writers, famous for brilliantly distilling into print transcendent moments of everyday life, sits almost as symbol of routine existence, captured on canvas by a Modernist virtuoso whose paintings of daily life pushed a self-satisfied British public to acknowledge a powerful new visual language (one it had tried to ignore as a brute French aberration).

Sisters with sister messages, in complementary mediums. *Ding.*

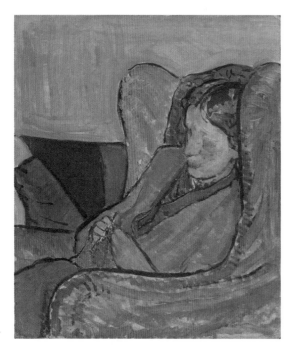

Vanessa Bell. *Virginia Woolf.* 1912.

captures something essential in her, a pose or way of being in the world as distinctive as her facial features. Virginia Woolf was noted among friends and family for the rapid mobility of her facial expressions—impossible to capture in paint or by camera—and also her violent dislike of posing for portraits of any kind. Bell understood her, body and soul. She ignored mere features, capturing her sister's essence instead. "It's more like Virginia in its way than anything else of her," Leonard Woolf told a critic decades after his wife's death (speaking of another faceless portrait of his wife by his sister-in-law, done that same year).

The sisters traded muse roles regularly.

At the time of her portrait, here, Woolf was at work on her first novel, then called *Melymbrosia,* later published as *The Voyage Out.* Bell served as model for one of the novel's main characters, Helen Ambrose. Bell would later loom large in Woolf's masterpiece, *To the Lighthouse* (#2 in a BBC top 25 greatest British novels ever poll), where a painter, Lily Briscoe, is the soul of the story. Later still, Bell was Susan in Woolf's most experimental work, *The Waves* (#16 in the BBC top 25).

But were they alike? In ambition, yes, but not much else.

Bell was stolid, self-contained, an almost totemic figure of self-possession, who, while socially unconventional, was, according to biographer Frances Spalding, "voraciously maternal." Virginia, on the other hand, was brilliant but brittle, childless, and

Bell's portrait of Woolf reveals the explosive impact on her art of Britain's first Post-Impressionist exhibition, organized two years before by her lover, Roger Fry, with the help of her husband, Clive Bell (hold on to your hat, that brain-twister and more to come). Experiencing Cézanne, Gauguin, van Gogh, pierced the young painter: "Here was a possible path," Bell wrote of seeing their work, "a sudden liberation and encouragement to feel for oneself."

The heavy black outline of forms in her portrait of Woolf, the loose, visible brushstrokes and the bright contrasts of orange armchair and teal background all reveal the influence of Post-Impressionism. But one thing in particular is Bell's own. She depicts her sister, a person as close to her as anyone in the world, without a face. Instead, Bell

emotionally fragile. One lived a long life, the other cut hers short. One is little known, the other revered.

* * * * *

Throughout my twenties Virginia Woolf was my literary idol due to her many thrilling attributes: sublime, groundbreaking fiction; crystalline, biting nonfiction; artistic courage; fearless childlessness; madness, which I believed connoted genius.

For my thirtieth birthday my husband gave me Woolf's *A Writer's Diary*, purchased at the legendary City Lights bookstore. We had just moved to San Francisco, and beyond some freelance work, I had no real job yet, so I lay across a stained rose carpet surrounded by unopened boxes in a dilapidated Victorian on Oak Street and read the diaries straight through, gulping entries like oxygen.

It was not until then, somehow, that I realized Virginia Woolf had a sister who painted. (In my feeble defense, my education as a Modernist was almost totally French- and German-centric, with a dash of Norwegian Edvard Munch thrown in.) As one of nine children, I'm cozier than most with the sharp elbows of sibling rivalry, and I'd long been fascinated that Virginia Woolf had seven siblings (two boys and two girls were half-siblings), but never looked deeper. Now on that rose carpet, in that drafty Victorian, I thought of Woolf's famous account of Shakespeare's thwarted and undeveloped sister in *A Room of One's Own*. And here,

suddenly, was Woolf's own talented sister. The one who survived. The sister who painted.

My first thought was: *how sad.* What fate could be worse than to be in close proximity to genius, capable of recognizing it, but, alas, something less-than? And Woolf's sister Vanessa Bell must have been less-than, because I'd barely heard of her. How terrible, and sadly typical, that in my long pursuit of women artists I'd apparently learned nothing. Least of all, that they are all too easily lost to time, a condition rarely any reflection on their talent.

A few weeks after inhaling *A Writer's Diary*—the boxes of books by now unpacked and installed on IKEA bookshelves in the back of the apartment—I discovered, quite unexpectedly, that I was pregnant. I grabbed Woolf's diary off the shelf, turned to the index, then reread every entry on Vanessa Bell, mother of three, who never stopped painting.

* * * * *

Such creativity was a kind of birthright. Her father was eminent critic and historian Sir Leslie Stephen, whose first wife was the daughter of novelist William Makepeace Thackeray. Meanwhile, Vanessa and Virginia's own mother, Julia, was niece and subject of photography pioneer Julia Margaret Cameron and also the model for some Pre-Raphaelite painters, whose strong-boned, wavy-haired heroines she epitomized. Bell's childhood was surrounded

by artists, writers, and thinkers on all sides, though from earlier generations. "The cruel thing," wrote her sister, "was that while we could see the future, we were completely in the power of the past."

Widowers with children from previous marriages, Leslie and Julia had four together: Thoby, Vanessa, Virginia, and Adrian. At the death of Leslie Stephen in 1904 (Julia had died in 1895), the siblings stayed together. They set up house in an unfashionable London neighborhood called Bloomsbury, where Thoby's Cambridge friends joined them in creating a lively gathering of influential artists, writers, and intellectuals who ultimately transformed British art and life.

The tomes written on the Bloomsbury Group—the name given their artful London clique—may outweigh that of any other twentieth-century phenomenon, save World War II. To keep this account pithy and keep it to Bell, I'll start with a quick chronology of Bell's life, which reads as a litany of loss: The month Bell turned sixteen, her mother died of rheumatic fever (in our brief history of women artists, dead mothers are a terrible, recurring theme). Two years later, the death of her half-sister, Stella, forced Bell into the role of "woman of the house." Between balancing the household budget and serving tea at 4:30, she squeezed in art classes at the Royal Academy. The death of Sir Leslie liberated her, but the sibling paradise of Bloomsbury did not last. Two years later, the eldest, Thoby, succumbed to typhoid.

At the death of her beloved brother, Vanessa married his friend Clive Bell. They had two children, Julian and Quentin. At age twenty-nine, Julian was killed while serving as an ambulance driver in the Spanish Civil War. Bell almost did not survive his death. When four years later her sister put stones in her pockets and waded into the river Ouse, Bell more than understood the stoicism required of wrenching loss.

But Bell's long and productive life was far from tragic. Her passions were deeply felt and abundant. Foremost were her children and her art, and maybe also love itself.

A multiplicity of love was helped along by husband Clive Bell, who insisted on an open marriage. To his credit, this openness was not for himself alone and extended to his wife, who soon took up with England's preeminent art historian, Roger Fry. Unlike Clive, her lover was devastated when after a few years she fell for painter Duncan Grant, then lived with him in marriagelike coupledom for some forty years. Together they had a child, Angelica, who was raised as a Bell. Vanessa and Clive never divorced and remained congenial friends. Meanwhile, Vanessa quietly shared her love of Grant with a series of his gay lovers (including writer Bunny Garnett, who many years later—yikes—married Angelica).

Vanessa Bell pursued art alongside whatever life threw at her. In 1912—her breakthrough year—she had two children under age four, a wandering husband who still expected laundered shirts and family meals, a married lover, a huge cast of friends and

relations who regularly dropped by for teas, dinners, and long evening visits, and a brilliant younger sister of fragile emotional health (Woolf had by now experienced at least two serious breakdowns). Through all of it, Bell painted.

"I don't think I'm nearly as enterprising as you (or Duncan)," she once wrote Fry, "about painting anything I don't find at my door." Reading about Bell in her sister's diaries, this is the talent I recognized I would most need as a mother: Bell simply got to work, with whatever was at hand. Such as her sister in a nearby armchair. Or houseguests.

To whit, Frederick and Jessie Etchells, a brother and sister duo of painters who were Bell's first guests at her new country home in late summer 1912. That Bell both hosted them (along with Frederick's annoying dog) and painted alongside them is testament to her work ethic.

On a formal level, Bell is assured here. Dark sinewy outlines—what Fry (a biased art historian, perhaps, but a sharp one) called her "slithery handwriting"—demarcate figures and shapes while the rest of the canvas pops with bold rectangles of color. As with Picasso, who was never wholly non-representational, these abstract passages refer to something concrete in the world. In this case, the canvases the siblings work on and those stacked against the wall behind Jessie. Equally rectilinear are horizontal slices of clear color denoting the garden view between open French doors: stone steps, red tile courtyard, green lawn, gray wall.

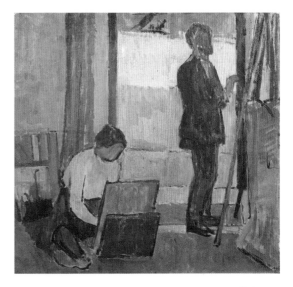

Vanessa Bell. *Frederick and Jessie Etchells Painting.* 1912.

Bell's painting offers more than a mere formal exercise. It's moving to see sibling artists working together (not so different from Bell painting her writer sister), but she includes a whiff of the injustice she must have sometimes known even in bohemian Bloomsbury. While Frederick (who Vanessa didn't much like) works standing at an easel (Was it Bell's easel? Did she have an extra? Did he bring one with him on the train?), his sister crouches on the floor. Her brother was unrepentant even decades later, when he told the Tate, "It is startling to come across so authentic a representation of oneself at a so much younger period, and Jessie is equally true to one's recollection." He must have seen his sister working on the floor a lot.

* * * * *

Bell's masterwork of this early period is the spare and haunting *Studland Beach*, called

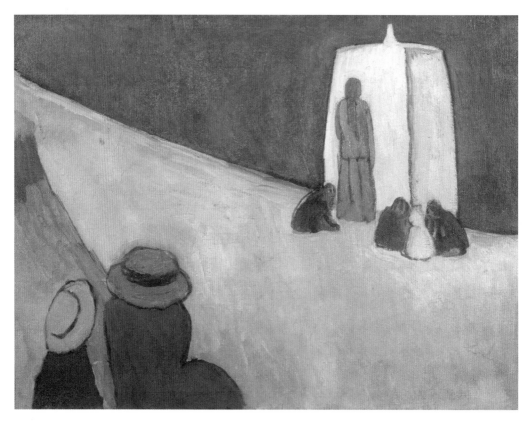

Vanessa Bell. *Studland Beach*. 1911.

"one of the most radical works of the time in England" by art historian Richard Shone. The painting's power lies as much in Bell's own past as in the Modernist future she helped create.

A diagonal shoreline divides the scene between water and sand, with figures above and below. In the upper right, a woman seen from behind stands before a white cabana as if entering a portal to another world. Maybe the very one revealed here: simplified, timeless, eternal, filled with children, anchored by women. The woman in a hat sitting in the lower left may be a nanny, but might also be Virginia Woolf. She rests on

the beach with a young child, watching the figures above: the standing woman with a single thick braid down her back, who has children at her feet hunched over hunting or building in the sand while she stares out at a horizonless sea. The figure calls to mind predecessors as wide-ranging as Piero della Francesca's quattrocento altarpiece of the *Madonna della Misericordia*, to modern visions of Munch and Matisse.

Bell's women and children by the sea predicts, maybe even partly inspired, Virginia Woolf's literary masterpiece *To the Lighthouse*. The novel grapples with the sisters' real childhood experience seaside with

multiple siblings, an overbearing father, and a warm, capable mother who dies too soon.

The Stephen family spent summers in St. Ives looking onto Godrevy Lighthouse, a singular verticality on the horizontal plane of the sea. One of the novel's main characters, Lily Briscoe, is a painter who suffers outward criticism and inward uncertainty, but who in the end prevails. Hers are the novel's final words: "With a sudden intensity, as if she saw it clear for a second, she drew a line there, in the centre. It was done; it was finished. Yes, she thought, laying down her brush, I have had my vision."

The magic of both *Studland Beach* and *To the Lighthouse* is the prosaic transformed into the highest art, so high as to be almost a spiritual experience. *Studland Beach* could be an altarpiece for a modern era— Mother and Child meet women and children. Everyday life becomes eternal.

* * * * *

Bell did the covers for her sister's books. Her abstracted, almost ecstatic lines denoting lighthouse, waves, or whatever was within (the covers are also charmingly literal) became the hallmark style of the Hogarth Press (a hand press and a publishing imprint that Virginia and her husband started in 1917).

And Bell continued to inspire her sister's art. As noted, Susan in *The Waves* is based on Bell, while the work as a whole seems influenced by her paintings. Woolf wrote in her diaries that *The Waves* was "an abstract

Vanessa Bell. *Cover of First Edition of 'The Waves' by Virginia Woolf.* 1931.

play-poem . . . a mystical eyeless book." It was, like her sister's paintings, faceless, abstracted, but always drawing on the vital stuff of life itself.

A decade after writing *The Waves*, Woolf deliberately drowned. Bell suffered at her loss, but went on. Into old age, painting until the very end. A survivor, she might have been her sister's hero. Near the end of Woolf's first novel, *The Voyage Out*, an old man declares, "It's not cowardly to wish to live. It's the very reverse of cowardly. Personally, I'd like to go on for a hundred years . . . Think of all the things that are bound to happen!"

ALICE NEEL

Alice loved a wretch.
She loved the wretch in the hero and the hero in the wretch.
She saw that in all of us, I think.

—GINNY NEEL

The self, we have it like an albatross around the neck.

—ALICE NEEL

IN THE WINTER OF 1931, a thirty-year-old painter named Alice Neel was strapped with restraints to a thin mattress in Philadelphia's orthopedic hospital. Institutionalized by her parents, Neel was raving, incontinent, and suicidal. She would become, arguably, the greatest American portraitist of the twentieth century, but was now forbidden by doctors to draw or make art of any kind. Art, the medical establishment believed, was too unsettling for a lovely young blonde like Alice Neel. She was instructed to sew instead.

Neel hated sewing.

She was kept to a strict institutional schedule like a prisoner: awakened for 5 a.m. breakfast, to be eaten with a rubber fork, followed by long days in barred rooms where she was ever watched by some figure of authority. Quite literally maddening for any artist, whose job it is to be observer, not observed.

But Neel needed watching. Released from the hospital, she strode into her parents' kitchen her first night home and stuck her head in their oven. Her brother found her there not quite dead in the morning (first thinking it was his mother's legs flung across the linoleum). While her father complained about the coming gas bill, Neel was bundled back to the suicide ward. There she tried swallowing shards of broken glass, then throwing herself down a laundry chute, then auto-asphyxiation by stocking. Nothing worked. "I couldn't pull long enough or hard enough," she said. "You cannot commit

suicide unless you—in a moment of frenzy— you do something irrevocable."

She never did, at least not in the sense of suicide. Neel's irrevocable act was to paint and never stop.

It was as a grad student in New York that I first saw one of Neel's paintings, a portrait of Andy Warhol. Immediately I adored her. Portraiture is, I confess, my favorite art form, and Neel was an alchemist of the soul. She portrayed things somehow only she could see: the psychology and spirit, the vital essence, of her sitters.

I kept looking from Warhol on the wall to the nearly empty gallery, hoping to catch someone's eye and ask, *Are you seeing what I'm seeing?* Neel had captured something no other painting or photo or album cover of the infamous Pop artist had come close to. Andy Warhol, a pale and vulnerable man in all his fragile humanity.

Remarkably, she was just as good when turning that all-seeing eye on herself. She lived long enough to capture one of the most knowing takes on aging ever made, up there with Rembrandt in its cold-eyed view of the sagging self. Eighty years old in this paint-ing, made in 1980, the master portraitist has turned her unsparing scrutiny upon her own still-formidable self. Her fluffy white grandma updo—incongruous on a nude, to say the least—rhymes with the bright white rag dangling from her left hand. Meant for dabbing paint, according to some commen-tators, the rag is also a flag of surrender. But surrender to what? I expect they mean

surrender to aging and the decline of the flesh. But what about the fact that after five decades of dedicated portraiture, this was Neel's first real self-portrait? That after cajoling dozens of sitters—men, women, and children—to doff their duds, she at last joins them. She has surrendered to her own inspection at long last, there on the same blue-striped loveseat upon which so many others sat for her. Here, finally, Neel sits for herself.

She's a tough customer. Modersohn-Becker pioneered the nude self-portrait—a brave and revolutionary act—but it was as a woman in bloom, of youth and artistic vigor and motherhood, adhering to more conven-tional standards of beauty. Neel has nothing left to own with pride. Her body is a fallen landscape of battles gone by, her broad, distended belly rests across flaccid thighs while large, fleshy breasts dangle almost as low. Neel gave birth to four children, and it shows.

Her cheeks are ruddy to almost red, from age or New York weather or a lifetime of hard living, while between those same cheeks, above and below downturned lips, her skin is ghastly green. That green patch is instantly familiar, maybe even a quota-tion, from Matisse's famous portrait of his wife from 1905, *The Green Stripe.* Neel shares Amélie Matisse's upswept hair, arch-ing eyebrows, pursed lips, and a trio of solid colors arrayed behind her. It's as if Neel is hooting at her Fauvist friend from the other end of the century, shouting, "Screw abstraction, Hank, we won after all!"

If this painting waves any flag it's that of portraiture still alive and kicking even after the artists and critics and art historians who "mattered" all believed it stone cold and long buried.

Neel's high-flown brows are familiar to anyone who's ever peered into a mirror putting on mascara, an indication of careful attention. Neel must have done this painting by looking in a mirror. For one thing, she disliked working from photographs, desiring the pulse of personhood and emotion beneath real flesh. But also, here she holds her paintbrush in the right hand and Neel was left-handed.

She wears glasses in a nod to old age and honest scrutiny and even waning sexual allure. To quote her contemporary, Dorothy Parker: "Men seldom make passes / At girls who wear glasses." Or to quote feminist art historian (and Neel subject) Linda Nochlin, eyeglasses "are hardly part of the traditional apparatus of the nude." Neel is being both scrupulous and poking a little fun: *Here ya go, male gaze, enjoy.*

Unlike Rembrandt's weary personal testaments to the ravages of time, there's no sense that Neel feels sorry for herself. What many might consider a ruin of a body is just realism at work, a fact like any other. Though painted in an age when finding something that might still *épater le bourgeois* was almost impossible, a naked old woman was pretty damned shocking.

"Frightful, isn't it?" Neel cackled to critic Ted Castle. "I love it. At least it shows a certain revolt against everything decent." No one ever revolted more consistently than Alice Neel.

* * * * *

While there's often some charming mystery to writing about artists of the past, holes in knowledge we can (however unconsciously)

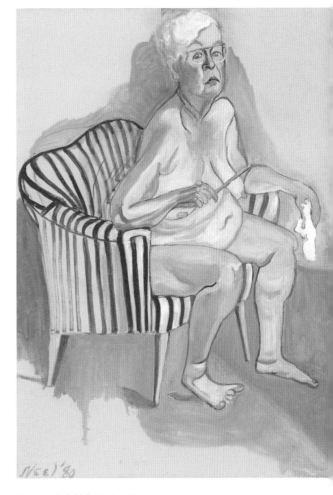

Alice Neel. *Self-Portrait.* 1980.

fill with our own hopes or ideals, when writing about artists close to us in time, there's the problem of knowing too much: every cough and letter, every lover and seaside sojourn and trip to the corner store. What, then, with a life like Alice Neel's, which spanned eight decades, one husband, three fathers of four children, who knows how many lovers and significant friends? There is nothing to do but spin the reel on high speed and hold on tight:

Raised in working-class Pennsylvania, Neel put herself through art school; graduated 1925, married a Cuban painter named Carlos Enríquez that same year; moved to Havana, where she was embraced by the Cuban avant-garde, got politically radicalized, had her first show and her first baby, a girl named Santillana; 1927 relocated to New York City, where Santillana died of diphtheria just before her first birthday; the following year had a second daughter, Isabetta, whom Carlos took to meet his parents, then abandoned in Havana while he went on to Paris so that Neel lost two children in less than two years, as well as a husband.

"At first all I did was paint, day and night," Neel said. She worked in a manic state for months until collapsing with what she called "Freud's classic hysteria," but might also be called guilt: "You see, I had always had this awful dichotomy. I loved Isabetta, of course I did. But I wanted to paint." The firestorm of sorrow, giddiness, and shame finally engulfed her.

How she ended up in a suicide ward and how she got out and how she found success at last all had the same source: "I was neurotic. Art saved me."

Neel made it out after convincing a social worker she was "a famous artist," then met a Spanish Civil War fighter and heroin addict named Kenneth Doolittle and moved into his place in Greenwich Village; two years later he burned more than three hundred of her watercolors and slashed over fifty oils; Neel moved in briefly with well-off Harvard grad John Rothschild (her lifelong friend and probable lover), before hooking up with a Puerto Rican nightclub singer named Jose Negron; they had a baby boy called Richard and when he was three months old, Negron abandoned them both in Spanish Harlem; two years later Neel had another son, Hartley, with left-wing filmmaker Sam Brody.

* * * * *

Significantly, both Neel's sons carry her last name. Through everything, she painted and parented and did what she had to do to survive.

Neel was resourceful, whether it meant working as an easel painter for the WPA, shoplifting, or scaring up welfare, food stamps, or full scholarships for her sons. The Rudolf Steiner School is right next door to the Institute of Fine Arts. I used to pass the Steiner kids on the sidewalk and wonder how those little bohemians found their way

to the Upper East Side. But then, how did I? Later, I sent both my children to the same kind of school in San Francisco and taught art history to high school students there for years. Art in Steiner schools is the linchpin of the curriculum, whether the class is English, history, math, or physics. In a sense, Neel sent her kids to her own version of parochial school, one that held art as the holy of holies.

Neel was adept at getting what she wanted, but it took a couple of decades of painting friends and neighbors in Spanish Harlem before she realized a little networking wouldn't kill her. With a nudge from her therapist, Neel starting asking art world folks in power to take a seat. Shades of shrewd Adélaïde Labille-Guiard.

Neel started in 1960 with poet and newly appointed Museum of Modern Art curator Frank O'Hara. As an art-maker himself and a gay man, maybe he seemed nearer Neel's regular milieu of outcasts. But Neel depicts O'Hara in perfect profile, a rare formal position for her (though he wears a rumpled gray crewneck) that calls to mind Roman emperors on coins or Renaissance profile portraits. Quite specifically, O'Hara here recalls Piero della Francesca's *Duke of Urbino*, who could be looking right back at the MOMA curator across five centuries. Painting O'Hara in profile emphasizes his "strong" nose and jutting chin, as does della Francesca's Urbino portrait. Both are men of power, though where the Duke of Urbino's structured red cap is almost crownlike,

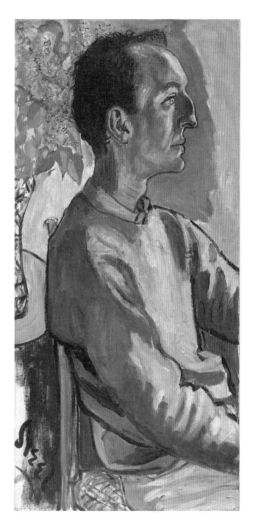

Alice Neel. *Frank O'Hara.* 1960.

O'Hara leans back into a spray of purple lilacs. O'Hara's open, staring eyes are as startlingly blue as a movie star's (Paul Newman's spring to mind; O'Hara liked a good movie-star reference), while behind him hangs a formless shadow, a kind of dark double portrait. That shadow looms large

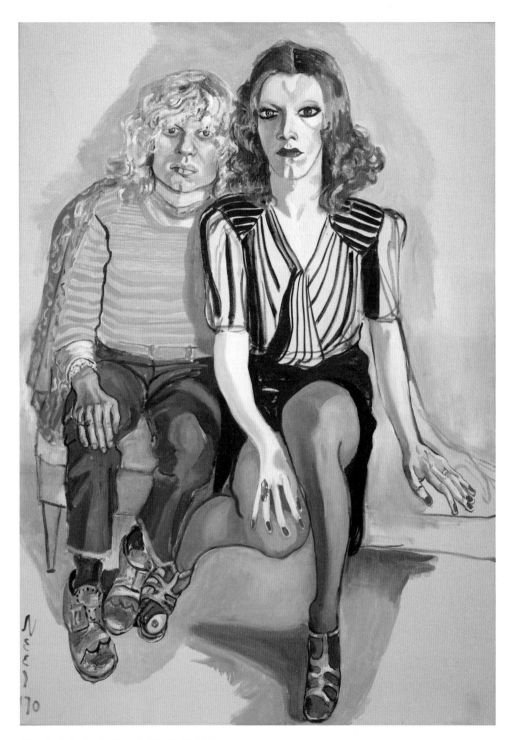

Alice Neel. *Jackie Curtis and Ritta Redd*. 1970.

for us, knowing that just four years later O'Hara would be dead at age forty, struck by a jeep on the beach at Fire Island.

Maybe Neel intuited O'Hara's dark near-future, or maybe she was anticipating her own. What worked for Labille-Guiard flopped for Neel. Though O'Hara showed and reviewed many figurative artists in the next few years, he never included Neel in any exhibition, and he never wrote about her work.

Same thing with Henry Geldzahler, curator of twentieth-century art at the Metropolitan Museum of Art, whose portrait Neel painted in 1967. But when she asked him to include her in a career-making show—*New York Painting and Sculpture: 1940–1970*—two years later, Geldzahler sneered, "Oh, so you want to be a professional." He did not include Neel in the exhibition.

* * * * *

The slings and arrows of Neel's professional life were legion. She might have become bitter, but mostly she just kept working. And yet. "I'm not against abstraction," she said. "What I can't stand is that the abstractionists pushed all the other pushcarts off the street." Still, she stuck to her guns, which meant the figurative in all forms.

According to curator Jeremy Lewison, "Many of her best portraits of the period were of gay men and gay couples." Neel painted O'Hara and Geldzahler, men who might have helped her who happened to be gay, and others, such as critics (and couple) David Bourdon and Gregory Battcock and that saintly (as in Saint Sebastian, or some other tortured soul) portrait of Pop artist Andy Warhol, pale and shirtless in a corset, both from 1970.

But I think her best painting of that year is the dual portrait of gay couple Jackie Curtis and Ritta Redd. Though Jackie is in drag on the right (and listed first in the title, which is as disorienting as their presentation and gender-neutral first names), Ritta, on the left, dressed in a boyish striped shirt and jeans, is the softer, more "feminine" of the two.

Both were part of Warhol's Factory and Curtis was a glam "Warhol superstar," but neither had any power in the art world, or the wider world, for that matter. Neel just wanted to paint them. Curtis is done up with blue eye shadow, red nail polish, a smart '50s-era skirt-and-blouse ensemble, and dark stockings (with a small hole where his right, polished big toe pokes through), but this is no Diane Arbus freak show. The men are as dignified as any Neel sitters, and clearly lovers. Curtis's right knee juts at an awkward angle toward us so that his lower leg presses against Redd's. It's a tender gesture of togetherness. There is a whiff of poignancy, even longing, in Neel's depiction of their shared affection. It's especially lovely considering homosexuality was not just an outlaw "lifestyle" then, but quite literally illegal. Being gay meant being seen as at best immoral and quite likely insane (homosexuality was on the American

Alice Neel. *Kate Millett*. 1970.

Psychiatric Association's list of mental disorders until 1973).

Not that Neel gave a shit about any of it, not morality or social opprobrium or even legality. Her sons remember FBI agents descending on the apartment at the height of the Red Scare with a thick dossier on Neel's communist sympathies. Rather than quake or cajole, Neel admired "these two Irish boys" and immediately invited them to sit for her "in their trench coats." The FBI men declined and quickly exited. Posterity weeps at the loss.

* * * * *

The rise of feminism was at last the perfect storm to raise Neel's battered boat. Here after all was a woman artist, in the thick of the New York art world for decades, who had been callously overlooked. She'd always been egalitarian in her approach to her subjects: working-class men and women of all races, mothers of all kinds, fine artists of every sex and race, pregnant women, curators and art historians, nudes of all ages, gay men and transvestites, the glory of humanity at every point on the way station of the century, and through it all she'd stuck to her own style, never swayed by theory or fashion. Feminists in the 1970s took up Neel's cause with vigor, though Neel refused to spout a party line. "I much preferred men to women," she shrugged. Her contemporaries rightly scoffed at Neel's feminist branding. Painter May Stevens has said, "She wasn't a feminist; she was an Alice Neelist."

Regardless, the movement served Neel well. In 1970, *TIME* magazine asked her to create their cover on Kate Millett, the Columbia grad student whose dissertation, published as *Sexual Politics*, was an unlikely bestseller. Last of a dying breed, Neel of course wanted to paint from the living model, but Millett refused. Like a lead singer worried about pissing off her bandmates, she didn't want to break ranks with the sisterhood by taking the limelight. Never one to pass up on opportunity, Neel settled for a photograph.

By painting the cover for *TIME*, Neel reached a bigger audience than any

contemporary artist could ever dream of, and the portrait of Millett is one of her best-known works. It is, unabashedly, icon-making. Staring, unsmiling, mannish and intense, with her dark hair and white men's shirt, Millett reminds me most of Robert Mapplethorpe's famous cover image of Patti Smith on the album *Horses* a few years later. Both are working-class hotties in crisp white shirts, conveying seriousness of purpose alongside a sexy androgynous glamor. Quite a feat. Perhaps Mapplethorpe had taken note.

Mapplethorpe photographed Neel herself not long before she died of cancer in 1984. It's a haunting picture, deliberately so. Neel knew she was dying and told Mapplethorpe she wanted to know what she'd look like dead. So she closed her eyes and opened her mouth, in imitation of innumerable nineteenth-century photographs of the recently deceased. The result is transcendent, like Bernini's *Ecstasy of St. Theresa*, a moment of piercing rapture and possible pain.

Neel depicted the human in all of us, including herself, the deformed, deranged, beautiful wretches that we are. "I tried to reflect innocently," Neel once said of her work. She was wickedly good at it.

LEE KRASNER

I sacrificed nothing.

—LEE KRASNER

IN A PHOTOGRAPH FROM the summer of 1927 two sisters pose shoulder to shoulder on a sandy beach in their bathing suits. Nineteen-year-old Lenore stares evenly at the camera, while Ruth, seventeen, smiles but glances away. They look like any American teenagers, but are not quite.

By now Lenore (a name she'd given herself) was going by "Lee" with her art school crowd in Manhattan, where she attended The Cooper Union for the Advancement of Science and Art. She'd understood her own destiny for years: "I don't know where the word A-R-T came from; but by the time I was thirteen, I knew I wanted to be a painter." Not exactly a predictable choice for the Brooklyn-bred daughter of an immigrant fishmonger.

She'd been born Lena Krassner, the sixth of her mother's seven children and the first born in America, just nine months after her Russian-Jewish parents were reunited after two years apart. Ruth came two years after her. Two American girls in a traditional Jewish family that spoke Russian and Yiddish at home, Lena and Ruth were almost a family unto themselves. They shared a bed growing up and shared the dislocation of being raised in two worlds: Old and New.

By the time her picture was taken on the beach, the girl now called Lee Krasner fully intended to plant her flag firmly in the New.

* * * * *

The following summer, in July 1928, Krasner's older sister Rose died of appendicitis, leaving behind two young daughters. According to Old World tradition, Krasner should now marry her brother-in-law and raise her nieces. This was not a request, but an outright expectation.

Lee Krasner. *Self-Portrait*. 1930.

She refused.

Ruth, just eighteen years old and perhaps more pliant, or with less grasp of her own destiny, stepped or was pushed into the breach. According to Krasner biographer Gail Levin, Ruth "never forgave her sister."

But crucially, and quickly, Krasner forgave herself.

The September after Rose's death, Krasner applied to the National Academy of Design, on Manhattan's Upper West Side, and was accepted. Like most serious art schools, students there began by sketching from casts of Classical and Renaissance sculptures before they could enter "life drawing" classes, to which they had to apply.

Krasner's application to life drawing was this assured self-portrait, done outside her parents' home in rural Long Island, where they had moved (and she with them) in 1926. "I nailed a mirror to a tree, and spent the summer painting myself with trees showing in the background," Krasner said. "It was difficult—the light in the mirror, the heat and the bugs." It was both technically challenging and a bold choice for a school steeped in nineteenth-century Academic (read: highly traditional) painting.

Krasner depicts herself as a no-nonsense young woman in a dirty painter's apron and short-sleeved work shirt with short hair to match. Her cool-eyed stare is familiar from the beach photo, but here she casts a cold eye on herself. Piercing and a little merciless, she doesn't flatter herself physically: her lips, nose, and ears are big, her eyes small. But in one way she does flatter: she wholly and self-consciously presents herself as a painter. *This* is me.

The painting got her into life drawing class (enticingly called "Life in Full") at the Academy, where she would be allowed to draw from the nude model, but not without a scolding from her teachers, who said, "When you paint a picture inside, don't pretend it's done outside." They thought she'd made up the trees for some reason, while keeping strictly to nature when it came to the awkward planes of her own face.

* * * * *

That Krasner was not conventionally attractive is often remarked on. Her biographer, Levin, who knew Krasner, writes, "I never considered Lee ugly, as several of her contemporaries and some writers have emphasized since her death." But Levin does go on at length about Krasner's great figure, even quoting a fellow female student at the Academy describing "the extremely ugly, elegantly stylized Lee Krasner. She had a huge nose, pendulous lips, bleached hair in a long, slick bob, and a dazzlingly beautiful, luminously white body."

Ever notice how no one ever talks about how Picasso wasn't good-looking? He wasn't. And he was short (5 ft 4 in/162 cm). Why does this never enter into accounts of his life and work? *Because it doesn't matter.*

Right?

And never, that I can recall, has anyone begun a discussion of Jackson Pollock's work with a phrase such as, "The bald but still virile painter . . ."

The first time I saw a picture of Krasner I was an undergraduate and she was my research paper subject. The photo showed her glancing up at Pollock with him looking back at her, a scraggly bunch of daisies held between them. They're a matched set those three, rough but serviceable. She is not hot; neither is he; the daisies are just okay. Awesome. I liked Krasner even more now that I'd caught sight of her, and liked Pollock, too, for liking her. It was, I'm sorry to say,

a kind of revelation to me at age nineteen that a man might want a woman for reasons other than looks (the opposite was all too obvious). For the right kind of man—even in this case, a volatile genius—attraction might lie in talent, passion, brains, and commitment.

There were bands I loved then with women in them, but no matter how punk rock, the women seemed up for display in a way their male counterparts didn't. Krasner—who was once tickled when a critic called her use of color "punk rock"—confirmed what I should already have known: looks don't mean shit; it's all about the licks.

If you know anything about Lee Krasner, you know she was married to Jackson Pollock, martyred saint of America's first home-grown church of Modernism, the cult of Abstract Expressionism. Ab Ex (as it's affectionately known) was the sublime coming together of cultivated European philosophy and brute "can-do" American action. Ab Ex as perfected by Pollock was all about doing. According to influential critic Harold Rosenberg, "At a certain moment the canvas began to appear to one American painter after another as an arena in which to act. What was to go on the canvas was not a picture but an event."

Ab Ex canvases were gestural and sprawling—slashes or spills of paint all over the canvas—and tended to the large (read: heroic). For the Abstract Expressionist, the canvas was a rectangle of cultivated battle,

no less than the boxing ring or wrestling mat. It tended to attract men. Or actually, no. It tended to *recognize* men, those brawling, "heroic" action figures.

But this is not about Jackson Pollock. This is about Lee Krasner, married to him for eleven years, but a painter for three decades after he died and painting for nearly twenty years before they met. If one of the great aims of Modernism was to "make it new" (to quote Ezra Pound, who was, somewhat confoundingly, quoting an eighteenth-century Chinese king), then it

Lee Krasner. *Seated Nude*. 1940.

was Krasner who got there first. She beat Pollock in the first round.

* * * * *

But I'm getting ahead of myself.

Krasner left the Academy in 1932 with a handsome White Russian émigré boyfriend named Igor Pantuhoff and a desire to pursue the new. One Academy instructor, Leon Kroll, had once told her to "go home and take a mental bath." Instead, she took off and immersed herself in the avant-garde.

She and Pantuhoff moved in together (they never married, possibly because Pantuhoff's anti-Semitic Russian family were the very sort whose pogroms caused Krasner's family to flee the Old Country in the first place). Together they frequented an eatery called the Jumble Shop, a gathering place for serious artists from Arshile Gorky to Willem de Kooning, where "you didn't get a seat at the table unless you thought Picasso was a god," according to Krasner.

Like de Kooning and Gorky—and like Picasso himself—Krasner had not yet taken up total abstraction. But as her *Seated Nude* demonstrates, she was working through the complex lessons of Cubism under the tutelage of German painter Hans Hofmann, a legendary teacher who taught a "push pull" aesthetic of puncturing the two-dimensional picture plane and reordering it using the tension of relationships between simplified

parts (color, form) rather than "illustrating" a given scene.

Eh?

If that sounds like nonsense, maybe Hofmann's words are clearer: "The ability to simplify means to eliminate the unnecessary so that the necessary may speak." After three years of taking classes with Hofmann, uncovering the simple and the necessary, Krasner broke through—she called it a "physical break in my work"—to abstraction.

* * * * *

Speaking of nonsense, it is, alas, a word sometimes (often?) associated with abstract artworks, and it occurs to me that we should tackle the elephant (or non-objective rectangle) in the room straight off. There is, no question, a pervasive sense that abstract art is some trick played on a gullible public, that artists and critics are laughing behind their silk hankies at the fools they've duped into taking this crap seriously. But you'll have to take my word for it: artists, critics, art historians, and gallery owners are all quite earnest in their regard for abstract art. I promise.

Still, even fairly highbrow pundits (e.g., Tom Wolfe in *The Painted Word*) have contended that abstraction is nothing less than charlatanism, practiced by lazy, greedy artists and a complicit art world on a naive public. Yet

the birth of abstraction—why it came into being—is as far from mean-spirited as possible. In fact, it was all about spirit. A new spiritual imagination for a new age.

After so many revolutionary nineteenth-century developments—railroads, photography, Darwinism, feminism—how could traditional Western art, whether a nude Greek god or a savior on a cross, express the modern spiritual condition? Impressionism tackled the problem by being a-spiritual, concerning itself solely with the material world. Post-Impressionists sought some symbolic meaning within the world itself (think of van Gogh's sunflowers or his roiling night sky). By the early twentieth century artists wanted to go even further, looking for ways to lift the veil of the known world and peek at what lies beyond.

Abstract art is sometimes described as a departure from reality, but a better way to say it might be that it seeks to express a *different* reality. The reality behind our visible world. Whether we're woo-woo wingnuts or utter rationalists, I think we can all agree such reality exists. Music, for example.

You wouldn't think of a jazz musician as a fraud trying to trick you into thinking noise was really music. No, because you feel music intuitively: your soul and spirit (and even body) understand its message. The same is true of abstract art if you give it time and attention. It will work on you, if it's good. And of course there's also no

accounting for taste. You might far prefer John Coltrane to John Cage. You may prefer some abstract paintings to others—I have strong opinions I won't bore you with here—but you can still know that those paintings were made with earnest goodwill and hope for conveying some true meaning.

* * * * *

But I digress.

In November 1941, influential Ukrainian artist and impresario John Graham (emphatically not his given name) invited Krasner to take part in a group show with big names like Matisse, Braque, Picasso, and some painter she didn't know, named Pollock. When they met soon after, she recognized him as a guy she'd danced with at an Artists Union party back in 1926. Legend has it (legendarily suppressed by Krasner) that Pollock asked her back then, "Do you like to fuck?" If she hadn't been charmed by him in '26, she was now bowled over by seeing his work, a feeling she later described as "wild enthusiasm." They were soon a couple.

Conveniently, by the time Krasner met Pollock, her White Russian had wandered away to Florida, where he left any lingering Modernist tendencies behind, becoming a society portraitist and faithful escort to rich Southern ladies. For her part, Krasner was working in the WPA's mural division (she later became Pollock's boss for a while) and

clubbing with her hero Piet Mondrian—"We were both mad for jazz"—who, along with so many other eminent European artists, had fled Hitler for New York.

Pollock's work showed Krasner a totally new way to approach abstraction: not formally from without as with European Modernism, but from within. In turn, she gave him support and connections. After Krasner discovered Pollock (yep, I mean it like that), she introduced him, and his work, to prominent artists and critics, such as Clement Greenberg, who more than anyone christened Pollock the savior of American painting.

She also brought Hofmann to meet Pollock. Hofmann's classes always used a model: witness Krasner's *Seated Nude*, a sketch done from life. He considered nature *the source*, an artistic imperative even for pure abstraction. The eminent instructor looked around Pollock's studio and, seeing no evidence of models, neither still lifes nor extant sketches, asked skeptically, "Do you work from nature?"

Pollock's reply speaks volumes: "I am nature."

With that, the wheel turned.

* * * * *

In 1945 the two painters were married. With financial assistance from Peggy Guggenheim—who liked Pollock as much

as she loathed Krasner, even though he was the one peeing in her fireplace at parties—they purchased a home in the Springs on Long Island. There, in a big barn that Pollock used as his studio, he developed his revolutionary drip paintings, the brilliant epitome of gesture, action, and abstraction in one mind-blowing explosion of beautifully ordered paint and canvas.

In a small upstairs bedroom of the main house that Krasner used as her studio, she too worked from within. Just, you know, a lot *smaller*. Like Pollock, she took to standing over her canvas rather than working on an easel, and dripping paint. But where he lunged and danced like a fencer parrying with an opponent, she worked with "controlled chaos." *Composition* is one of thirty-one paintings that make up her *Little Image* series (1946–1950), done in the bedroom at Springs. Here Krasner layers in thick surfaces of paint, divvying up the canvas with an all-over grid of white skeins that create dozens (hundreds?) of smaller images, like hieroglyphics in an Egyptian tomb. Like Egyptian hieroglyphics, there's a tantalizing sense that if we only had the right key, we might unlock this mysterious language. At the same time, there's something universal in their form, something we intuitively recognize as meaningful and human and timeless. Many commentators have connected Krasner's *Little Image* paintings to the Kabbalah of Jewish mysticism, and more prosaically, simply to the Hebrew

Lee Krasner. *Composition.* 1949.

language she studied as a child. Certainly, in the painful years following World War II, Judaism must have often been in her mind, and heart.

Ah, Krasner's heart.

* * * * *

She knew life with Pollock would be tumultuous. Early in their courtship, she'd gone with his brother to get him out of Bellevue, where he'd been drying out for days after a bender brought on by his mother coming to town. Pollock was an alcoholic, no doubt, and an angry, violent drunk at that. It was a

Lee Krasner. *Milkweed*. 1955.

lot, but Krasner was willing to take on all of it for the sake of art, and love.

Critic Amei Wallach has said of Pollock and Krasner that "his energy was lyric, hers was thundering. He was Mozart to her Wagner." I smiled when first reading this because I've often thought of Krasner as Salieri to Pollock's Mozart (in the pop-culture sense, i.e., the movie). Not that Krasner was dangerously envious or conniving, but because like Salieri she was an excellent artist, close enough to genius to know it immediately when she saw it. Much has been made of Krasner's tireless promotion of Pollock, both

before and after his death, but she never stopped making art. Never. As artists they stood shoulder to shoulder, doing the work. Unlike the movie version of Salieri, Krasner did not want this Mozart dead. She very much wanted him to paint, and to live, on.

Famously, Pollock did neither.

The final year of his life, Pollock painted not at all, though Krasner tried to keep him working and sober. She got a reputation for bitchiness, which may have been deserved. But then, she had some things to feel bitchy about.

Her own work was not one of them. By the time Pollock died in an alcohol-fueled car crash (one young woman died with him; his mistress lived) in the summer of 1956, Krasner had completed a series of impressive collages made by tearing up old paintings she found insufficient and reassembling the shards on canvas. As in *Milkweed* here, the results revealed a beautiful balancing point somewhere between Matisse and Motherwell, embracing the past and present, hers and the whole history of Modern art. Krasner had found her own way, working from without and within. Her work had never been better.

Krasner named the collage paintings after they were made, coming up with titles by association. So *Milkweed* isn't a "picture" of the plant per se, but a feeling or spirit or color or shape linked with it, at least in her mind. As to what *Milkweed* or any other

Krasner artwork *means*, she said, "I think my painting is autobiographical if anyone can take the trouble to read it."

It strikes me that the collages are Krasner's most obviously autobiographical work. What is autobiography if not selecting chunks of the past and artfully reorienting them in the present? Krasner of course meant more than this mechanical act. She meant that her work as a whole, which continued long past the *Little Image* series and collages and well into the next three decades, expanding in size, color, and motion, was ripe with her joys and sorrows. Krasner was a restless, protean painter, changing and growing until the end. She did not have children; she did not remarry. She painted. Art itself was her whole life.

Sixteen years after Krasner's death, Marcia Gay Harden won the Best Supporting Actress Oscar for depicting her in the biopic *Pollock* (2000). I'd known about the movie for years, even before it was made. Susan Emshwiller, daughter of my wonderful first writing mentor, Carol Emshwiller, wrote the screenplay. It's a great film. But the irony of Best *Supporting* Actress is too much. If you want to know Krasner, look to her art.

LOUISE BOURGEOIS

In my art I am the murderer.

—LOUISE BOURGEOIS

Art is a guaranty of sanity.

—LOUISE BOURGEOIS

SOMETIMES YOU DO JUDGE a book by its cover. We've all experienced the siren song of a compelling picture stirring some covetous need (*The Goldfinch*, anyone?). Back in the days before Amazon or Google, you could know almost nothing about a book (or album!), and still want it simply because of a captivating image.

That's how on a late afternoon on the Lower East Side in the early '90s I happened to leave Saint Mark's Bookshop with a copy of Lucy Lippard's *From the Center* zipped inside my leather jacket. I wasn't stealing; it was raining. I was protecting the cover, the reason I'd needed to own that book.

This was the first time I encountered a *Femme Maison*, part of a series of drawings and paintings done in the late 1940s by French-American artist Louise Bourgeois, wherein the heads of nude female figures are covered by—or have perhaps transmogrified into—houses. I've seen many examples since, but the Lippard cover is still my favorite.

In stark black and white, it depicts a nude with curving thighs and hips, but with everything from her navel up contained in a boxy rectilinear house (though two U-shapes that imply breasts show through the first floor). It's a heavy load. This is no suburban-picket-fence-type house, this is a

Louise Bourgeois. *Femme Maison.* 1984.
Version 2 of 2, only state, variant. 1984. Photogravure with Chine-collé, plate: 10¹/₁₆ x 4⁷/₁₆ inches; sheet: 19⁵/₁₆ x 14¹⁵/₁₆ inches. The Museum of Modern Art. © The Easton Foundation / Licensed by VAGA, NY.

frickin' château, with a big central staircase and two stories of Roman arches like a mini coliseum. The figure's left hand hangs loose at her side, while the other—or so I first thought—cheerfully waves. She seemed to be waving at me. Flagging me down? Later I thought the gesture might read differently, something like, *Hey you! Can you get this house off me?* The wall above her limp left hand is suspiciously coffin-shaped.

This was how I discovered Louise Bourgeois, a mother and an artist then around eighty years old, living just blocks west of where I'd first found her, and still furiously producing great work.

Femme Maison is literally "woman house," but it really means "housewife." Bourgeois was a housewife when she made them, and a pretty good one. Might we imagine that they are self-portraits of a kind? Bourgeois said that a *Femme Maison* "does not know that she is half naked, and she does not know that she is trying to hide. That is to say, she is totally self-defeating because she shows herself at the very moment that she thinks she is hiding."

I hadn't known anything about the artist then, but her *Femme Maison* contained everything I—a young woman starting out in life—feared (or secretly hoped for?) about womanhood. That a home would consume me, destroy a vital part of my personality and intelligence, i.e., my head. But also, *Hey man, that is one big-ass house. Maybe I could have a house like that?*

Ah, the conflicting desires of young womanhood.

I carried Lippard's book safely through a light rain, to the apartment I shared with my friend and fellow grad student, Martha, who was smart as shit, with a low voice, dry laugh, and a wit to match. I was still close enough to high school to hope her brains and savoir faire might sluff off on me by proximity, though the chasm between us felt unbridgeable. I had dyed black hair straight out of the Ramones; Martha was ringed in God-given blonde curls like a Raphael angel. She was from academic-sounding Andover and her father worked at Harvard. I was from Montana and the California coast, my father a grocery store attorney. She was a Medievalist; I was a Modernist. But we were both interested in feminist art history (the subtitle of Lippard's book was, in fact, *Feminist Essays on Women and Art*). I researched women artists, while Martha's scholarship was far more searching. While I wrote about Adélaïde Labille-Guiard, she wrote about Christ's wounds as vaginal images and the like. But we were both, if I may flatter myself, hell-raisers of our kind. She was my sister in art and crime.

I partly bought the Lippard book thinking we'd both read it. I can't remember if I ever loaned it to Martha, and don't know where it is now, cannot find it among my many bookshelves and boxes. The memory of it simply ends with its acquisition.

* * * * *

But Louise Bourgeois, she remembered everything. A handy trait in an artist, as her work amply reveals. Because that work—and it is a massive oeuvre spanning some seven decades, multiple media, and almost zero culling—relates in some way to her own biography, an overview of her life is practically a requirement.

Bourgeois was born in Paris on Christmas Day, 1911. "I was a pain in the ass when I was born," she said, noting the unpleasant interruption in holiday Champagne and oyster service, not to mention the doctor's extreme inconvenience. If her work—and words—are to be believed, that prick of perceived nuisance pierced her childhood. Especially where her father was concerned.

She'd been named after him (Louis Bourgeois), partly because he wanted a boy. Her father was not above sadistic teasing for what she lacked in that regard (Google *Louise Bourgeois-peels tangerine* for a gutting spectacle of how childhood pain can linger even into glorious old age). The accusation of penis envy by her father—involving said tangerine and a table knife—seems tailor-made for Surrealist purposes. It's no wonder Bourgeois grew up to create haunting tableaux with titles like *The Destruction of the Father*.

She waited out World War I—her father was away fighting—with her mother's family, who ran a business locating and repairing old tapestries, massive textiles with intricate weaving and complex scenes

with elaborate borders and backgrounds. Repairing them was as much art as trade.

When Bourgeois's father came home from the war, he scouted the countryside for tapestries (often repurposed to divide up barns or keep horses warm on cold nights) while her mother ran a workshop out of their home, overseeing a staff of twenty-five

women. Her mother was both practical and artistic, capable of running a large workshop and of recreating beautiful artworks of the past. Though strong in many ways, her mother was not physically vital. She'd barely survived the Spanish flu during World War I (an epidemic that killed some forty-three thousand soldiers), and Bourgeois spent much of her childhood attending to her mother's health.

She said she wanted to be indispensible, and she was in other ways as well. By age ten, Bourgeois was drawing in the missing parts of tapestries. Since they were huge and heavy, they'd often been dragged along, wearing away the bottoms. "I became an expert at drawing legs and feet," Bourgeois said. "It taught me that art can be interesting, as well as useful. That is how my art started." It was in the workshop's sewing room, sitting with gossiping women intent on work but free to talk, that Bourgeois discovered her young English nanny was also her father's mistress. The rage it inspired fueled her art for decades.

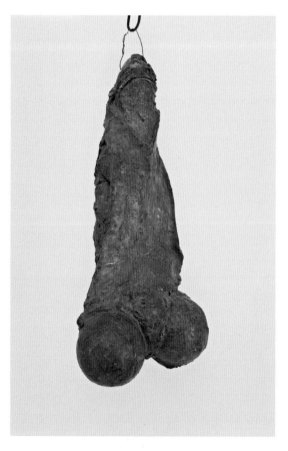

Louise Bourgeois. *Fillette.* 1968.
Latex over plaster, 23½ x 11 x 7½ inches. The Museum of Modern Art. © The Easton Foundation / Licensed by VAGA, NY.

Her father considered contemporary artists "parasites," but when Bourgeois's mother died in 1932 (ah, these dead mothers!), she abruptly switched from studying math at the Sorbonne to studying art. For her, the two pursuits were not so far apart. "The sculpture is a problem to be solved," Bourgeois said. "And it is a pleasure to find a solution." She studied in excellent studios by exchanging translating skills for art instruction (it was Americans who could pay, so she at least had her hated English

nanny to thank for that). Bourgeois knew many Surrealist artists, but refused the roles they proffered, which was as either model or mistress.

In 1938, she met an American art historian named Robert Goldwater while selling him a Picasso print in a small gallery she ran inside the family's tapestry workshop in Paris. "In between conversations about Surrealism and the latest trends," she said, "we got married."

* * * * *

Marrying Goldwater got her out of Paris and into New York, which was fortunate, as World War II was on the horizon. Just as fortunate, it meant leaving behind the weight of European art history, along with social and familial constraints.

By 1941, Bourgeois was *une vrai femme maison*, a housewife with three young sons and a respected New York intellectual for a husband. She kept making art, though not everyone knew that professor Gold-water's wife was also an artist. Surrealists who'd likewise escaped Europe sometimes gathered at their home. Bourgeois was unimpressed. "I objected to them," she said. "They were so lordly and pontifical." Shades of the father. Shades, certainly, of a male prerogative that she resisted, and some-times skewered in her work.

While a 2-ft/61-cm latex penis might imply certain pornographic (and male wish-fulfillment?) properties, in Bourgeois's

conception, it's mostly amusing. Bulbous, wrinkly, and oversize, it is, by implication, a little overblown. A take underscored by the work's title, *Fillette*, which means "Little Girl."

Not so mighty after all, Mr. Penis. It might be called "my little pet," and that's just how it's portrayed in a famous photograph of Bourgeois taken by Robert Mapplethorpe in 1982. Bourgeois, grinning and pleased with herself, has *Fillette* tucked casually under one arm, her right hand cupped beneath the glans penis as if it were the muzzle of a small dog—a wiener dog?—tucked under the arm of her fur coat. She might be any lady who lunches in midtown, one who doesn't go anywhere without her little pet. A different sort of lady. As if Leonardo's *Lady with Ermine* were reincarnated in 1980s Manhattan, fondling a phallus instead of a weasel.

* * * * *

By the time she made *Fillette* in 1968, Bourgeois was showing her work after a long hiatus from active participation in the art world. She'd done the *Femme Maison* series in 1946–1947, then not long after had given up painting for good. From as far back as her studies in Paris, her instructor, the painter Fernand Léger, had told her, "You are not a painter. You are a sculptor."

Her first sculptures were tall abstract standing pieces carved from lightweight balsa wood that she called her *Personages.*

"You can have a family and work in wood," she explained. "It's not dirty. It's not noisy. It's a humble, practical medium." The totemic *Personages*, bolted directly to the floor without bases, were almost like a small crowd of their own populating her first one-woman show of sculpture in 1949.

Her father died in 1951, which rattled Bourgeois to her core. Her violent reaction to his death somehow stopped her from showing for a decade, but she kept working.

Goldwater taught art history at the Institute of Fine Arts, where one of his students was Lucy Lippard. As a young critic, Lippard curated a groundbreaking show in 1966 called "Eccentric Abstraction." Bourgeois hadn't shown for some time, but Lippard heard about her former professor's wife's work and paid a call to her basement studio. What Lippard found astonished her. "Many artists destroy their work not because it is bad but because it is not successful—because other people are not interested in it," Bourgeois said. Years of steady, inventive work filled every space of her studio.

Lippard featured Bourgeois in her "Eccentric Abstraction" show alongside artists decades her junior. The older artist was a hit.

Timing couldn't have been better. Feminism was on the rise and Bourgeois was the perfect object lesson: a talented visionary who'd been unjustly overlooked. In 1973, her husband, Robert, died. "I was a runaway girl, and Robert saved me," she told

the *New Yorker* in 2002. In a long career of truth-telling, Bourgeois was always grateful for her husband. And yet, after his death she flourished, and so did her work.

Bourgeois died in 2010 at age ninety-eight, a celebrated artist working until the end.

* * * * *

Four years later, in 2014, Martha and I were together for the first time in a decade. Circling fifty, our hair now the same dirty blonde and shoulder length, we were both mothers of two teenaged children, an older boy and a younger girl each. Both married to the men we'd been dating twenty-five years before, the fathers of those children. We'd both known what it was to be a *femme maison*, like Bourgeois, managing children alongside careers in art. We'd ended up more alike than I could have imagined possible. Except that Martha had gotten her PhD and become a full professor, while I'd left the Institute to write.

We were back in New York, so revisiting the Institute of Fine Arts was essential. We peeked in on the old seminar room with its big round table, and the lecture hall next door, once the mansion's former ballroom, lined by mirrors and gilt pilasters, lit by chandeliers. We crossed the Great Hall, with its curving staircase and multilevel tapestry that might have made me think of Louise Bourgeois, if I'd had her in mind.

We looked in the "Oak Room," where wine and tea were served after Friday afternoon lectures, then wandered into the "Marble Room," with its wall-to-wall golden-hued stone, where we ate and bitched and gossiped. How many hours did I sit in that room? More than in any lecture or seminar, that's certain.

"Look," Martha said. Pushed against one wall was a model of the building we were in, on a stand in an open cage, with movable oval mirrors above and to each side.

"I forgot about this," I said, moving closer. I'd seen the press release when it was donated, but never thought of it again. Bourgeois had created and then given to the school a work called *The Institute*. It was as literal as could be imagined: a replica. Far from Bourgeois's typically astonishing vision, it seemed out of place in her oeuvre.

Later I read a piece by feminist art historian and Institute grad Linda Nochlin, quoting Bourgeois: "The Institute played an important part in my life. For many years my husband Robert Goldwater taught there. The four o'clock Friday lectures and tea were events I enjoyed." Oh, me too.

There was something Alice-in-Wonderland-like about being inside the Institute looking at an artwork called *The Institute* that was just that: the Institute. It was like I'd taken some of those Wonderland pills and things were swerving bigger, then smaller, then bigger. Time was zooming in and out, too.

Louise Bourgeois. *The Institute.* 2002. Silver, 12 x 27¾ x 18¼ inches. Steel, glass, mirrors, and wood vitrine: 70 x 40 x 24 inches. Institute of Fine Arts, New York University. © The Easton Foundation / Licensed by VAGA, NY.

There I was again with Martha in the Marble Room, as we'd been hundreds of times many years ago.

We touched the mirrors, turning them up and down, getting the bird's-eye view of the roof and angles on the side walls, but never able to see inside. Cast in silver, *The Institute*'s windows coolly reflected back at us. There is always something unerringly true about Bourgeois's choice of material. Silver is a chilly medium. And though *The Institute* can apparently be taken apart— each floor dismantled and peered into, like a 3-D jigsaw puzzle of rooms and levels—if

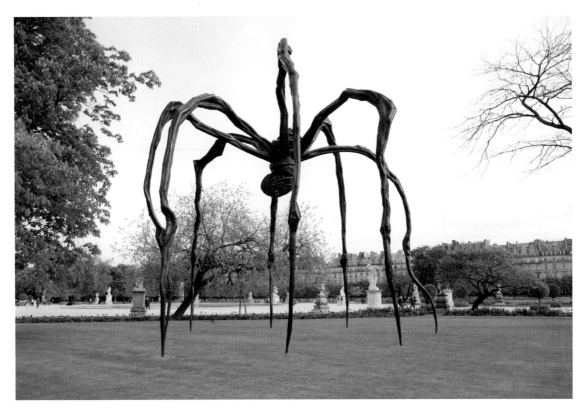

Louise Bourgeois. *Maman*. 1999.
Bronze, stainless steel, marble. 30.5 x 33 feet. © The Easton Foundation / Licensed by VAGA, NY.

you are just looking (the case for most any viewer), you cannot see in. The entire thing feels exclusive, hermetic to the point of being off-limits.

That's a little how it felt when I was a student there, too. As if, again, by some looking-glass magic I had made it inside a place where I did not belong.

Or maybe I did.

Linda Nochlin said of her time as a young woman at the Institute, "It was difficult, but not always so—at times, the struggle itself was exhilarating and energizing. Bourgeois's late work, among other things, reminds me of the contradictory aspects of a vanished past."

I was overcome with a sense of the past colliding with the present. "I miss this," I said.

Martha laughed her throaty, '40s-movie-star laugh. "You could still have it," she said, as if that were obvious, then gesturing it was time to go. I followed her out, hoping she was right.

This book starts soon after Martha said those words. Having just finished a years-long project, I suddenly knew it was women artists I wanted to write about next.

* * * * *

Probably Bourgeois's most famous—and most loved—late work is *Maman*, a towering 30-ft-/914-cm-high spider, originally in steel with six copies cast in bronze. *Maman*'s eight dark, rough-hewn legs and skittery stance are as far as can be imagined from the glinty architectonic severity of *The Institute*, though they were made within a few years of each other. Bourgeois's imagination always contained multitudes.

Maman means "mother," and beneath her abdomen hangs a clutch of twenty-six marble eggs. Far from horror-movie sinister, the giant spider radiates a strange benevolence. When displayed at venues across the world, children play beneath its legs and busy urbanites stop to take smiling photos.

Bourgeois easily explained *Maman*'s appeal: "The Spider is an ode to my mother. She was my best friend. Like a spider, my mother was a weaver. . . . Like spiders, my mother was very clever. Spiders are friendly presences that eat mosquitoes. We know that mosquitoes spread diseases and are therefore unwanted. So, spiders are helpful and protective, just like my mother."

Spiders are like mothers, at least Bourgeois's mother. They are also like artists, weaving, creating, repairing. In that way, Bourgeois is a kind of *Maman*, too, a benevolent mother for us all.

RUTH ASAWA

Whenever there was a free moment, I would sit down and do some work.
Sculpture is like farming. If you just keep at it, you can get quite a lot done.

—RUTH ASAWA

IN THE SPRING OF 1942, sixteen-year-old Ruth Aiko Asawa, born and raised in Norwalk, California, packed a single suitcase of belongings and together with her mother and five of her six siblings reported to the Santa Anita Racetrack for internment. The previous December, Japan had bombed Pearl Harbor. Her younger sister, Nancy (Kimiko), was then in Japan visiting extended family, and was forced to remain for the duration of the war. Asawa's father, a truck farmer (independent, local, small), buried or burned anything in the family home too overtly Japanese, including kendo equipment, decorative books, and dolls. But as an older businessman in the local Japanese community, he was still suspect. In February 1942, Umakichi Asawa was arrested by FBI agents, then interned at an enemy detention camp in New Mexico. For the next six months, Asawa didn't know whether her father was alive or dead. She would not see him again for six years.

At Santa Anita, the remainder of Asawa's family inhabited the racetrack's former horse stalls. "We were given two stalls," Asawa said. "My brothers lived in one and we lived in the other. They gave us an army blanket, a pillow, and a cot. We made our own mattresses out of straw."

Asawa, a young woman whose entire world had been ripped to pieces, later told an interviewer, "We had a really good time, actually. I enjoyed it."

Heh?

Some eighteen thouseand people of Japanese heritage were interned at Santa Anita while Asawa was there, a lively concentration of culture and talent. Asawa went from being a girl attending a (surprisingly) diverse public school, to direct instruction from Japanese Americans who came from the highest ranks of professional fields. An ad-hoc school was set up in the racetrack's bleachers and there Asawa had her first contact with career artists, including the former director of the Art Students League of Los Angeles, at least one WPA artist, and three animators from the Disney Studios.

"How lucky could a sixteen-year-old be?" Asawa said.

Ever optimistic, not given to grudges, Asawa was no Pollyanna, either. When made to say the Pledge of Allegiance at Rohwer Relocation Center in Arkansas, where her family was sent after six months at Santa Anita, she and her classmates added their own coda after *with liberty and justice for all*—adding, with a loud bravura flourish, *Except us!*

* * * * *

After graduating from the Arkansas relocation center high school, Asawa availed herself of a government-paid bus ticket to any Midwest college (no one of Japanese heritage was allowed on the coasts). Already, she wanted to study art, but the famed Art Institute of Chicago was too expensive. So with the assistance of a Quaker-funded scholarship, she nabbed the cheapest school available: Milwaukee State Teachers College.

At age seventeen Asawa arrived alone in Milwaukee, ready to begin her education as an art teacher. She did well for three years, but in her fourth she needed classroom experience to graduate and her advisors would not place her in Milwaukee's public schools due to lingering ill-will against the Japanese. Asawa left college without a degree. (Decades later, the school tried giving her an honorary doctorate, but Asawa insisted on the BA she'd earned instead.)

Fortunately, the summer before her final year in Milwaukee, Asawa had taken a bus to Mexico with her eldest sister, Lois (Masako), who was studying Spanish. In Mexico City, Asawa saw José Orozco painting a public mural, and took an art class at the Universidad de Mexico with Clara Porset, a Cuban refugee and friend of German refugee artist Josef Albers, who was then teaching at an experimental school in North Carolina called Black Mountain College. She told Asawa about Albers and his school.

When she couldn't complete the teaching program, Asawa thought of Albers. "Had Milwaukee State Teachers College not rejected me and forced me to the alternative of Black Mountain College, I would have retired as an art teacher with retirement benefits," she said. Mexico and Black

Mountain College meant everything to what Asawa would become.

The summer after she started at Black Mountain, Asawa returned to Mexico, where she taught drawing to children in Toluca. From villagers she learned how to weave baskets out of wire, a strategy of utilizing what was effective and at hand. The technique—no more complicated than crochet—beautifully met many criteria that Asawa had soaked up under Albers's tutelage.

Before the war, Albers had studied and taught at the Bauhaus, an influential German school that fed European Modernism, from painting, sculpture, and architecture to craftwork and industrial design. Through Albers (among many others, including his wife, renowned textile designer, Anni), the rational ideals of the Bauhaus were transmitted to American artists: refined simplicity, elegance, truth to material.

When she returned to Black Mountain that fall, Asawa began creating her own works in wire. "You make the line, a two-dimensional line, then you go into space, and you have a three-dimensional piece. It's like drawing in space," she said. She'd discovered a humble method that utilized industrial materials to create forms as elegant as nature itself. Asawa's hanging chain-mail baskets feel almost like they might have been birthed in a kind of mechanized petri dish. They are both insistently man-made and feel elemental, living parts of the natural world.

Ruth Asawa. *Untitled.* c. 1955.

Bourgeoning, breathing, they sway as they hang and cast complicated, ever-changing shadows.

* * * * *

Ruth Asawa. *Andrea Fountain.* 1968.

I knew about Ruth Asawa from the history of Black Mountain. Her fellow students included such influential artists as Ray Johnson and Robert Rauschenberg, while instructors spanned the gamut, from painter Jacob Lawrence to composer John Cage, from choreographer Merce Cunningham to architect Buckminster Fuller, her mentor and lifelong friend.

So I respected Asawa but knew little about her until moving to San Francisco, where she was famous as "the fountain lady." Said fountains—mermaids, one on a sea turtle nursing a merbaby; a cylinder jam-packed *horror vacui* style with notable

city landmarks molded by local children; and others—filled me, I confess, with some dismay. *These* were products of Black Mountain?

They're not my thing, but so what? Many people adore them, including the throngs who rallied to defend the landmark-filled fountain when Apple started its demolition for its new building in a shared plaza on Union Square.

So I didn't "get" Ruth Asawa. That is, until one Sunday when I visited the de Young Museum with my teenaged son. He needed to find a work of art he liked for a class

and document—i.e., stand next to it and take a picture—his choice. I was thrilled he wanted me there, ready to instruct and advise.

Surprise! It didn't go that way. I started by pointing out an awesome, painterly Richard Diebenkorn—*noncommittal shrug*—then moved onto Wayne Thiebaud's groovy Pop art territory—*nothing*—and on and on through the Modern galleries. It wasn't until one of the more *retardataire* sections of the nineteenth century that he found *the one*. He handed me his phone. I pointed it at him, my eyes wide. I took a second picture with my phone and texted my husband: *Where did we go wrong?*

There was our son, messy surfer hair, black San Franpsycho T-shirt hanging on his skinny body, grinning in front of Frederic Church's romantic landscape, *Rainy Season in the Tropics*, complete with rose-colored mist and a rainbow.

"What do you like about it?" I asked.

He shrugged, as if I could no more understand the appeal of Frederic Church than I could that of World of Warcraft. ("They're related," my husband wisely pointed out later. "Think Middle Earth.")

I gave up, suggesting we check out the view from Hamon Tower before we left. It was a rare clear day and, in a town of few tall buildings, a coveted chance to look out over our beautiful city.

We turned the blind corner to the atrium with the elevators and I caught my breath. Hanging above and around us were more than a dozen works in wire, some dangling baskets, some starbursts of spiky metal, some shimmering cascades of chain mail. Light played through the layers and shapes, causing shifting shadows to play over the walls, floor, and ceiling, as if we were underwater. I frickin' loved it.

"What about these?" I said.

My son gave a noncommittal nod. "Pretty cool," he said, pushing the Up button.

It was an almost perfect inversion of my first real museum experience, when I was barely a teen myself. We'd driven cross country in July, from Montana to D.C., in a van with no air-conditioning. So the Smithsonian was like heaven, cool and spare and vast. Almost immediately, I spotted a huge Cy Twombly (as I now know), grayish green and filled end to end in a looping white script that looked like handwriting, but couldn't be read. It spoke some language I didn't know, but I still loved it, like hearing French for the first time and understanding nothing beyond that it was wonderful, even if I had no idea what was really being said. I wanted to keep looking, but family friends hurried us along to see "a real painting" they couldn't wait to show us.

It was also huge, a Bierstadt mountain landscape with a mirroring lake reflecting craggy peaks above, surrounded by dusk's

Imogen Cunningham. *Ruth Asawa at work with children.* 1957.

pink haze. At the water's edge, a deer family shyly drank, innocent but alert. Basically, it looked a lot like Montana.

Why had I so much preferred the first painting, the one I hadn't fully understood? To paraphrase Lee Krasner when speaking of her teacher, émigré Hans Hofmann: "His was the lesson of abstraction, and I got it." I just got abstraction; I liked it straight off.

But for my son it was the reverse, sublime landscape trumping any abstract art, whether painting or sculpture. He held the elevator

doors while I snapped a shot of the wall plaque. In the tower, while he took in the view, I looked at my phone. The works in the atrium were by Ruth Asawa. Now I got her.

* * * * *

Before we left I bought a catalog of Asawa's work, humbled by my previous disregard. She was so much more than I'd realized.

At Black Mountain, Asawa met a young architecture student from the South named Albert Lanier and they hit it off. Lanier heard that you could get a full meal plus a bottle of wine in North Beach for less than a buck, so in late summer 1948 he headed west and set up shop in San Francisco. That fall, the California Supreme Court struck down laws prohibiting interracial marriage. The summer of 1949 Asawa married Lanier in San Francisco. They had six children in ten years.

The year before she was married, Asawa exhibited her first wire "basket" pieces at Black Mountain College. In 1950, the year after her marriage, she showed similar pieces at the Art Association Annual at the San Francisco Museum of Modern Art. She had her first two children that same year. Point being, neither marriage nor children impeded her work.

This fabulous photograph by Asawa's friend, celebrated photographer Imogen Cunningham, demonstrates how: She just did it. Kept making art, kept raising children, kept doing all kinds of things. I copied the picture from the catalog and carried it around in my notebook. If Asawa could have four kids arrayed around her like a procreative Leonardo Madonna (see his *Virgin of the Rocks*), one a diaperless baby helping himself to a bottle, but keep her head down concentrating on a new piece (while finished works float around her family like household gods), then I could write some during my daughter's soccer practice at the to-hell-and-back fields across town.

* * * * *

Of course Asawa could only do her part. She couldn't control the critical assessment of her, or her art. In reviewing her work in 1954, *TIME* magazine described the artist: "Rush Asawa, 28, is a San Francisco housewife and mother of three." Though the article says she "studied under Abstract Painter Josef Albers at Black Mountain College," it only compares her work to another Japanese American sculptor, Isamu Noguchi (who, the article points out, studied with Constantin Brancusi). Though both Americans who studied with Europeans, the reviewer insists: "Noguchi and Asawa share one quality of Oriental art that Western artists often lack: economy of means. Their Japanese ancestors devoted vast efforts to making a single brushstroke look easy." So there you go, art by genetic transmission rather than by serious study with European

Ruth Asawa. *Untitled.* c. 1962.

artists whose work was utterly defined by economy and radical simplicity (see Brancusi's *Bird in Space* or Albers's *Homage to the Square*).

* * * * *

Asawa explored the possibility of wire for decades, following line into space wherever it led, neither burdened by past success nor afraid to explore new styles.

In the 1960s, friends brought her a desert plant from Death Valley, thinking she'd enjoy its unusual, outer-space shape, and she did. But when she tried drawing the plant, its unusual structure proved difficult to capture in two dimensions, so she began sculpting. A new style of "tied" wire sculpture was born, anchored at the center while simultaneously reaching up and down into space.

These could almost be portraits of the artist.

Her career was, more or less from the start, one of national and even international scope. By the end of the 1950s, Asawa had already

exhibited across the country, including
New York shows at the Peridot Gallery
and the Whitney Museum of American
Art, and at the American Art Exhibition at
the Art Institute of Chicago, where one of
her pieces was the cover of the exhibition
catalog. Just six years after leaving Black
Mountain College, one of her hanging pieces
was included in the 1955 São Paulo Biennial.

If her reach was wide, Asawa's roots ran
deep, not just in her family that came to
include more than a dozen grandchildren
and great-grandchildren, but also in the
community. In addition to public fountains,
murals, and mosaics, Asawa spearheaded
the Alvarado Arts Workshop, a successful
effort to keep art in financially strapped
San Francisco public schools. And she was
instrumental in starting a public arts high
school in the city, the first on the West
Coast, now called the Ruth Asawa San
Francisco School of the Arts.

Child of truck farmers, Asawa was pro-
foundly gifted at growing things: art,
children, a long marriage, deep and lasting
changes in public education. She was herself
a force of nature.

ANA MENDIETA

She was excited and optimistic. She told me she was going to give up drinking and smoking because women artists did not get recognition until they were old. She said that she wanted to live long enough to savor it.

—B. RUBY RICH

Perhaps she had become addicted to exile.

—JOHN PERREAULT

IN THE HOT EARLY MORNING of September 8, 1985, a doorman working the night shift in Greenwich Village heard a woman's voice pierce the night, screaming, "No, No, No, No," then moments later, the sound of a large object striking somewhere nearby.

Artist Ana Mendieta, thirty-six years old and married less than a year to renowned sculptor Carl Andre, fifty-two, had just plummeted from the bedroom window of their nearby apartment—thirty-four stories—and died on impact.

Because Mendieta is known for the ethereal self-portraits-cum-crime-scene-outlines she called *Siluetas*—and because the police took no photos—it's tempting to imagine the scene. Rather than gruesome, I want to picture Mendieta as she was in her very first *Silueta*: a naked body covered in white flowers, all ripeness and purity, associating her own procreative forces with the power of the Great Goddess. Or perhaps, like *Silueta Muerta* here (see page 146), her arms raised overhead in an ancient gesture of prayer.

* * * * *

Ana Mendieta. *Silueta Muerta*. 1976.

But there is more than eerie symbolism lurking in this story. On the 911 tapes, after her fall, Andre informed the emergency operator that he and his wife were both artists and had been arguing about his being more "exposed to the public than she was" and that in the heated course of things "she went out the window." A bizarrely passive construction, as if she were a little bird who'd suddenly taken flight. Mendieta was indeed little, under 5 ft/152 cm tall, weighing just 93 lb/42 kg. Their high bedroom window was barely within her reach.

When the police arrived, they found the room in wild disarray, fresh scratches marking Andre's face and arms. He showed the officers a book about himself, saying, "I am a very successful artist and she wasn't. Maybe that got to her, and in that case, maybe I did kill her."

Two things are worth pointing out here. One, Mendieta, recently returned from working at the American Academy in Rome after winning the prestigious Rome Prize, was plenty successful. Two, both artists were big drinkers and had been drinking heavily that night.

Even Andre doesn't seem to know exactly what happened; over the years, he's given three very different accounts. First to the 911 operator, then to the police, then to the *New Yorker*. In the magazine's 2011 interview, Andre told Calvin Tomkins that the warm night had turned suddenly cool and Mendieta had gotten up from their bed to close the window and "just lost her balance."

Andre was arrested and briefly held. Bitter art-world factions sprang up immediately, for and against him. No question, Andre had power and wealth on his side. Artist friends paid his bail, and in 1988, he was acquitted. A celebrated pioneer of Minimalist sculpture, Andre and his brilliant career were affected not at all.

* * * * *

I only discovered Mendieta in 1992, the year the Guggenheim opened its new SoHo location (now defunct) not far from the gallery where my husband worked.

I'd been following media coverage of the new space for weeks, when I read this from Roberta Smith in the *New York Times:* "At the opening preview of the Guggenheim Museum SoHo on Thursday evening, 400 demonstrators protested the fact that this exhibition included only one woman and no minority artists, and also that it featured the work of Mr. Andre, who was found not guilty of murder in the death of his wife, the artist Ana Mendieta."

Wait, what?

"As these objections suggest," Smith continued, "the show is not the most diplomatic way for the Guggenheim to introduce itself to the downtown art world."

Some protestors at the SoHo Guggenheim preview carried a large banner that read: *Carl Andre is in the Guggenheim. Where is Ana Mendieta? ¿Dónde estás Ana Mendieta?*

I'd been hearing about Carl Andre's Minimalist sculptures since I began studying art history. His name and work were everywhere—museums, galleries, Manhattan apartments—along with work by contemporaries like Donald Judd, Sol LeWitt, and Robert Ryman.

But who was Mendieta?

I had to go looking for her.

The first things I located were all about her death, then finally, in a book on art of the 1970s on our own bookshelf, I saw my first versions of her *Siluetas*, ghostly outlines that were both immediate—*Here I*

am—and timeless. Mendieta made *Siluetas* for seven years, creating outlines of the female form—frequently her own—from materials of the natural world. She often left the imprint of her body directly on the earth, whether stone, mud, leaves, graves, or more. The *Siluetas* were ephemeral in nature, but Mendieta carefully preserved them via photographs and film.

The more I discovered about Mendieta, the more amazed I was by how much she had done. The *Siluetas* were the beginning of a new and powerful art form she pioneered, one combining earthworks, feminism, performance, conceptual art, photography, and film. Where was Ana Mendieta? She was everywhere, if you knew what to look for.

Born in Cuba, she came to the United States in 1961 at the age of twelve with her sister Raquelin, fourteen. They had only each other, having left behind their mother and younger brother; their father, once a Revolutionary stalwart, had been jailed by Castro. *Operation Pedro Pan* saw fourteen thousand children airlifted from Cuba to the United States under the aegis of the Catholic Church. When she stepped off the plane in Miami, Mendieta kissed the ground.

Her romance with America was short-lived. The sisters were sent to Iowa of all places, where they often lived apart in a series of orphanages, foster homes, and reform schools. From a prominent Cuban family that proudly traced its ancestry to Spain, the girls were blindsided by the racism in Iowa. "It never entered our minds that we were colored," Raquelin said. The isolation

and abuse they experienced as teenagers made a rebel of Mendieta, one fiercely proud of her identity as a Cuban woman.

She studied art at the University of Iowa, and stayed for graduate school. It was there, in the homely dirt of the Midwest, that Mendieta founded a new art form when she was still a student.

* * * * *

In 1981, Mendieta wrote in an artist's statement, "I have been carrying out a dialogue between the landscape and the female body (based on my own silhouette). I believe this has been a direct result of my having been torn from my homeland (Cuba) during my adolescence. I am overwhelmed by the feeling of having been cast from the womb (nature). My art is the way I re-establish the bonds that unite me to the universe. It is a return to the maternal source." Mendieta sometimes filled in the *Siluetas* with spirals, labyrinths, or a raised bisecting line. And sometimes she made a raised portion first, like a kind of crater, then formed a *Silueta* down inside, almost like a small figure of herself within an earthen womb.

When Mendieta first began working in the natural world in the early 1970s, Earth Art was a powerful new idiom in American sculpture. Probably the most famous of the early earthworks was Robert Smithson's *Spiral Jetty*, 1970, where the artist created a 1,500-ft-/457-m-long coil of rock and earth spinning counterclockwise into Utah's Great Salt Lake.

Earth Art tended toward the massive and the masculine, requiring big machines and accompanying egos. Works such as Michael Heizer's *Double Negative* and Walter De Maria's *The Lightning Field* epitomize the muscular size and scope of the style. If there were an ancient prototype for the new art, it would be Stonehenge way back in the Neolithic, impressive and lasting, at least in part because it's just so damned big. The Neolithic inspiration for Mendieta runs more to the plastered skulls of Jericho and myriad Great Goddess images found all over the world.

According to art historian Jane Blocker, Mendieta made over two hundred works utilizing the earth as a key component. "I make sculptures in the landscape. Because I have no motherland, I feel a need to join with the earth, to return to her womb."

Nowhere is earth as womb more vivid than in her *Volcano* series. The *Volcanoes* are both vaginal and womblike, implying sex, creation, fertility, and—through what she did with them—transformation.

Alongside earth, Mendieta often used blood and gunpowder, essential elements in the rituals of Santeria, an Afro-Cuban religion that fascinated her. Mendieta earnestly believed in the mysterious potential of art. As a student, she'd rejected painting because of what it could not do: "I realized that my paintings were not real enough for what I wanted the images to convey and by real I mean I wanted my images to have power, to be magic." It may sound a little New Age nutty, but Mendieta undercuts

Ana Mendieta. *Volcano Series no. 2.* 1979.

Ana Mendieta. *Volcano Series no. 2.* 1979.

Ana Mendieta. *Untitled.* 1985.

any bullshit with her intensity. She was fierce.

Like an artist-shaman, in *Volcano Series no. 2* from 1979, shown here, she molded the earth to her purposes, filled the goddess-shaped hole with gunpowder, and set it on fire. The transformation of gunpowder—light-filled, spewing, active, and alive—to dead ash was a kind of transubstantiation of matter. One she, as the artist, had performed in and on the earth.

Magic.

* * * * *

In 1983, Mendieta took up residence at the American Academy in Rome. The city was a revelation. It offered a new context for her Latin heritage. According to author Robert Katz, Rome was "a midplace in the geography of her soul between Cuba and America, neither motherland nor fatherland, a kind of sisterland where she felt strong and free."

With use of a dedicated studio, Mendieta began working indoors for the first time. Her final pieces were also her first meant to be exhibited in a gallery just as she'd made them, objects in themselves, with a palpable sense of permanence. Totemic and upright, they're made from large, often curving slabs of the trunks of fallen trees. A contemporary letter from her dealer mentions a "shield project," of which these are likely part.

Which, it turns out, is heartbreaking.

An Italian collaborator of Mendieta's told the artist's niece (Raquel Cecilia Mendieta, a filmmaker) that the original piece of curved wood once had a handle in the back, implying its protective purpose. Onto the trunks' surfaces, Mendieta burned shadowy shapes with gunpowder. These mysterious symbols recall the magical power superimposed on shields of the past. Constantine, for example, affixing the Chi Rho—symbol of Christ—on the shields of his men at the Battle of the Milvian Bridge, not far from Mendieta's own studio in Rome, from which he had emerged victorious more than 1,500 years before.

But as Raquel Mendieta ruefully notes of her aunt's last artworks, "These shields did not protect Ana."

* * * * *

Thirty years after the death of Ana Mendieta, the Dia Art Foundation in Beacon, New York, featured a retrospective of Carl Andre's work. Protestors cried "Tears for Ana Mendieta" inside the exhibition and wrote "Ana" in fake blood in the snow outside. At Dia headquarters in Manhattan, others dripped chicken blood across a banner on the sidewalk reading, "I Wish Ana Mendieta Was Still Alive."

Her absence is felt as a great weight.

Many long for what might have been.

But look how much there is.

Though most of her art was meant to be "ephemeral" in one way, Mendieta

relentlessly documented her work at every stage. More than a hundred films alone (many recently discovered) are part of her wide-ranging oeuvre, which includes performance pieces on rape, on the slaughter of animals, on transformation and rebirth, self-portraits with her nude body manipulated and distorted as it's pressed against sheets of glass, self-portraits with masculine facial hair, and so much more.

In recent years, Canadian artist Elise Rasmussen began visiting many of the sites of Mendieta's works in Iowa, Mexico, and Cuba. Though she was told again and again that there was nothing left, she found plenty. This, it seems, was Mendieta's hope.

In a piece in the *New Inquiry*, Haley Mlotek quotes Cuban-American curator Olga Viso on Mendieta's interest in the "residue" of her works: "She liked to think that someone hiking in the area might discover one of her weathered *Siluetas* and believe that they had stumbled upon a prehistoric gravesite, carving, or painting."

That makes sense. In her *Silueta Muerta* and many others, Mendieta claimed herself as part of the earth, part of time itself. As protean and prolific as any artist of her generation, she created powerful art still alive in the world.

Where is Ana Mendieta?

All around us.

CHAPTER 14:

KARA WALKER

Often I'll be surprised at even what I could think,
self-righteous goody-two-shoes that I am.

—KARA WALKER

Mommy makes mean art.

—HER DAUGHTER

SO, I MISSED ONE of the great events in twenty-first-century American art. Like skipping Woodstock, or passing up the Six Gallery reading where Allen Ginsberg debuted *Howl*. An essential cultural moment, squandered. And there's no getting it back. It's gone now. Forever.

And that sucks.

In early May 2014, artist Kara Walker unveiled a genuine colossus in Brooklyn, a 75.5-ft-/2,301-cm-long, 35.5-ft-/1,082-cm-high gritty and glistening white mammy sphinx. In photographs, her ample whiteness fills the dark-but-soaring industrial space she inhabits. She crouches, impassive face framed by a

stereotypical knotted head rag, nipples forward, bum high. She is beautiful and terrible, haunting and sickening and humorous. And, she's made of sugar.

The show's title does not include the words *mammy* or *sphinx*. That would be too easy. Instead, it was nearly as epic as the main event. An announcement at the entrance read:

At the behest of Creative Time, Kara E. Walker has confected:

A Subtlety
or the Marvelous Sugar Baby
an Homage to the unpaid and overworked
Artisans who have refined

Kara Walker. *At the behest of Creative Time Kara E. Walker has confected: A Subtlety, or the Marvelous Sugar Baby, an Homage to the unpaid and overworked Artisans who have refined our Sweet tastes from the cane fields to the Kitchens of the New World on the Occasion of the demolition of the Domino Sugar Refining Plant.* 2014. A project of Creative Time. Domino Sugar Refinery, Brooklyn, NY, May 10–July 6, 2014. © Kara Walker, courtesy of Sikkema Jenkins & Co., New York.

our Sweet tastes from the cane fields to the
Kitchens of the New World
on the Occasion of the demolition of the
Domino Sugar Refining Plant.

There is so much to unpack in this piece, it could easily furnish an entire chapter of its own, with lots left over for its very own doorstopper of a book. If you listen closely, you can almost hear the clickety-click of dissertations well underway.

So, *A Subtlety, or the Marvelous Sugar Baby.*

A brief and very much not-exhaustive tour:

Commissioned by Creative Time, an organization dedicated to ambitious public art projects, *A Subtlety* was anything but. Except, actually, it was. It turns out "subtleties" were once elaborate edible sugar sculptures made to adorn the tables of the über-rich. Who knew?

Well, Walker, for one. And in addition to using the very material that same factory processed to create a monument to its

demise (Domino donated 160,000 lbs/ 72,572 kg pounds of sugar for its construction), she mined sugar's dark past, one she's compared to the "blood diamonds" of today: "Sugar crystallizes something in our American Soul. It is emblematic of all Industrial Processes. And of the idea of becoming white. White being equated with pure and 'true,' it takes a lot of energy to turn brown things into white things. A lot of pressure."

The *Sugar Baby* looks black, but she's white. The ghost of America past.

In its day, the Domino Sugar plant processed more than half the raw sugar in the United Sates, a busy blue-collar factory in a thriving blue-collar town. Now it's gone the way of subtleties past. The nineteenth-century building—with its soaring space and spanning girders, a kind of industrial-age cathedral—was slated for imminent demolition after the *Subtlety* show. To be replaced by upscale apartments, half a million square feet of commercial space, and a waterside promenade.

In its review, the *New York Times* wrote, "The smell hits you first: sweet but with an acrid edge, like a thousand burned marshmallows." Which, together with the white colossus herself, reminded me of the otherworldly, gigantic, and malevolent Stay Puft Marshmallow Man at the end of the first *Ghostbusters*. "I do what I'm feeling and what I'm feeling is monstrous," Walker said in a conversation with filmmaker Ava DuVernay. "And I do it in the nicest possible way."

Though the sphinx of ancient Greece (the female one, as opposed to the male Egyptian version) was malevolent, Walker's creature is anything but. She is terrible, in the sense that she is large and imposing— awe-inspiring as an ancient god—but she is also reserved, regal, above the fray. She is ennobling, even in her position, which is an unfortunate one.

Some of the Instagram and Twitter posts were, predictably, lame. Too many selfies posed not in front, but *behind*, pointing at or goofing on the *Sugar Baby's* epic-sized labia. On this point, Walker is philosophical: "I put a giant ten-foot vagina in the world and people respond to giant ten-foot vaginas in the way that they do. It's not unexpected." In this piece and many others, Walker is the opposite of the Internet scold. She's saying—in effect—this life, our history, our lust and livelihoods and loves, are deeply complicated. Also, they are fucked up.

But public disregard for the brutal history embodied in her *Sugar Baby* infuriated many. The piece bred plenty of controversy, including protests online and in person. Along with it: effusive praise for the artist.

Not so surprising for a woman who won a MacArthur Foundation "genius" grant at age twenty-seven, the second-youngest recipient ever. (In case you're keeping score, the youngest: eighteen.)

* * * * *

For those of you reading this book straight through: we've come full circle. Like

Artemisia Gentileschi, and the vast majority of women artists before the modern era, Walker became an artist because she was raised by an artist: "One of my earliest memories involves sitting on my dad's lap in his studio in the garage of our house and watching him draw. I remember thinking: 'I want to do that, too.'"

Walker spent her first thirteen years in Stockton, gateway town to California's Central Valley, where Dad—Larry Walker—was a professor and chair of the art department at the University of the Pacific. In her father's (correct) view, Stockton was an artistic backwater and it was holding back his career. For his daughter, it was an upbeat '70s "Free to Be You and Me" childhood of pleasant activities and thoughtless diversity. She was black, sure, but everyone was something.

Things were very different when Larry moved the family to Atlanta in 1983 to take a similar position at Georgia State University, a bigger school in a much bigger city. But even by the 1980s, it was a place not far enough removed from Jim Crow. The Atlanta Child Murders were a recent terror, there were monuments to the Confederate Army in the neighborhood park, and the KKK left scary notes on her white boyfriend's car. Walker processed almost none of it at the time; that came—volubly—later.

Walker studied at the Atlanta College of Art, then the Rhode Island School of Design for grad school, where she had her breakthrough. When *New York* magazine critic

Jerry Saltz happened on some of her work in a shared studio space he was visiting there, "I felt like a thunderbolt had hit the back of my head. I was sickened, thrilled, and terrified."

That's an almost perfect summation of my first encounter with Walker's work. This was at the Drawing Center in SoHo in 1994, back when she was still a RISD student. It was a little like catching the first Beatles set at the Indra Club in Hamburg. Front row at the revolution.

I'd started the day at the gallery where my husband was a preparator, checking out some Byron Kim paintings he'd recently hung. They were fantastic: a series of monochromatic canvases in earthy tones of brown, peach, buff, and sand—J.Crew sweater colors made painterly and pure. They were lovely, yes, but also oddly compelling, though I couldn't say why. They were neither hard-edged nor painterly, but somehow they were just right.

"They remind me of Brice Marden," I said to my husband, high praise.

He nodded or didn't, dashing back and forth behind me as I looked. He was at work; I wasn't. "They're portraits of his friends and family," he said at some juncture. "Their skin colors."

Now I loved them. There's nothing I like more than a good portrait. Abstraction plus portraiture—the seemingly impossible—was pretty close to perfection in my book. I had a little freak-out in front of them.

Kara Walker. *Gone, An Historical Romance of a Civil War as It Occurred Between the Dusky Thighs of One Young Negress and Her Heart.* 1994.
Cut paper on wall. 156 x 600 inches. © Kara Walker, courtesy of Sikkema Jenkins & Co., New York.

Artist Glenn Ligon was there (it occurs to me that it may have been his show my husband was hanging while I hung out). He saw or (please God, no) heard me and came over. We admired Kim's paintings together and then he said something like, *If you like these, you should check out this artist named Kara Walker down the street.* When I asked for details, he said to just go, that I needed to see for myself.

So I strolled blithely into the Drawing Center, expecting more abstract paintings. I was charmed to see nothing of the kind. And not conceptual art or Neo-expressionist paintings or graffiti art or any of the things you might have expected to see in SoHo in 1994. This was totally unexpected, something almost like a history painting, big and bold

and self-assured and . . . pretty. 50 ft/15 m of gracefully cut silhouettes superimposed across the wall's white surface.

Then I looked closer. My next thought: Holy. Shit.

Gone, An Historical Romance of a Civil War as It Occurred Between the Dusky Thighs of One Young Negress and Her Heart was, frankly, terrifying.

Walker's silhouettes are nearly life-size. I felt subsumed in the scene, pulled in, implicated. I wasn't totally sure what was going on, but whatever it was, it was deeply disturbing.

Reading it, approximately, from left to right: A hoop-skirted white woman leans in

to kiss a sword-clad "gentleman" beneath a mossy Southern-looking tree. The man's sword pokes backward at the bum of a black child holding the neck of a big strangled bird. A black woman who may be part boat floats before them. Behind her is a rocky outcropping where a white man is being fellated by a black child. The white man raises his hands in ecstasy and they point to a black man floating above, his engorged penis like a balloon carrying him upward. Below him to the right, a black girl does a scatological jig, while a black woman with a kerchief on her head and a broom in hand is thrust forward by a white man whose head is buried up her skirt.

How did I know the race of any given figure, since all of them were black cutouts? Stereotypes. The white characters are a Scarlett O'Hara-ish woman and Southern "gentlemen" in fitted breeches and tails. The skinny black characters have pigtails, nappy hair, hanging sacks for clothes. "The silhouette says a lot with very little information, but that's also what the stereotype does," Walker said, of discovering her signature style. "So I saw the silhouette and the stereotype as linked."

Standing there unsettled in the gallery reminded me of an evening at Robert Rosenblum's house, where he sometimes hosted students. A reconception of van Gogh's *The Potato Eaters* hung on one of Rosenblum's walls. Googly-eyed, big-lipped black sharecroppers replacing Dutch peasants. On the high right, almost like a flashing neon sign, it said: *Eat Dem Taters*. I respected Rosenblum as much as anyone

I've ever known but could not begin to understand that painting in the context of his dining room. Was it really okay for a white art historian, curator, and critic to own, much less display, such a painting? I didn't know where to look.

I later discovered that Robert Colescott, the artist of *Eat Dem Taters*, had been a big influence on Walker, and particularly that painting. At least the continuity of my consternation was consistent.

Like the gruesome humor in Colescott's work, Walker's *Gone* shines, in the words of Linda Nochlin, with "a kind of pseudo-Rococo perkiness throughout." Yes, I could see it even on my first encounter: racial horror show meets Rococo naughty. Walker's *Gone* is a kind of mash-up of Goya's *Disasters of War* and Fragonard's *The Swing*. She is their twentieth-century love child, equally unflinching in depicting violence and sex.

I was pretty sure it wasn't okay for me to be enjoying Walker's work so much. I wasn't even sure it was okay for me, a white girl in her twenties, to be looking at it at all.

But I couldn't look away.

* * * * *

I wasn't the only one who thought I shouldn't be looking. Artist Betye Saar, and many other artists, thought so, too.

Soon after Walker landed the MacArthur, Saar sent some two hundred letters (oh, those pre-Internet days—now that

was dedication! And not cheap, either) addressed especially to black artists and intellectuals: "I am writing you, seeking your help to spread awareness about the negative images produced by the young African American artist, Kara Walker." Actually, she wasn't just asking for awareness, but calling for censorship of Walker's work (which was effective in at least one instance). Saar said it wasn't personal, though it's hard to take her at her word: "I have nothing against Kara except that I think she is young and foolish," she said. Saar did concede that she found Walker's work "revolting" and questioned her intentions as an artist. "The goal is to be rich and famous. There is no personal integrity," Saar said. "Kara is selling us down the river."

Saar's own, celebrated, work also often utilizes racial stereotypes—Uncle Tom, Aunt Jemima, Little Black Sambo—but with a crystal-clear party line. Her most famous piece, *The Liberation of Aunt Jemima* from 1972, is a vitrine lined with a backdrop of smiling Aunt Jemima faces, presumably from pancake boxes. Standing before them is a plump and grinning mammy figurine. Propped against her belly is a picture of a mammy holding a white baby. In one hand the figure herself holds a broom and in the other, a shotgun. Aunt Jemima may still be smiling, but she's not gonna take it anymore. Totally worth saying, and got it.

Walker's art isn't like that. It's far more complicated, implicating, scary, and confusing. And it's brave as hell. When the attacks on her work began, Walker was pregnant and, soon after, the mother of a newborn

Kara Walker. *Rebel Leader* (from *Testimony*). 2004. Cut paper with pencil, pressure-sensitive tape, and metal fasteners on board. 18 x 14.5 inches. © Kara Walker, courtesy of Sikkema Jenkins & Co., New York.

daughter. It was undoubtedly a psychic and spiritual one-two punch, but nothing has stopped Walker from continuing to make hella difficult art.

That's true even when she's using an image similar to Saar's—in this case, black female stereotype holding broom and gun (from her 2004 video work *Testimony: Narrative of a Negress Burdened by Good Fortune*). Violence is not implied, but carried out in the lynching of a white slave master (by jittery silhouette puppets). There is a steady willingness to hold a cold eye on the horror. Walker doesn't just threaten the tough stuff: she makes us undergo it with her.

Kara Walker. *Alabama Loyalists Greeting the Federal Gun-Boats from Harper's Pictorial History of the Civil War (Annotated)*. 2005.
Offset lithography and silkscreen. Sheet: 39 x 53 inches. © Kara Walker, courtesy of Sikkema Jenkins & Co., New York.

* * * * *

One of the slams against Walker early on was that the white establishment just loved her so much. There may be something there, I don't know, but it's hard not to sense the lip-purse of sour grapes. Unquestionably, from the MacArthur to the Metropolitan Museum of Art, Walker has traveled in the highest of high circles.

In 2006, she was the first living artist in the history of the Met invited to curate an exhibition using the museum's permanent collection. Gary Tinterow, curator of nineteenth-century, modern, and contemporary art (that vast position embodied in one person says a lot about the Met's relationship to "newer" art), gave Walker carte blanche to do what she wanted: show her own work, the work of some other artist, a selection, whatever.

Walker responded with a timely exhibition titled "After the Deluge." It featured wide-ranging samples of water and terror—from an obscure seventeenth-century Dutch etching, *The Bursting of St.*

Anthony's Dike, to a crowd favorite from
the American Wing, Winslow Homer's late
nineteenth-century painting *Gulf Stream*,
depicting a solitary black man adrift on a
stormy, shark-infested sea. The whole show,
title included, was a response to the very
real recent horror of Hurricane Katrina.
Walker highlighted how often water and
terror and race have converged in art and
history. Especially American art/history.

Of her own works from the Met's collection,
she included her print portfolio, *Harper's
Pictorial History of the Civil War (Anno-
tated)*. In these works, Walker takes
etchings of *Harper's* original visual jour-
nalism (*Harper's* hired thousands of artists,
including Winslow Homer, to create images
during the war) and superimposes the
images of slaves on the mainstream (read:
white) narrative. Those were the people
and stories of the war that were overlooked,
just as the marginalized populations of New
Orleans during and after Katrina were; both
led to wholesale tragedy.

But that's me talking, not Walker. Though
her work is powerful, complicated, and
brave (and beautiful), she makes no claims
for its usefulness.

"I don't think that my work is actually effec-
tively dealing with history," she's said. "I
think of my work as subsumed by history or
consumed by history." Or, to quote the epic
title from one of her large drawings (that
itself quotes, and alters, Martin Luther
King), *The moral arc of history ideally
bends towards justice but just as soon as
not curves back around toward barbarism,
sadism, and unrestrained chaos.*

SUSAN O'MALLEY

I want to go back to my eighth grade dream of being an artist.
Because if I don't do it now, then when will I???
Why delay the truth in your heart?

—SUSAN O'MALLEY, AGE 24

How we spend our days is, of course, how we spend our lives.

—ANNIE DILLARD, *THE WRITING LIFE*

IN 2014, ARTIST SUSAN O'MALLEY lost her mother to a degenerative brain disease called multiple systems atrophy. O'Malley and her five close-knit siblings—four sisters and a brother—watched Lupita O'Malley transform over three years from a vibrant teacher of special needs children to needing a great deal herself. Lupita was, toward the end, wheelchair-bound, with difficulty speaking and writing. Faced with her mother's steep decline and sure knowledge that the disease would kill her, O'Malley did not turn to the Catholic faith of her childhood or to hope in some yet-unknown science.

Susan O'Malley turned to her art. She made art with her mother.

In 2012 O'Malley had a show called *My Healing Garden Is Green* at the Romer Young Gallery in San Francisco. The phrase was her mother's, written after her terminal diagnosis. O'Malley asked her mom to write down phrases she often used with her children. Lupita O'Malley's stabbing, broken handwriting is almost illegible. But her daughter framed blown-up prints of those shaky phrases—graphic black on white against white gallery walls—so that they look almost like gestural abstract paintings,

Susan O'Malley. *I Love You Baby.* 2012.

except that when you look closely, they coalesce into readable, declarative statements: *I Love You Baby. Trick Your Brain & Smile. If it takes more energy to frown then be happy.*

They are upbeat, heartbreaking, and deeply human.

"I am so grateful for her," O'Malley wrote about her mother, "not only for agreeing to make art with me, but for her endless inspiration on how to live: with love, grace and a sense of humor."

The same might be said of O'Malley herself. Actually, the same is said of her.

I'm struck by all the lost mothers in this brief sampling of women artists. The mothers of Artemisia Gentileschi, Adélaïde Labille-Guiard, Edmonia Lewis, Vanessa Bell, and Louise Bourgeois all died when their daughters were still children or teenagers. O'Malley was in her late thirties. And there's Paula Modersohn-Becker, just thirty when she died shortly after becoming a mother herself, leaving behind her infant daughter.

It may not be anything common in their experience that made these motherless daughters look to art. Maybe it's coincidence, or just the sort of lives I'm drawn to, or a simple fact of history that if we select x number of women from before x time, encounters with early death are inevitable.

But at least in O'Malley's case, her mother's struggle with a terminal illness did help focus her desire to make art. She was already an artist—lively, productive, public—but she was also a busy curator and gallery manager for the San Jose Institute of Contemporary Art. It's all too easy in such positions (curators, art handlers, editors, publishers) to allow the creative work of others to overshadow your own. Often, it's a necessary fact of making a living.

But with her mother's illness, O'Malley dedicated herself with more intensity to her own art and in that arena things went well. Her pieces were widely exhibited, at prestigious California venues such as Montalvo Arts Center and Yerba Buena Center for the Arts, and as far afield as England, Denmark, and Poland. She also began work on her first book.

At Montalvo in 2013, O'Malley was featured in "Happiness Is" alongside artists Christine Wong Yap and Leah Rosenberg. "It became a really collaborative project," according to exhibition curator Donna Conwell, not least because of O'Malley: "Her working process was so incredibly open." O'Malley further collaborated with Rosenberg in 2014 at Yerba Buena's *Bay Area Now 7* (NorCal's version of, say, the Whitney Biennial), but the cooperative nature of her art embraces viewers as much as fellow artists.

While her mother was dying, O'Malley was creating work for "Happiness Is," which could have been a gruesome irony. Yet one of the show's most moving pieces was her *A Healing Walk*. Montalvo is situated on 175 acres/71 ha, with miles of widely utilized hiking trails. On one steep trail O'Malley installed nine signs of a type that might be found in Muir Woods to the north, explaining the flora, fauna, or history of the place. But O'Malley's signs express states of presence and of mind, such as: *This Beautiful Moment, Your Mind Quiets, You Look Up, You Are Here Awake and Alive.*

Nine was the number favored by Dante in structuring his *Divine Comedy*, which begins with a walk: *In the middle of our lives / I found myself in a dark woods / the right road lost.* Dante's guide is the poet Virgil; in *A Healing Walk*, the artist O'Malley is ours. And just as Virgil takes Dante through Hell, then on a steep path up until they see the stars, O'Malley's path culminates in a summit overlooking the quiet balm of the natural world.

O'Malley's walk offered healing for herself, and for others. Her art is generous that way.

Lupita O'Malley died in 2014. By then Susan O'Malley had quit her job and was working full time on her art. Soon after her mother's death, she was also focusing on an exciting new creative project: she was pregnant with twin girls. O'Malley was becoming, in the

way Paula Modersohn-Becker once so beautifully captured, procreative in every sense.

* * * * *

O'Malley's early life hardly strikes me as fertile ground for a budding artist. She was raised in a nondescript suburb of San Jose, a place not known for art. A high-achiever, she went to Stanford (class of 1999), where her friend and fellow undergrad Christina Amini says, "There were very few studio art majors. Maybe five out of a class of fifteen hundred." O'Malley was not one of them. She started as a human biology major, with no interest in becoming a doctor, and by her junior year realized she was accruing a lot of credits toward urban studies, so she majored in that and liked it fine. "What was exciting to me was that it was about how we live," O'Malley wrote a few years after graduation. "How the structures that we've built relate to our human interactions. The idea of community, and how what we've developed makes communities or hurts communities. How all of these ideas intersect with each other."

The thing about places like Stanford (in case you don't know) is there's a white-hot spotlight held on success. O'Malley saw this as something of a liability: "I realize that it didn't leave a lot of room for big mistakes or wanting to admit big mistakes. But big mistakes are part of the learning process and how we grow up." After Stanford, she followed the traditional path of movers and shakers and moved to New York with friends. She was there less than two

years before recognizing her mistake. She didn't want to "make it" in New York—she wanted, quite simply, to make art.

So she moved in with her mom, where she used the garage as a studio and took art classes at nearby Foothill College.

The above might sound (and feel) a lot like failure when you're twenty-four years old (and a Stanford grad)—living back with your mom, going to community college—but O'Malley sucked it up and named herself artist-in-residence of her Willow Glen neighborhood in San Jose. Her urban studies interests—and wry humor—are apparent in her earliest works.

O'Malley did not to set out to *épater* the bourgeoisie she was "stuck" among. No, she dropped a kindly note in her neighbors' mailboxes letting them know she might rearrange the leaves on their lawns or roll up the garden hose in a certain manner. Neighbors sent supportive notes and e-mails. Passersby sometimes asked if she was the new artist-in-residence. One homeowner created his own lawn leaf pattern.

From the outset O'Malley's art had her trademark hijinks and witty charms: a big mowed ring in a grassy expanse of front lawn, like a suburban crop circle; leaves cleared right along the axis of a tree's potential shadow, as if it were painted there; a rock garden where white ornamental stones have been arranged to read "Lawn," like the old "generic" marketing (bag, hat, aspirin) of the '70s. The work also demonstrates her talent for community, for

Susan O'Malley. *Lawn*. 2008.

elevating all kinds of environments—urban, suburban, woods, countryside—and maybe most importantly, elevating the people in those environments, whose lives and living spaces are deemed worthy of art.

In her short films, *How to Be an Artist in Residence* and *A Few Yards in San Jose*, it's striking how much a part of her environment O'Malley is. She's no punk rock anarchist or paint-splattered artiste, but a young woman with plain midlength brown hair in (not especially cool) blue jeans, T-shirt, and sneakers.

She takes up her work like an Andy Goldsworthy of the mundane, arranging rocks and leaves and rolling up hoses. Also, hugging fire hydrants or washing her hands in a birdbath. Watching her reminds me of Joseph Beuys, another earnest explorer of his own origins. But imagine if instead of Beuys crashing his Luftwaffe plane and getting wrapped in felt and animal fat by nomadic Tatars, he was raised with five siblings in a San Jose subdivision.

Beuys's story is a little like a fairy tale (of the dark, Germanic variety) and there's something of the same in O'Malley's origins

(a brighter, American version). Raised in a supportive family, she got into Stanford. There she made a lifelong best friend, Amini, and met her future husband, Tim Caro-Bruce. If there's a theme in O'Malley's story, it's about making art and making connections, and how she brings those two things together: "There is something magical about breaking the silent space between a stranger and myself. I have a theory that people are waiting to be asked and to be heard."

* * * * *

She was not shy about asking. In grad school at California College of the Arts, she founded the *Pep Talk Squad*, consisting of her and Amini in matching checkered Vans and red track jackets with *Pep Talk Squad* silkscreened by O'Malley on the back. "We were goofy gals in our midtwenties," Amini says. "The silliness of our outfits allowed people to approach us."

And people did. When asked, "Is there anything you need pep or encouragement on?" most people offered up real and difficult personal issues. Each session was a genuine conversation, lasting something like fifteen minutes. As journalist Bonnie Tsui has pointed out, O'Malley embodied that rarest of the human species, "an extrovert but a good listener." In other words, perfect for her task.

One of the *Pep Talk Squad* would ask questions while the other typed up responses on a portable typewriter, on carbon paper

so both parties had a copy. After listening carefully, reflecting back the nature of the problem to make sure they nailed it, the *Pep Talk Squad* read an *Official Pep Talk* and closed by throwing up their arms like a stadium wave and cheering, "Goooooo Mike!" (Or whatever said Pep Talkee's name might be.)

Try it. Let someone do it for you, or insert your own name in front of the mirror and cheer for yourself. It feels great. I'd bet *Pep Talk Squad* recipients also felt great. After the cheer, they received a button proclaiming, "I had a pep talk today." Ah, those lucky few.

Pep Talk Squad performances were part earnest (if awesomely wacky) encouragement of others, and some part critique of the dead seriousness of so much art school production. Witness the academic reaction to the work: a pamphlet O'Malley created promoting the *Pep Talk Squad* was her grad school thesis. Critiques ran to asking how her work was art rather than, say, self-help, psychology, or therapy.

* * * * *

Maybe it was all of those. Art can be, of course. Matisse knew that when he said he wanted art that was "a soothing, calming influence on the mind, something like a good armchair."

I first saw O'Malley's work sometime in 2013, bright and popping posters in places normally reserved for advertising

(newsstands, BART stations) consisting of phrases like: *This Is It, This Place Right Now*, and *More Beautiful Than You Ever Imagined*. I spotted my first one on Market Street—*This Is It*—and assumed it was something about a new app or software or some such. But the lack of further advertising made me look closer. In the lower left corner it read, *The Thing Quarterly*, a local artist-run publication. I was totally charmed to find art in the very mouth of Mammon, where Twitter and Facebook and grillions of start-ups were busy setting up camps, raiding the city and the world.

Called *Mantras for the Urban Dweller (Moment to Moment)*, the series, as explained by O'Malley, was "open-ended public service announcements; invitations to pause amid the hustle of the city." I didn't see much pausing near her *Mantras*, at least where I was. But I did see homeless people, tech hipsters, art students, tourists, flâneurs, UPS drivers, and more, the messy horde of our too-cool city, rushing by them. Including me.

O'Malley understood this reality, but hoped to nudge us elsewhere. "In these works I'm suggesting my wish for how things could be: if we paid closer attention to our being, to our grieving, to the way the sun makes a spectacular reflection on the buildings at that certain time of day. It has to begin somewhere, why not here?"

JD Beltran, artist and president of the San Francisco Arts Commission, believes

O'Malley's art does begin it. "[Her] work will always remain relevant and powerful, because it taps into the human condition— what we tell ourselves every day that spurs us to continue to go on in our lives," Beltran writes. "And not just go on, but revel in the present, and to pursue what inspires us."

Included in a group show with O'Malley at Intersection for the Arts, Beltran fell in love with and bought on sight one of her pieces, a black rectangle with white lettering proclaiming: *You Are Here*. Beltran calls it "a map of your own personal geography." Looking at it, she says, "I'm actually aware of 'being here now.'" Not bad for three little words in black and white.

* * * * *

Though often quite simple, O'Malley's textual pieces pack a big punch. The next time I spotted her work was a couple of years after the first, in the East Bay. I didn't know it was hers right away, though I should have. It had her every hallmark: bright yellow with black lettering like a textual smiley face, declaring: *Less Internet, More Love*. It plastered the side of a building in Berkeley, so large and insistent that I read it easily as I drove by. It made me smile.

I'd been visiting my friend Chaylee in Oakland and was headed into Berkeley on an errand. Though I'd rarely gone to the East Bay during my previous fifteen years in San Francisco, for the past eighteen months I'd

Susan O'Malley. *Less Internet More Love*. 2015.

visited Chaylee and her children every few weeks or so. She'd been there for me when my own kids were little, and I wanted to do the same. Seeing the mural confirmed my best intentions—that human contact, however erratic, beats out e-mail any day.

It wasn't until I was home and Googled Less Internet, More Love that I discovered the terrible coincidence of seeing O'Malley's work again (it was her of course; I should have known).

The week before her bright yellow mural went up, O'Malley was at home in Berkeley getting things shipshape before the scheduled delivery of her twin daughters in three days. She wrote e-mails and posted a note on Facebook asking if anyone could help transport an artwork. An artist friend came by to borrow a book, young daughter in tow. It's easy to imagine O'Malley thinking how amazing it was that soon she would have daughters herself.

Her husband was working in an adjoining room that day when, not long after the friend and his daughter left, he heard a noise. Going in to investigate, he found O'Malley on the floor, unconscious. He started CPR. EMTs were there within minutes, but O'Malley could not be revived.

Her daughters, delivered at the hospital via C-section, lived just long enough for their father to hold them.

Susan O'Malley was thirty-eight years old when she experienced a fatal heart arrhythmia caused by an undiagnosed tumor attached to its outer membrane.

This, to an artist whose work was all about the heart.

It is unspeakable. Outrageous. Unthinkable.

I know. I've withheld this tsunami of unutterably terrible truth until nearly the end. But I did so in hopes of holding O'Malley's big-hearted art—if just for some minutes—apart from the heartbreaking fact of her death. Her art should be, and deserves to be, experienced on its own wacky, brave, and beautiful terms.

At Montalvo, they've reinstalled *A Healing Walk* and are working to make it a permanent exhibition. Not because O'Malley died, but because of what she made. "She is a significant Bay Area artist," explains Conwell. "We love Susan and we love having her work here, but this is not a memorial. She is going to help bring attention to an important collection with her work." And so, her collaborations continue.

O'Malley's final project was a book called *Advice from My 80-Year-Old Self*. It came out a year after she died, her words and images still vibrant and working in the world.

Using her genius for connection, O'Malley had asked more than a hundred people of all ages and walks of life to imagine time traveling to the future and meeting themselves at age eighty. What words of wisdom might this future self give? The book—big sheets filled with her trademark bold text and brilliant colors—illustrates those answers. From the idiosyncratic, *It Was a Good Call to Buy the RV* and *It's OK to Have Sugar in Your Tea*, to the broadly instructive, *Don't Be Afraid* and *Don't Ever Lie*, to the somewhat plagiaristic, *Your Heart Has Reasons Your Head Does Not Know* (see Pascal), they all share an abiding belief in the wisdom we have within. If we listen to our hearts. (Actually, that's one too: *Do Things That Matter to Your Heart*.)

My favorite of these is the only one not brightly colored. In stark black and white it proclaims: *Art Before Dishes*.

I believe it. I try to act accordingly.

Thank God for us that O'Malley did, too.

Susan O'Malley. *Art Before Dishes*. 2014.

Our story began with my finding sixteen women artists in the third edition of H. W. Janson's seminal *History of Art*. I've presented fifteen here. Why one short?

I've left room for myself. For you. For anyone who wants it.

Insert yourself *here*.

In her groundbreaking work *The Obstacle Race*, Germaine Greer wrote, "Books are finite; the story of women painters has no end—indeed it may be said to be just beginning—but a book must stop somewhere."

Insert "artist" for painter and the story is the same. Hell, insert anything you like— poet, architect, filmmaker, actor, brain surgeon, astronaut—and run with it. Great lives and great works are endless: we just have to look for them. And, of course, create them.

* * * * *

Let's get started.

ACKNOWLEDGMENTS

No amount of thanks can express what I owe the following people or the gratitude I have for their existence. It is my gobsmacking good fortune to know them.

Thanks to Carol Edgarian, generous mentor and friend, whose advice on looking to the heart has transformed my writing and my life. Thanks to Danielle Svetcov for her faith, which has sustained me, and her astonishing willingness to dig in. All thanks to Bridget Watson Payne, for believing in this book and shepherding it into existence with such kindness and intelligence.

Great thanks to the wonderful folks at *Narrative Magazine*, especially Carol Edgarian and Tom Jenks. Gratitude for my writing peeps at the San Francisco Writers' Grotto; I can't say enough about the support, and fun, I've found there.

Thanks to my parents, Jake and Polly Quinn, for everything of course, but especially for always esteeming the creative life. Thank you to my sisters, Padeen Quinn and Diane Regan-Sandbak, for illustrating early what awesome women look like. Thanks to my brothers, Brendhan, Patrick, Tom, John, Chris, and Bill, for being such good men. Special thanks to my nephew, Sam Hoiland, whose life assistance meant the difference between doing the work and losing my mind.

Thanks to Sharon and Tom Welter for decades of unconditional love, and for happily hanging with the grandkids while I hid upstairs and wrote. Thank you to Sheila Schroeder and Jason Phillips for a place to work (and play) summer after summer at the enchanting Chautauqua Institute. Thanks to Martha Easton and Mark Trowbridge for grad-school awesomeness and beyond, and for their essential help with stories here.

Thanks to the many amazing women whose friendship and wisdom have been vital, especially Stacey Hubbard, Annette Hughes-White, Rafferty Atha Jackson, Chaylee Priete, and Tahlia Priete. Special thanks to Jennifer March Soloway, whose many hours of counsel in the pool and on the page have so often saved me. And thanks to Bill and Cindy Feeney, for decades of art and friendship.

Finally, ultimate and greatest thanks go to Rick, Lukas, and Zuzu. Without you I'm nothing. With you is everything.

SELECT BIBLIOGRAPHY

Als, Hilton. "The Shadow Act: Kara Walker's Vision." *The New Yorker*, October 8, 2007.

———. "The Sugar Sphinx." *The New Yorker*, October 8, 2014.

Alther, Lisa, and Françoise Gilot. *About Women: Conversations Between a Writer and a Painter*. New York: Doubleday, 2015.

Ashton, Dore, and Denise Brown Hare. *Rosa Bonheur: A Life and a Legend*. New York: Viking Press, 1981.

Auricchio, Laura. *Adélaïde Labille-Guiard: Artist in the Age of Revolution*. Los Angeles: Getty Publications, 2009.

Blocker, Jane. *Where Is Ana Mendieta?* Durham, NC, and London: Duke University Press, 1999.

Boime, Albert. "The Case of Rosa Bonheur: Why Should a Woman Want to be More Like a Man?" *Art History* 4, no. 4 (December 1981): 384–409.

Broud, Norma, and Mary D. Garrard. *The Expanding Discourse: Feminism and Art History*. New York: Icon Editions, 1992.

Buck, Kirsten Pai. *Child of the Fire: Mary Edmonia Lewis and the Problem of Art History's Black and Indian Subject*. Durham, NC, and London: Duke University Press, 2010.

Chadwick, Whitney. *Women, Art, and Society*. London: Thames & Hudson, 2012.

Christensen, Kate. *The Great Man*. New York: Doubleday, 2007.

Faurschou, Luise and Jens, Zhu Qui, and Maya Kovskaya. *Louise Bourgeois: Alone and Together*. Copenhagen and Beijing: Faurschou Foundation, 2012.

Garrard, Mary. *Artemisia Gentileschi*. Princeton, NJ: Princeton University Press, 1989.

Greenberg, Jan, and Sandra Jordan. *Runaway Girl: The Artist Louise Bourgeois*. New York: Harry N. Abrams, 2003.

Greer, Germaine. *The Obstacle Race: The Fortunes of Women Painters and Their Work*. New York: St. Martin's Press, 1979.

Heartney, Eleanor, Helaine Posner, Nancy Princenthal, and Sue Scott. *After the Revolution: Women Who Transformed Contemporary Art*. Munich/London/New York: Prestel Verlag, 2013.

Heilbrun, Carolyn G. *Writing a Woman's Life*. New York: Ballantine, 1988.

Hess, Thomas B., and Elizabeth C. Baker. *Art and Sexual Politics*. New York: Macmillan Publishing, 1973.

Hoban, Phoebe. *Alice Neel: The Art of Not Sitting Pretty*. New York: St. Martin's Press, 2010.

Hofrichter, Frima Fox. "A Light in the Galaxy." In *Singular Women: Writing the Artist*, edited by Kristen Frederickson and Sarah E. Webb. Berkeley, CA: University of California Press, 2003.

Janson, H. W. *History of Art*. 3rd ed. New York: Harry N. Abrams, 1986.

Lee, Hermione. *Biography: A Very Short Introduction*. New York: Oxford University Press, 2009.

———. *Virginia Woolf*. New York: Vintage Books, 1999.

Levin, Gail. *Lee Krasner: A Biography. New York*. William Morrow, 2011.

Lewison, Jeremy, Barry Walker, Tamar Galb, and Robert Storr. *Alice Neel: Painted Truths*. New Haven, CT: Yale University Press, 2010.

Lurie, Alison. *The Truth about Lorin Jones*. New York: Avon Books, 1979.

Malcolm, Janet. *Forty-one False Starts: Essays on Artists and Writers*. New York: Farrar, Straus and Giroux, 2013.

Merz, Beatrice, Olga Gambari, Raquel Cecilia Mendieta, and Linda M. Montano. *Ana Mendieta: She Got Love*. Milan: Skira Editore, 2013.

Messud, Claire. *The Woman Upstairs*. New York: Vintage Books, 2013.

Mlotek, Haley. "Tracing Ana." *The New Inquiry*, March 24, 2014.

Nochlin, Linda. *Women, Art, and Power and Other Essays*. New York: Harper & Row, 1988.

O'Malley, Susan. *Advice from My 80-Year-Old Self*. San Francisco, CA: Chronicle Books, 2016.

Parker, Rozsika, and Griselda Pollock. *Old Mistresses: Women, Art and Ideology*. New York: Pantheon Books, 1981.

Perry, Gillian. *Paula Modersohn-Becker*. London: The Women's Press, 1979.

Radycki, Diane. *Paula Modersohn-Becker: The First Modern Woman Artist*. New Haven, CT, and London: Yale University Press, 2013.

Reilly, Maura, ed. *The Linda Nochlin Reader*. New York: Thames & Hudson, 2015.

Salenius, Sirpa, ed. *Sculptors, Painters, and Italy: Italian Influence on Nineteenth-Century American Art*. Padua, Italy: Il Prato, 2011.

Saltz, Jerry. "An Explosion of Color, in Black and White: Kara Walker's silhouettes don't just broach America's touchiest subject—they detonate it." *New York* magazine, November 1, 2007.

Sandel, Cora. *Alberta Alone*. Athens, OH: Ohio University Press, 1984.

———. *Alberta and Freedom*. Athens, OH: Ohio University Press, 1984.

Schjeldahl, Peter. "A Woman's Work." *The New Yorker*, June 29, 2009.

Shone, Richard. *The Art of Bloomsbury*. Princeton, NJ: Princeton University Press, 1999.

———. *Bloomsbury Portraits*. New York: Phaidon Press, 1976.

Slatkin, Wendy. *Women Artists in History*. Upper Saddle River, NJ: Prentice Hall, 1990.

Smith, Roberta. "After the Deluge." *The New York Times*, March 24, 2006.

Sontag, Susan. *Against Interpretation*. New York: Anchor Books/Doubleday, 1964.

Spalding, Frances. *Vanessa Bell*. New Haven, CT, and New York: Ticknor & Fields, 1983.

Stokstad, Marilyn. *Art History*. Upper Saddle River, NJ: Prentice Hall, 2005.

Straussman-Pflanzer, Eve. *Violence & Virtue: Artemisia Gentileschi's Judith Slaying Holofernes*. New Haven, CT, and London: Yale University Press, 2013.

Tsui, Bonnie. "Trick Your Brain and Smile." *San Francisco Magazine*, December 21, 2015.

Walker, Kara, and Larry Walker. "Artists in Conversation." *BOMB Magazine*, May 8, 2014.

Wallach, Amei. "The Lee Krasner Who Was Herself amd Only Herself." *The New York Times*. Oct. 3, 1999.

Welu, James A., and Pieter Biesboer. *Judith Leyster: A Dutch Master and Her World*. New Haven, CT, and London: Yale University Press, 1993.

Winterson, Jeanette. *Art [Objects]*. New York: Alfred A. Knopf, 1996.

Woolf, Virginia. *A Writer's Diary*. San Diego/New York/London: Harcourt Brace & Company, 1982.

ART CREDITS

ARTEMISIA GENTILESCHI:

Judith Severing the Head of Holofernes. Uffizi. Alinari / Art Resource, NY.

Susanna and the Elders. Private Collection / Bridgeman Images.

Self-Portrait as La Pittura. Royal Collection Trust / © Her Majesty Queen Elizabeth II, 2015.

CESARE RIPA:

Illustrated title page from *Iconologia*. © British Library Board / Robana / Art Resource, NY.

JUDITH LEYSTER:

Monogram (detail of *Carousing Couple*). Musée du Louvre. Erich Lessing / Art Resource, NY.

Self-Portrait. National Gallery of Art, Washington, DC / Bridgeman Images.

The Proposition. Mauritshuis. Scala / Art Resource, NY.

Early Brabantian Tulip. Frans Hals Museum / de Hallen Haarlem. Photo: Mooie Boeken. Purchased with the support of the Rembrandt Society.

ADÉLAÏDE LABILLE-GUIARD:

Self-portrait with Two Pupils, Mademoiselle Marie Gabrielle Capet (1761–1818) and Mademoiselle Carreaux de Rosemond (died 1788). 1785. Oil on canvas, 83 x 59½ inches. Gift of Julia A. Berwind, 1953 (53.225.5). The Metropolitan Museum of Art. Image Copyright © The Metropolitan Museum of Art / Art Resource, NY.

Portrait of Madame Adélaïde. Châteaux de Versailles et de Trianon. Photo: Gérard Blot / Jean Schormans. © RMN-Grand Palais / Art Resource, NY.

Portrait of François-André Vincent. 1795. Musée du Louvre. Photo: Jean-Gilles Berizzi. © RMN-Grand Palais / Art Resource, NY.

PIETRO ANTONIO MARTINI:

Paintings Exhibition at the Salon of the Louvre. Hamburger Kunsthalle / Christoph Irrgang / Art Resource, NY.

MARIE DENISE VILLERS:

Portrait of Charlotte du Val d'Ognes. Oil on canvas, 63½ x 50⅝ inches. Mr. and Mrs. Isaac D. Fletcher Collection, Bequest of Isaac D. Fletcher, 1917 (17.120.204). The Metropolitan Museum of Art. Image Copyright © The Metropolitan Museum of Art / Art Resource, NY.

A Young Woman Seated by a Window. Private Collection. Courtesy of Sotheby's.

Study of a Woman from Nature (also called *Madame Soustra*). Musée du Louvre. Photo: Jean-Gilles Berizzi. © RMN-Grand Palais / Art Resource, NY.

MARIE VICTOIRE LEMOINE:

The Interior of an Atelier of a Woman Painter. Oil on canvas, 45⅞ x 35 inches. Gift of Mrs. Thorneycroft Ryle, 1957 (57.103). The Metropolitan Museum of Art. Image Copyright © The Metropolitan Museum of Art / Art Resource, NY.

ROSA BONHEUR:

Portrait of "Buffalo Bill" Cody. Buffalo Bill Center of the West / The Art Archive at Art Resource, NY.

The Horse Fair. Oil on canvas, 96¼ x 199½ inches. Gift of Cornelius Vanderbilt, 1887 (87.25). The Metropolitan Museum of Art. Image Copyright © The Metropolitan Museum of Art / Art Resource, NY.

Ploughing in the Nivernais. Musée d'Orsay. Photo: Gérard Blot. © RMN-Grand Palais / Art Resource, NY.

ÉDOUARD LOUIS DUBUFE:

Portrait of Rosa Bonheur. Châteaux de Versailles et de Trianon. Photo: Gérard Blot. © RMN-Grand Palais / Art Resource, NY.

EDMONIA LEWIS:

The Death of Cleopatra. Smithsonian American Art Museum, Washington, DC / Art Resource, NY.

Forever Free (The Morning of Liberty). Howard University Gallery of Art, Washington, DC.

The Wooing of Hiawatha (Old Arrow-Maker and His Daughter). Smithsonian American Art Museum, Washington, DC / Art Resource, NY.

HENRY ROCHER:

Carte-de-Visite of Edmonia Lewis. National Portrait Gallery, Smithsonian Institution / Art Resource, NY.

PAULA MODERSOHN-BECKER:

Self-Portrait, Age 30, 6th Wedding Day. Museen Böttcherstraße, Bremen.

Portrait of Clara Rilke-Westhoff. Hamburger Kunsthalle / Elke Walford / Art Resource, NY.

Reclining Mother and Child II. Museen Böttcherstraße, Bremen.

Self-Portrait with Amber Necklace II. Kunstmuseum Basil / Martin P. Bühler.

VANESSA BELL:

Virginia Woolf. © National Portrait Gallery, London. © Estate of Vanessa Bell, courtesy Henrietta Garnett.

Frederick and Jessie Etchells Painting. Tate, London / Art Resource, NY. © Estate of Vanessa Bell, courtesy Henrietta Garnett.

Studland Beach. Tate, London / Art Resource, NY. © Estate of Vanessa Bell, courtesy Henrietta Garnett.

Cover of First Edition of 'The Waves' by Virginia Woolf. Private Collection / The Stapleton Collection / Bridgeman Images. © Estate of Vanessa Bell, courtesy Henrietta Garnett.

ALICE NEEL:

Portrait of Alice Neel based on a photograph © The Estate of Alice Neel / Courtesy David Zwirner, New York / London.

Self-Portrait. National Portrait Gallery, Smithsonian Institution / Art Resource, NY. © The Estate of Alice Neel / Courtesy David Zwirner, New York / London.

Frank O'Hara. National Portrait Gallery, Smithsonian Institution / Art Resource, NY. © The Estate of Alice Neel / Courtesy David Zwirner, New York / London.

Jackie Curtis and Ritta Redd. Cleveland Museum of Art / Leonard C. Hanna Jr. Fund / Bridgeman Images. © The Estate of Alice Neel / Courtesy David Zwirner, New York / London.

Kate Millett. National Portrait Gallery, Smithsonian Institution / Art Resource, NY. © The Estate of Alice Neel / Courtesy David Zwirner, New York / London.

LEE KRASNER:

Portrait of Lee Krasner based on a photograph © Fred W. McDarrah / Getty Images.

Self-Portrait. The Jewish Museum, New York / Art Resource, NY. @ The Pollock-Krasner Foundation / Artists Rights Society (ARS), New York.

Seated Nude. 1940. Charcoal on paper, 25 x 18 7/8". Gift of Constance B. Cartwright. The Museum of Modern Art / Licensed by SCALA / Art Resource, NY. @ The Pollock-Krasner Foundation / Artists Rights Society (ARS), New York.

Composition. The Philadelphia Museum of Art / Art Resource, NY. @ The Pollock-Krasner Foundation / Artists Rights Society (ARS), New York.

Milkweed. Albright-Knox Art Gallery / Art Resource, NY. @ The Pollock-Krasner Foundation / Artists Rights Society (ARS), New York.

LOUISE BOURGEOIS:

Portrait of Louise Bourgeois based on a photograph © Satoshi Saikusa / Trunk Archive.

Femme Maison. © The Museum of Modern Art / Licensed by SCALA / Art Resource, NY.

Fillette. © The Museum of Modern Art / Licensed by SCALA / Art Resource, NY.

The Institute. Institute of Fine Arts, New York University / Christopher Burke / © The Easton Foundation / Licensed by VAGA, NY.

Maman. Manuel Cohen / The Art Archive at Art Resource, NY.

RUTH ASAWA:

Portrait of Ruth Asawa based on a photograph from Nat Farbman / Getty Images / Ruth Asawa Estate. Courtesy Christies.

Untitled. c. 1955. Iron and galvanized steel wire. 123 x 16 x 16 in. The Fine Arts Museums of San Francisco, gift of Jacqueline Hoefer.

Andrea fountain. Ghirardelli Square, San Francisco, CA. 1968. Photo and Artwork © Estate of Ruth Asawa.

Untitled. c. 1962. Galvanized steel wire. 24 x 24 x 24 in (61 x 61 x 61 cm). The Fine Arts Museums of San Francisco, gift of the artist.

IMOGEN CUNNINGHAM:

Ruth Asawa at work with children. 1957. Imogen Cunningham Trust.

ANA MENDIETA:

Portrait of Ana Mendieta based on a photograph © The Estate of Ana Mendieta Collection, LLC/ Courtesy Galerie Lelong, New York.

INDEX